Reflections & Undercurrents

ERNEST ROTH AND PRINTMAKING IN VENICE, 1900–1940

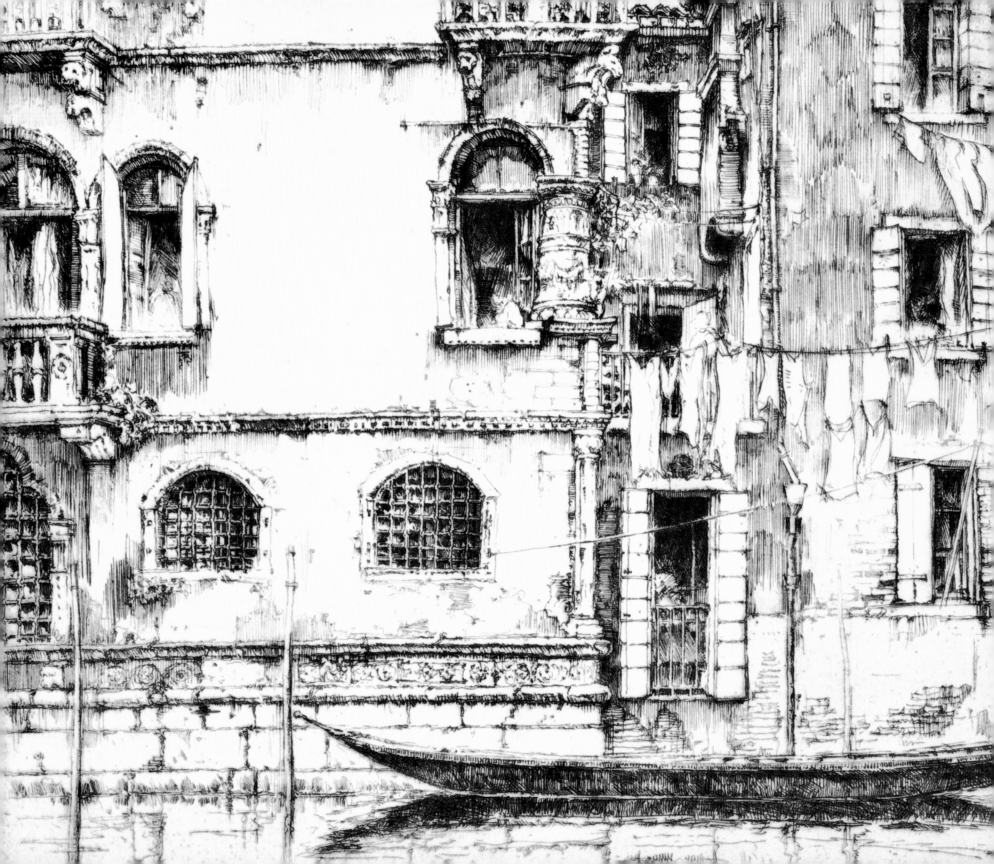

Reflections & Undercurrents

ERNEST ROTH AND PRINTMAKING IN VENICE, 1900–1940

Eric Denker

Edited by Phillip Earenfight

THE TROUT GALLERY
Dickinson College
Carlisle, Pennsylvania

Distributed by
University of Washington Press
Seattle, Washington

With affection, for Massimo Lumine and Birgit Müller-Lumine

. . . most of all we remember, as one recollects a splash of vivid color

or a chord of pure harmony, the very essence of friendship.

—Dorothy Noyes Arms and John Taylor Arms
Hill Towns and Cities of Northern Italy (1932)

Published by
THE TROUT GALLERY
Dickinson College, Carlisle, Pennsylvania

Distributed by
University of Washington Press
PO Box 50096
Seattle, WA 98145–5096
www.washington.edu/uwpress

First published 2012 by
The Trout Gallery, Carlisle, Pennsylvania
www.troutgallery.org
Editor: Phillip Earenfight
Design: Kimberley Nichols, Patricia Pohlman
Dickinson College Office of Design Services
Photography: Andrew Bale
Printing: Triangle Printing Company, York, Pennsylvania
Typography: Frederic Goudy's Old Style (1915) and LTC Deepdene (1931), Eric Gill's Perpetua (1929) and Gill Sans (1929)

Front cover: Ernest David Roth, *Ca' d'Oro*, etching, private collection, fig. 32, pl. 57.
Facing title page: Ernest David Roth, *The Stones of Venice* (detail), etching, collection of Mr. & Mrs. Robert Martin, fig. 49, pl. 72.

Library of Congress Cataloging-in-Publication Data
Denker, Eric.
 Reflections & undercurrents : Ernest Roth and printmaking in Venice, 1900-1940 / Eric Denker ; edited by Phillip Earenfight.
 p. cm.
 Catalog of an exhibition held at Trout Gallery.
 Includes bibliographical references and index.
 ISBN 978-0-9826156-4-5 (alk. paper)
 1. Venice (Italy)--In art--Exhibitions. 2. Roth, Ernest David, 1879-1964--Exhibitions. 3. Roth, Ernest David, 1879-1964--Friends and associates--Exhibitions. I. Earenfight, Phillip. II. Trout Gallery. III. Title.
 NE962.V45D46 2012
 769.92--dc23
 2012001542

ISBN: 978–0–9826156–4–5

Printed in the United States

CONTENTS

DIRECTOR'S FOREWORD

A copper etching plate, like the ones used by artists such as James McNeill Whistler or Ernest David Roth, is small, lightweight, and portable. Indeed, Whistler carried his prepared plates in hand, tucked snuggly between the protective pages of a book; in his pocket, an etching needle no larger than a fountain pen. Such simple materials convey an air of lightness, ease, and portability, in keeping with the Venetian environment. In contrast, an etching press is large and heavy. It requires a sizable studio and weighs several hundred pounds. Next to the etching plate and needle, the press is an anchor that tethers the artist to the studio. Although the press frees the artist's ideas from the plate, it is a luxury few can afford. Consequently, a press often becomes a central force behind a printmaking community. Such was the case for Ernest David Roth and his fellow etchers in Venice, who worked in the city during the early twentieth century. In *Reflections & Undercurrents: Ernest Roth and Printmaking in Venice, 1900–1940*, curator Eric Denker considers the life and work of Roth and his contempo-

raries, exploring connections among the artists through a study of their prints (several of which they made together and circulated among each other), letters, and diaries. Denker's pioneering research unearths many unpublished documents, shedding light on the artistic and personal relationships of etchers working in Venice in the wake of Whistler and his circle. By reconstructing the social world of Roth and his contemporaries, Denker corrects and deepens our understanding of the etchers working in "La Serenissima." The Trout Gallery is deeply indebted to Eric Denker for making *Reflections & Undercurrents* possible and bringing this important body of scholarship to the public.

Phillip Earenfight
Director
The Trout Gallery, Dickinson College

AUTHOR'S PREFACE

The literature of printmaking, driven by the dual engines of scholarship and the marketplace, is dominated by monographs that stress individual artistic development and by catalogues raisonnés. Significantly, this approach establishes an artist's oeuvre and chronology. Essays that attempt to describe the artistic milieu, the context of the works, generally appear only when the literature is sufficiently mature. As the title of this catalogue conveys, *Reflections & Undercurrents: Ernest Roth and Printmaking in Venice, 1900–1940* is intended to examine both the production of and the interaction among printmakers who were seduced by the unique character of the lagoon city. Most of these artists knew the Venetian prints of James McNeill Whistler and his generation and most were aware of the work of their contemporaries; this provides a singular opportunity to understand a group of American printmakers and their European counterparts as they strove to capture the essential aspects of Venice.

Several avenues of investigation were available in reconstructing this narrative. Some are con-ventional, some more unusual. Exhibition records were helpful, as were articles in contemporary periodicals. We are particularly fortunate that John Taylor Arms, the greatest promoter of printmaking in America in the first half of the twentieth century, left extensive diaries that are now publicly available. The records of his contact with artists in America and Europe are invaluable to an understanding of the era. His voluminous writings, studio books, and archival records also provide firsthand information on the contacts among printmakers.

We have a special type of documentation for printmaking, however. Printmakers regularly gave their prints as gifts or exchanged favorite impressions, and these often carry dedications that testify to their mutual affection and admiration and provide a unique personal record. Many of these prints ended up on the open market. Two of the most significant surviving collections are that of John Taylor Arms at the College of Wooster and that of Fabio Mauroner at the Civic Gallery in Udine.

I began this project exploring Ernest David Roth's prints of Venice. Though only one of the

many cities in which Roth and his contemporaries worked, Venice functioned as a tightly defined arena in which to examine the contributions of individual artists. Roth has not been the subject of a monograph or catalogue raisonné since 1929—the midpoint of his career. Similar gaps in scholarship exist for most of his contemporaries, including his friends Jules André Smith, Louis Rosenberg, and most of the printmakers included in this catalogue. The exceptions are John Taylor Arms and James McBey. As my research progressed, I became aware of how the rich printmaking environment in America reflected the aesthetic exchanges among these artists and their European contemporaries. While Roth remains at the center of my examination, the resulting essays are intended to reconstruct this previously overlooked and vibrant era.

One reason for the neglect of these artists is their position outside the mainstream narrative of avant-garde art in the twentieth century. Simply stated, their work is more closely related to nineteenth-century precedents than to the evolution of modernist art. As art history moves into the twenty-first century, we benefit from the multiple narratives that reveal a more complete depiction of an era. My hope is that this catalogue will be the beginning of a new and fuller understanding of these talented printmakers and their works.

Eric Denker, Curator

ACKNOWLEDGMENTS

Every catalogue and exhibition is the result of a curator's vision tempered by the assistance of many collectors, scholars, and museum staff members. Over the years I have benefited from the experience and wisdom of many whose contributions deserve acknowledgment in print. For *Reflections & Undercurrents: Ernest Roth and Printmaking in Venice, 1900–1940*, I first give my profound thanks to the collectors, including Jane and Derek Allinson, Judith and Robert Martin, Charles Rosenblatt, and Selina B. Stokes and Thomas L. Stokes, Jr., who have generously loaned their works for the exhibition.

I also thank President William Durden of Dickinson College, where the show originates, and his administration. My sincere gratitude goes to the director of The Trout Gallery, Phillip J. Earenfight, for his tireless efforts. Phillip and the hardworking members of The Trout Gallery staff—James Bowman, Wendy Pires, Stephanie Keifer, Rosalie Lehman, Catherine Sacco, and Satsuki Swisher—deserve credit for their substantial contributions to the catalogue and exhibition. I am indebted to Kim

Nichols and Pat Pohlman at Dickinson College Design Services, for their handsome catalogue design, to Andrew Bale, for his photographic services, and to Kurt Smith and Amanda DeLorenzo at the Print Center, for producing the exhibition graphics. Mary Gladue proofed and strengthened the text in countless ways. At the University of Washington Press, I thank Pat Soden and Nicole Mitchell, for bringing this book to a wider audience.

For their gracious assistance with the research and catalogue I extend my appreciation to my museum colleagues: Marie Galbraith, Cynthia Roznoy, and Suzie Fateh-Tehrani at the Mattatuck Museum; Katherine Blood at the Library of Congress; Kitty McManus Zurko at the College of Wooster Museum of Art; Donald Myers and Colleen Hanson at the Hillstrom Museum of Art; Helena Wright at the National Museum of History and Technology; Margaret Glover at the New York Public Library; Elizabeth Wyckoff at the St. Louis Art Museum; and Hydee Schaller and Lucinda Edinberg at the Mitchell Gallery, St. John's College.

A very special thanks to Josephine Rogers for

her biographical research on the artists discussed in chapter 5.

Heartfelt appreciation goes to members of the staff at the National Gallery of Art: Charles Ritchie, David Gariff, Lynn Russell, Franklin Kelly, Wilford Scott, Gregory Jecman, Carlotta Owens, Ginger Hammer, Amy Johnston, Lorene Emerson, Barbara Bernard, Peter Huestis, Zev Slurzberg, Lorena Baines, Debbie Adenan, and David Applegate.

In Italy I benefited from the generous assistance of Franco and Maria Ferrari, Massimo Lumine and Birgit Müller-Lumine, Bruna Caruso, and Annamaria Pozzan at the Fondazione Bevilacqua La Masa. I am indebted to Isabella Reale and the staff of the Galleria d'Arte Moderna, Udine. I extend my thanks also to Virginia McClellan and her husband, the late Aubrey McClellan, Meredith Jane Gill, Tom Whitmore, Milos Cvach, Jeffrey Meizlik, and Ingrid Nilsson, and to Renato Miracco at the Embassy of Italy in Washington, DC.

Many years ago Gabriel Weisberg instructed me in the significant contributions of art dealers and galleries in research and scholarship. I gratefully acknowledge the assistance in America of Jonathan Flaccus, Scot Campbell, William Greenbaum, Pia Gallo, Egon and Joan Teichert, Thomas French, and Keith Sheridan, and, abroad, George Amore, Manlio Penso, Giampaolo Buzzanca, and Franco Filippi. Special thanks also to Robert Newman, who spent many hours with me discussing the art and lives of John Taylor Arms and Ernest David Roth.

A Note on Italian and Venetian Vocabulary

Although many of the Italian and Venetian words and phrases have been translated for the reader, a certain number of foreign words have been retained, particularly in titles of works. In Italian, a *ponte* is a bridge, a *campo* is a square, a *riva* or a *fondamenta* is a walkway along a body of water, a *porta* is a door or gateway, and a *traghetto* is a ferryboat. In Venetian usage, a *rio* is a canal, a *ca'* (short for casa/house) refers to a palace, a *sottoportico* is an underpass, the Molo is the broad *fondamenta* in front of the Palazzo Ducale and the Piazzetta, and the *Bacino* is the basin of San Marco.

Reflections & Undercurrents

ERNEST ROTH AND PRINTMAKING IN VENICE, 1900–1940

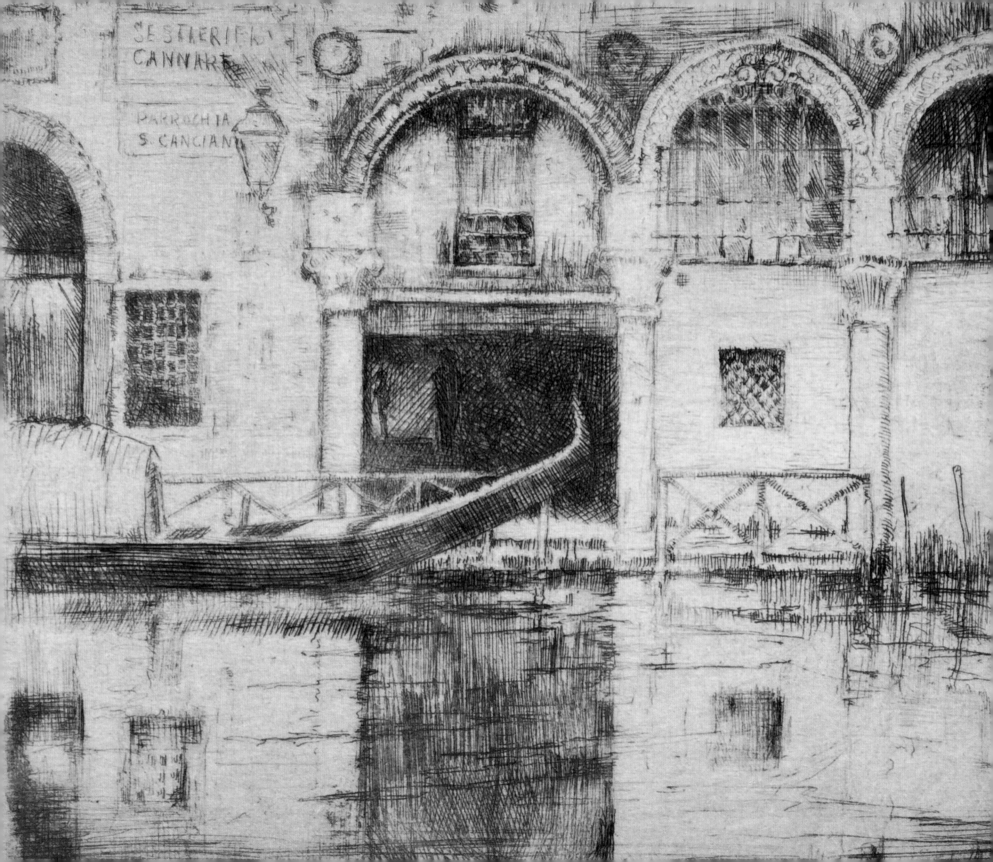

INTRODUCTION

Surely if good Americans go to Paris when they die,
all good etchers go to Venice both before and after.

Helen Fagg, *Fine Prints of the Year* (1926)[1]

Ernest David Roth (1879–1964) was one of the most significant American etchers of the first half of the twentieth century. His work ranges from important views of New York and Paris to exotic images of Istanbul and Segovia. His most important achievements, however, are his prints of Italy, in particular the approximately forty-five views he did of Venice between 1905 and 1941. In these etchings, Roth employed a supple line and rich tone that capture the essence of Venetian architecture in the clear light of the Venetian lagoon. Roth's Venetian masterworks have never been the subject of an independent exhibition, catalogue, or book. Many have never been reproduced. This exhibition and catalogue of approximately one hundred works bring together thirty-five of Roth's most important

Venetian views, including variant printings of the plates, preparatory drawings, and the plates themselves, with prints by his predecessors and his most important artistic contemporaries.

The catalogue begins with an exploration of the works of Roth's nineteenth-century precursors, James McNeill Whistler and his circle, including Otto Bacher (American, 1856–1909), Mortimer Menpes (Australian, 1860–1938), and Joseph Pennell (American, 1860–1926). The following chapters examine Roth's Venetian etchings, relating the prints both to those artists who preceded him and to the works of his better-known American contemporary, John Taylor Arms (1887–1953) and his Venetian friend and colleague Fabio Mauroner (1884–1948). The final chapter discusses Venetian prints by some of Roth's most accomplished contemporaries, including Herman Armour Webster (American, 1878–1970), Sydney Mackenzie Litten (British, 1887–1949), James McBey (Scottish, 1883–1959), Donald Shaw MacLaughlan (Canadian, 1876–1952), John Marin (American, 1870–1953), and Jan Vondrous (Czech-American,

Ernest David Roth, *Traghetto, Venice* (detail), fig. 20, pl. 45.

1884–1956). The appendicies contain a complete checklist of the Venice prints by Roth, Smith, Arms, Rosenberg, and Webster.

Unless otherwise noted, the prints and drawings in this catalogue are from a private collection that is a promised gift to The Trout Gallery of Dickinson College in Carlisle, Pennsylvania.

Overview

In 1880 the American expatriate printmaker James McNeill Whistler pioneered etchings depicting a "*Venezia minore*," focusing not on tourist monuments, but on representing what he called a "Venice of the Venetians." His etchings emphasize small squares, back alleys, and isolated canals rather than the traditional sights of San Marco, the Grand Canal, and the Rialto Bridge. Whistler chose an economic style for his depictions, evoking rather than simply recording the detailed contrasts of light and shadow and the reflections of architecture on water. He refused to draw his plates in reverse of the actual topography, resulting in the rendering of all of his subjects as mirror images.[2] His followers, including Bacher and Menpes, capitalized on

Whistler's approach to Venice—his attention to more typical local Venetian scenes and his reversal of topography. Whistler's friend and biographer Joseph Pennell continued this tradition well into the twentieth century.

The etchers of the subsequent generation revered Whistler's work, even as they sought their own personal visions of Venice. Ernest Roth arrived in Venice in 1905, the year he began etching. His works were shown in the VII Venice Biennale of 1907, where they were purchased by Queen Margherita of Italy, a signal achievement. In the same decade the expatriate American etcher Herman Armour Webster began to produce Venetian plates, as did the Canadian artists Donald Shaw MacLaughlan and Clarence Gagnon (1881–1942). Over the next thirty-five years Roth returned frequently to Venice to capture various aspects of La Serenissima (most serene republic). At the XXII Biennale, in 1938, he was invited to show his work in the Black-and-White section of the central Italian Pavilion.

In the 1920s Scottish printmaker James McBey captured Whistler's sense of the Venetian atmosphere in a series of evocative prints, while Louis

Rosenberg, who trained at the Massachusetts Institute of Technology, produced seven prints that reflect his approach to Venetian architecture. From 1926 to 1935, Roth's good friend John Taylor Arms executed ten images of Venice in his meticulous architectural style, half of them in direct emulation of Roth's choice of subjects. Roth, Rosenberg, and Arms were the nucleus of a circle of American etchers that created a timeless vision of European and American cityscapes and landscapes in the 1920s and 1930s. Each also depicted London and Paris and other, smaller picturesque towns in France, Italy, and Germany, but the Venetian views are at the center of their accomplishment. Curiously, although these printmakers were generally attracted to the beauty of Italy, and Venice in particular, Rome was mostly ignored. Roth represented the eternal city only twice, and Arms not at all.

In the early twentieth century, Roth's close friend Fabio Mauroner depicted contemporary Venetians in their everyday lives. Unlike foreign visitors, Mauroner knew a Venice that only a longtime resident and native speaker could know, and he captured it in a series of brilliantly drawn images. He celebrated the typical quotidian life of the city as well as important religious feasts and holidays. Mauroner differed from such artists as Arms, McBey, and Roth, who conceived of Venice as a series of picturesque views but did not convey the day-to-day lives of the Venetians. This was what Whistler originally had claimed to have discovered, "the Venice of the Venetians." Mauroner's images of the previously neglected squares of Campo Santa Margarita, Campo San Giacomo dell'Orio, and Campo San Giovanni in Bragora spring to life as outposts of everyday life in Venice, whether of the daily fish and flea markets, or on holiday occasions. Although not well known today, Fabio Mauroner demonstrated an equally high level of dedication to his craft as his contemporaries while representing a uniquely native approach to Venetian imagery. Mauroner's friend and colleague Emanuele Brugnoli also captured Venice in its familiar monumental forms, everyday life, and special holidays. The inclusion of these contemporary Italian printmakers contributes to a richer and fuller understanding of the achievements of Ernest Roth and other American and foreign artists in Venice in the first half of the twentieth century.

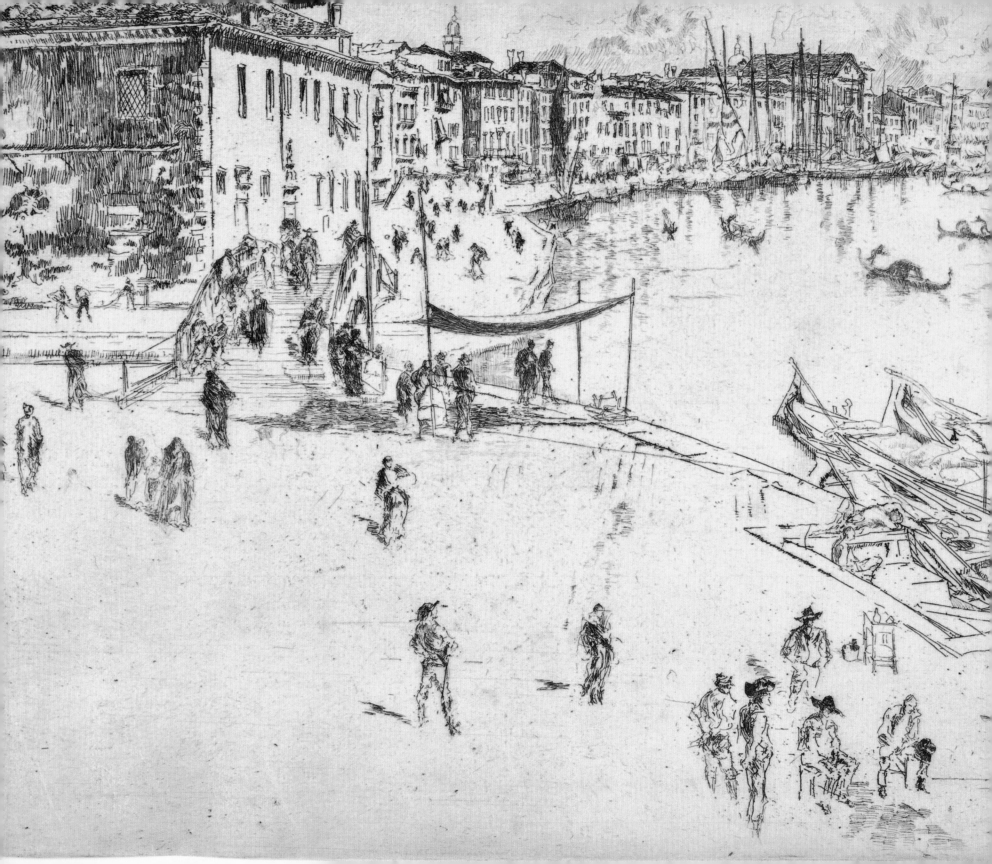

1. The Whistler Legacy in Venice

The story of Whistler in Venice is the centerpiece of the artist's legend, a tale of his fall from grace, his exile, and his triumphant return.[3] The narrative begins with the Whistler-Ruskin trial of 1878, and concludes with two exhibitions at the Fine Arts Society in 1880–81. The events leading up to the trial began with a review by John Ruskin that appeared in July 1877 in his *Fors Clavigera*, the now-infamous condemnation of Whistler's work in an exhibition at Sir Coutts Lindsay's new Grosvenor Gallery:

> *For Mr. Whistler's own sake, no less than for the protection of the purchaser, Sir Coutts Lindsay ought not to have admitted works into the gallery in which the ill-educated conceit of the artist so nearly approached the aspect of wilful imposture. I have seen, and heard, much of Cockney impudence before now; but never expected to hear a coxcomb ask two hundred guineas for flinging a pot of paint in the public's face.*[4]

Whistler made a calculated decision to bring suit against the critic for libel, resulting in the most celebrated trial in the history of art, *Whistler v. Ruskin*. The jury found in favor of Whistler, agreeing with the artist that Ruskin had committed libel. However, the jury awarded Whistler only one farthing, not the thousand pounds that he had sought. Whistler also was required to pay his own court costs, which normally are assessed against an unsuccessful defendant. The trial, a Pyrrhic victory, led to Whistler's bankruptcy in May 1879.

By the summer of 1879 Whistler was suffering from financial insolvency and a lack of new patronage resulting from the adverse publicity of the trial. The Fine Arts Society, a prominent London commercial gallery, approached the American expatriate about a commission to etch a series of prints of Venice for December holiday sales. In September, Whistler departed for Venice with the intention of producing twelve etchings over a period of three months. Ultimately, Whistler remained in Venice not just for a season, but for fourteen months. During his time in the city he executed more than fifty

James McNeill Whistler, *The Riva, #2* (detail), fig. 3.

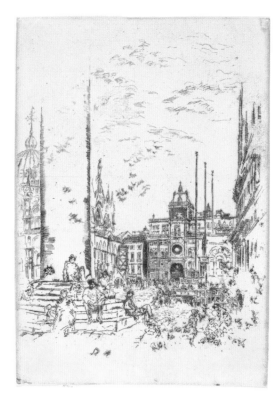

prints, a handful of paintings, and approximately one hundred pastels. Whistler's etchings are the core of his Venetian achievement. On returning to England, the exhibitions of Venetian etchings and pastels re-established his artistic reputation, and marked a positive turning point in his career.

Whistler's stylistic innovations and the influence of his vision on subsequent generations of artists are embodied in the Venice prints. Whistler arrived in Venice late in September, and although he had agreed to finish the plates by December, it soon became clear that he would not meet his deadline. The autumn and winter of 1879–80 were unusually cold in Venice, and Whistler suffered without the modern conveniences of London. In an early letter to his sister-in-law Helen he lamented how he missed London, complaining about the Italian language, the Venetian food, and how the cold was limiting his progress on the commission.[5] Subsequently he wrestled with the subject matter of Venice, overwhelmed by the visual riches of the city. Whistler's goal was to develop his own approach to the city in a way that would distinguish his work from the anecdotal sentimentality of established Victorian imagery. His achievement relies in part on his original conception of a Venice that was best known to contemporary Venetians—the long vistas, the back alleys, the quiet canals, and the diverse bridges that cross them, and the unexplored squares of city life. Whistler's innovation was his perception of a hitherto under-appreciated aspect of the city, a "Venice of the Venetians" as he called it. One author defined Whistler's content as "*Venezia minore,* a lesser Venice, the Venice of her own day-to-day inhabitants."[6] Whistler did execute prints of familiar sights including the Piazzetta, the Rialto Bridge, the grand promenade of the Riva degli Schiavoni, and numerous views of the well-known churches of San Giorgio Maggiore and Santa Maria della Salute. How then did his perception of the city differ from those who came before, and what aspects of that vision most affected the younger artists who came after him? Placing Whistler in the larger context of Venetian view painting is necessary for understanding his stylistic influence

on his contemporaries and later artists.

Painters and printmakers had depicted Venice for two hundred years by the time of Whistler's arrival in September 1879. Beginning in the late seventeenth century, the naturalized Dutchman Gaspar Vanvitelli and then Luca Carlevaris responded to the demands of British and other foreign visitors to the city for *vedute*—views—of recognizable Venetian scenery. In the eighteenth century Canaletto, his nephew Bellotto, and his competitors Michele Marieschi (Venetian, 1710–1743) and Francesco Guardi (1712–1793) all specialized in paintings that captured the city's familiar views and major monuments for the upper-class visitors who made Venice an important destination on the Grand Tour. Canaletto's paintings and prints of the city were intended for the tourist market and focused on the major attractions of La Serenissima. Prior to the advent of photography, prints were the most readily available and popular form of reproducing landscape and city views. In the early nineteenth century, after the fall of the Venetian Republic to the French in 1797, British artists such as J. M. W. Turner (1775–1851) and Richard Parkes Bonington (1802–1828) brought a greater inter-

est in the effects of light and color to the limpid atmosphere of the lagoon city. They remained faithful, however, to the focus of the previous era in their choice of recognizable subjects, including the Grand Canal, the Rialto Bridge, and the monumental buildings around Piazza San Marco. The interest in the traditional *vedute* of the city continued uninterrupted through the nineteenth century, contemporaneous with the more modern approach of Whistler and Sargent.

Whistler rejected the idea of merely documenting the most famous buildings of Venice, and marginalized their appearance in his work. When he did include the Basilica, the Ducal Palace, or the church of Santa Maria della Salute in his work, they are placed in the distance and as part of an ensemble, a component of a design that minimizes individual recognition. In his etchings, Whistler further conveyed his disdain for their function as nostalgic mementos of a visit to the city by his refusal to draw his designs in reverse on the plates. In his prints, Whistler eschewed certain subjects: landmarks of architecture, interiors, and large-scale figural scenes. The artist recorded few images of the Piazza San Marco, the Basilica, or the Grand Canal.

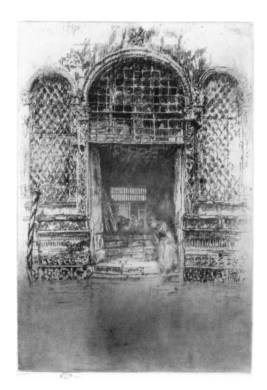

Fig. 2. James McNeill Whistler, *The Doorway*, 1879–80

Etching, 29.3 × 20.3 cm (11 1/2 × 8 in.)
Rosenwald Collection, National Gallery of Art, Washington, DC

Occasionally Whistler did record a notable site, as in the etching *The Piazzetta* (fig. 1, K 189), but in this case he drew the image directly onto a prepared etching plate, allowing the normal reversal of the printing process to render the scene as a mirror image. He claimed that his intent was not to produce picturesque and recognizable scenes for the British tourist, but to produce etched masterpieces of line and tone.

Other possible explanations exist for Whistler's refusal to draw images onto the plate in reverse. He came of age with a generation of artists in France, primarily Monet and the Impressionists, who valued the informality and spontaneity of drawing and painting in front of the motif. It would have been laborious for Whistler to first execute a careful depiction of a scene, only to subsequently have to trace or reproduce it freehand on the plate. This process would have robbed the image of the immediacy that Whistler hoped to capture in rendering the scene. Whistler's followers, among them

Menpes, Pennell, and Bacher, and later artists such as Ernest David Roth, John Marin, and John Taylor Arms, often employed the same practice for their prints of Venice.

Another innovative trait of Whistler's Venetian etchings was his development of a central motif, a focal point for the design that dominates the composition but does not extend to its edges. His predilection for emphasizing only the important central elements of the design—while leaving the margins incomplete—is a crucial aspect of the avant-garde nature of his art. In etchings such as *The Doorway* (fig. 2, K 188) Whistler developed the central motif of the plate while leaving the ancillary details largely unfinished. Here, as in a number of his Venetian prints, the artist added a layer of ink to the lower portion of this plate prior to printing to indicate the murkiness of the water in contrast to the precise delineation of the palace. Whistler often added additional surface tone by selectively wiping the copper plates, leaving a thin film of tone over parts of the image. When he printed these plates, the veils of ink conveyed different lighting conditions, times of day, and atmospheric conditions. These etchings paralleled the Impressionist

program for capturing a subject under specific and accurately depicted lighting conditions. Whistler either printed each impression himself, or supervised the printing so that each image utilizing selective wiping was unique. His preference for images of contemporary Venice combined with his avant-garde compositions and his innovative inking produced works of startling modernity that influenced an entire generation of printmakers.

One of Whistler's favorite Venetian subjects was the close-up of a palace fronting on a small canal, closely cropped and seen straight on from across the water. As in *The Doorway*, Whistler often gave little or no visual indication of the scale or structure of the remainder of the buildings. Instead, in vertical compositions he focused on the inherent geometric shapes of façades and their decorative surface patterns. In his Venetian etchings, the artist's graphic shorthand, indebted to his study of Rembrandt, adds to the freshness and sparkle of the city's palaces, canals, and alleys.

While printing these works, Whistler began his practice of trimming the finished prints to the plate mark, leaving just a tab for his signature penciled butterfly and the abbreviation "imp." to denote that

he had printed the impression himself.[7] Whistler felt that British collectors placed undue importance on the amount of margin surrounding old master prints and assigned it to contemporary prints as well.[8] Scholars have suggested that the cost of rare and expensive papers forced Whistler to economize, or that the plates themselves often cut through the paper at the plate mark anyway, and Whistler simply made a virtue of these problems. Another rationale is equally plausible. The thin film of ink on the surface of many etchings left the plates difficult to handle. A proof could be pulled more expediently if the printer did not need to exercise as much precaution in handling the paper, trimming away any soiled borders after the printing.

Whistler left Venice in November 1880, returning to London where he began printing the etchings for the Fine Arts Society. The initial exhibition of the First Venice Set opened in the small back room of the Society on December 1, 1880. The show was not a great financial success,

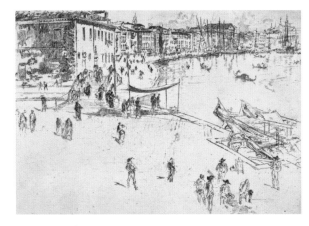

Fig. 3. James McNeill Whistler, *The Riva, #2,* 1880

Etching, first state, 21.4 × 30.1 cm (8 7/16 × 11 7/8 in.)
Private collection

although it was well covered in the daily periodicals and art journals of the time. Critics were divided on the merits of Whistler's etchings, but contemporary artists quickly perceived and embraced the freshness of Whistler's vision.

Whistler drew many images from the windows of the boardinghouse where he lived during the final four months of his stay in Venice in the summer and autumn of 1880. Some views were from the southern side of the L-shaped Casa Jankowitz, looking across the lagoon to the island and church of San Giorgio Maggiore. Others looked west toward Piazza San Marco. *The Riva, # 2* (fig. 3, K 206) and its variant, *The Riva, # 1* (K 192), constitute the most elaborate of these views west along the wide Riva degli Schiavoni, stretching from the nearby Campo San Biagio to the domes of the Basilica of San Marco.

Whistler worked from the second or third floor of the boarding house and devoted the entire lower half of the composition to details of life in Campo San Biagio, including approximately two-dozen people walking, talking, standing, and sitting. He indicated the time of day (morning) by the direction of the shadows, and the position of the boats suggests low tide. The right side of the composition is dominated by the expansive *Bacino* of San Marco, the calm waters disturbed only by the movement of a few gondolas. Along the left side of the etching, a little more than halfway up the plate, is the bridge of the Arsenale. At this point the Riva rotates gently west, although Whistler emphasized a more dramatic angle. Beyond the bridge is the largest structure in the etching, the Gothic-style arsenal military bakery constructed in 1473. This bakery produced the biscuits that supplied the Venetian maritime fleet. Whistler depicted the bakery with its east façade in shadow, an afternoon effect inconsistent with the shadows in the foreground. The upper third of the etching comprises the rest of the Riva, including a variety of hotels and rooming houses, and the prominent façade of the church of the Pietà, Santa Maria della Visitazione. Beyond the church, at the end of the Riva and largely obscured by sailing ships, are the Ducal Palace and the domes of the Basilica of San Marco. Whistler omitted the Campanile of San Marco in this image, although he included a faint outline of it in the alternative view of the Riva.

In the Wake of the Butterfly

Whistler influenced his contemporaries and later generations in a variety of contexts: artists who were in direct contact with him in Venice or, later, in London and Paris; contemporary printmakers who viewed his work in the 1880s and 1890s, after his return to England; and later generations of painters and printmakers who encountered his revolutionary work after the etchings became well known.

A circle of young printmakers and their teacher Frank Duveneck (American, 1848–1919) encountered Whistler while he was still in Venice. In 1878 Duveneck had started teaching private art classes in Munich, shortly thereafter moving his students to Florence. He stayed in Florence until April 1880, when he decided to move the class to Venice for the summer. Duveneck lived on the Riva degli Schiavoni in the Casa Kirsch, an inexpensive rooming house not far from the church of the Pietà, about halfway between the Piazza San Marco and Whistler's residence at the Casa Jankowitz. Duveneck's views of the Riva degli Schiavoni (Poole 12, 13), the long quay along the *Bacino* of San

Marco, were among his earliest prints and, according to Bacher, influenced Whistler to adopt this vantage point in both of his subsequent etchings of the Riva.[9] Duveneck usually chose recognizable vistas for his Venetian views, as in his 1883 *The Grand Canal from the Rialto Bridge* (fig. 4). The view, a mirror image, is from the southeastern steps to the Rialto Bridge, looking past the Riva del Ferro toward the great turn in the Grand Canal.

Duveneck's group of students had been identified in Florence as the Duveneck "boys": John White Alexander, Otto Bacher, Charles Abel Corwin, Ralph Curtis, George Edward Hopkins, Harper Pennington, Julius Rolshoven, Julian Story, and Theodore Wendel.[10] They mostly lodged in and near Casa Jankowitz, an inexpensive five-story *pensione* Corwin had found in the picturesque Venetian district of Castello. Casa Jankowitz catered to students and foreign artists. The older artists Robert Frederick Blum and Ross Turner also became associated with the "boys." According to Bacher's memoir, *With Whistler in Venice*, Whistler first came into contact with the group in the late

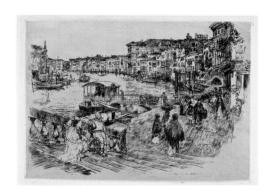

Fig. 4. Frank Duveneck, *The Grand Canal from the Rialto Bridge*, 1883

Etching (printed by Lewis Henry Meakin), 27.6 x 40 cm (10 7/8 x 15 3/4 in.) Private collection

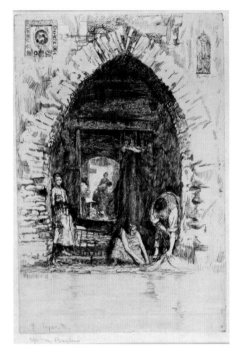

Fig. 5. Otto Henry Bacher,
Lavanderia, 1880

Etching, 32 × 22.2 cm (12 5/8 × 8 3/4 in.)
Private collection

spring of 1880 when he was still living in Dorsoduro in the vicinity of the Frari. Bacher noted that the artist soon returned to draw pastels and create etchings from their windows, which had marvelous views of the city and the lagoon.[11] Shortly after, Whistler moved in to the Casa, partly for the striking views, partly to have access to a printing press Bacher had brought with him, and partly for the camaraderie. Whistler was gregarious and always enjoyed an audience. The "boys," in turn, idolized the accomplished and flamboyant artist. Bacher and others recall how Whistler would display his latest work to the students as well as to others in the expatriate community.[12] Inevitably, a number of the younger artists responded to Whistler's approach to

Venetian imagery, appreciating his subject matter though not immediately adopting his centralized compositions based on the vignette, and his lighter handling of the etching needle leaving broad areas of the plate untouched.

Otto Henry Bacher produced an extensive body of prints of Venice that reveal Whistler's influence in subject and format. Bacher began etching in 1876 and studied with Duveneck in Munich between 1878 and 1880. His prints therefore reflect the influence of both his teacher and of Whistler. Bacher adopted Whistler's subject of a partial view of an anonymous palace opening onto a canal in his etching *Lavanderia* (fig. 5), in which an isolated figure of a launderer stands in the doorway. Whistler utilized this format many times, in *The Doorway* (K 188), *The Garden* (K 210), and, perhaps the closest to *Lavanderia*, the lovely vignette *The Dyer* (K 219). Bacher also produced several horizontal panoramas of the Riva from the Casa Jankowitz, including *View from Whistler's Window* (fig. 6). This print focuses on the Ducal Palace, seen at the end of the Riva, in the center, much as Duveneck had done in his images of the Riva. The plate was heavily drawn in the sky and in the water. As did Whistler, Bacher

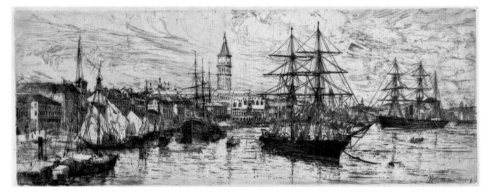

Fig. 6. Otto Henry Bacher, *View from Whistler's Window*, 1880

Etching, 11.4 × 31.4 cm (4 1/2 × 12 3/8 in.)
Private collection

drew his composition directly onto the plates, creating a mirror image of the site.

Some of Bacher's etchings differ markedly from Whistler's approach to the lagoon city, however. His view *The Rialto* (fig. 7) is a conventional composition of a traditional landmark, the elegant stone bridge that had spanned the Grand Canal for close to three hundred years. Bacher executed the view from in front of the Riva del Ferro on the San Marco side of the bridge, perhaps from a moored gondola. He placed the design directly onto the plate, resulting in the Whistleresque reversal of the actual view, with the Fondaco dei Tedeschi rising beyond the Rialto to the left, and the Palazzo Camerlenghi above the bridge on the right. However, the details extend to the extreme edges of the plate in contrast to Whistler's usual emphasis on the central motif only.

In another, more traditional Venetian image, *Corner of San Marco* (fig. 8), Bacher represented a woman praying beneath a sculpted image of the Madonna and Child in the Basilica. Large-scale images of Venetians were unusual in the etchings of the Whistler circle, except when they were employed as picturesque stereotypes of laundresses, dyers, lace makers, and bead stringers.

Whistler returned to London in November 1880, almost a year later than he promised, and spent the following month finishing the plates, selecting the etchings, and printing the proofs for his upcoming exhibition. Recognizing the importance and innovation of his new works, Whistler exhibited them widely during this period. Multiple showings of Whistler's work in London were followed by exhibitions in Paris and Munich and, across the Atlantic, in New York and Philadelphia. Patrons, collectors, and artists had ample opportunity to judge the new work firsthand, and they responded favorably, particularly to the etchings. Several young artists in London gravitated toward Whistler at this time, helping him to print the Venice sets and following in his artistic footsteps.

Many of the printmakers that came into contact with Whistler through exhibitions of his work reacted positively to the design innovations and graphic vocabulary of his Venetian prints.

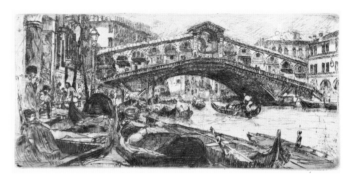

Fig. 7. Otto Henry Bacher, *The Rialto,* 1880

Etching, 11.4 × 24.8 cm (4 1/2 × 9 3/4 in.)
Private collection

Fig. 8. Otto Henry Bacher,
Corner of San Marco, 1880

Etching, 33 × 14.9 cm (13 × 5 7/8 in.)
Private collection

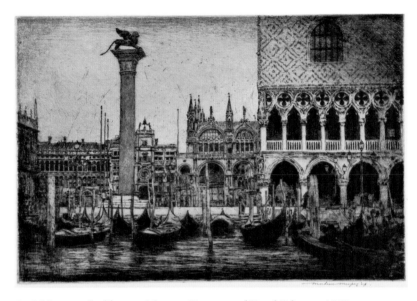

Fig. 9. Mortimer Luddington Menpes, *Piazzetta and Ducal Palace,* c. 1910

Etching and drypoint, 20 × 30.1 cm (7 7/8 × 11 7/8 in.)
Private collection

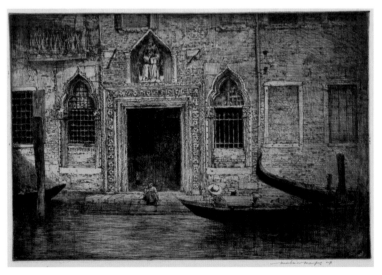

Fig. 10. Mortimer Luddington Menpes, *Abbazia,* c. 1910

Etching and drypoint, 20 × 30.1 cm (7 7/8 × 11 7/8 in.)
Private collection

Following Whistler's lead, Mortimer Menpes, Joseph Pennell, and others attempted to reproduce the atmospheric effects of water and light in deserted lanes, out-of-the-way canals, and little known *campi* to convey a deeper understanding of contemporary Venice. Of these artists, Menpes had the closest personal contact with Whistler.

Menpes had been studying at the South Kensington Schools when he met Whistler at the Fine Art Society galleries during the winter of 1880–81. The Australian instantly idolized Whistler, who was working on the printing of the first Venetian plates. "From that hour I was almost a slave in his service, ready and only too anxious to help, no matter in how small a way. I took off my coat there and then, and began to grind up ink for the Master."[13] Menpes helped print the Venetian plates and was the first of Whistler's followers in London in the decade following his return from Venice. The Pennells noted that Whistler attracted many younger artists, who believed in his ideas and saw him as a role model. Although many profited from their exposure to Whistler's aesthetic theories, most eventually quarreled and broke with the pugnacious American. Only Menpes and Walter Sickert (1860–1942)

were Whistler's pupils in the traditional sense of receiving instruction.[14]

Menpes rarely dated prints, making it difficult in the absence of other documentation to assess his development.[15] His etchings of Venice are varied, at times indicating a close affinity to Whistler's subjects and approach to format, at other times showing significant departure. Menpes's *Piazzetta and Ducal Palace* (fig. 9), for example, is completely antithetical to Whistler's approach to Venice. The view is from the *Bacino*, just off the Molo looking north toward the great Gothic structure. In an updated version of Canaletto's style, familiar monuments of Venetian architecture are carefully rendered and highly finished to be immediately recognizable and appealing to viewers familiar with the city. The etching also reveals key aspects of Menpes's own style, his ongoing fascination with tonal contrasts, texture, and the play of shadows. Similarly, Menpes's etching *Abbazia* (fig. 10) is a horizontal composition, comparable to one of Whistler's standard formats, and focuses on the canal-side entrances to unidentified buildings. The geometric architectural elements, viewed straight across a canal, are also key aspects of Whistler's

etching *The Doorway*. Menpes carefully rendered the water gate to the deconsecrated abbey from the Grand Canal, including such intricate details as the rosettes around the frame and the iron grillwork of the surrounding windows. Whereas Whistler concentrated on the key elements in his compositions, Menpes delineated each bit of dilapidated stone and stucco with precision, displaying an almost photographic approach to detail. Whistler subtly evoked the crumbling stones of Venice, whereas Menpes attempted to record the city down to its most minute detail. Similar to Whistler, however, he successfully conveyed a sense of solitude and languor. Whistler was renowned for the delicate, spidery lines he employed to create his images. Menpes's Venice etchings are more heavily inked, have bolder lines, and show much more dramatic tonal contrasts.

Menpes's etching *The Bridge of Luciano, along the Grand Canal* (fig. 11) is a view of an unidentified side canal in Venice. The subject is Whistleresque—a view of the day-to-day visual reality of

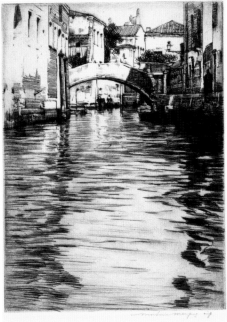

Fig. 11. Mortimer Luddington Menpes, *The Bridge of Luciano, along the Grand Canal*, c. 1910

Etching, 20.3 × 15.2 cm (8 × 6 in.)
Private collection

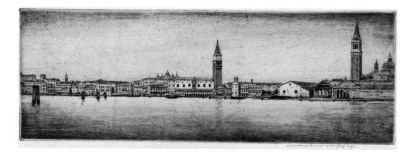

Fig. 12. Mortimer Luddington Menpes, *St. Mark's Basin,* 1910

Etching, 10.4 × 30.4 cm (4 1/16 × 11 15/16 in.)
Private collection

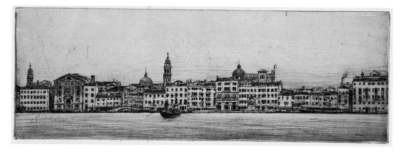

Fig. 13. Mortimer Luddington Menpes, *The Riva degli Schiavoni,* 1910

Etching, 10.3 × 30.2 cm (4 × 11 7/8 in.)
Private collection

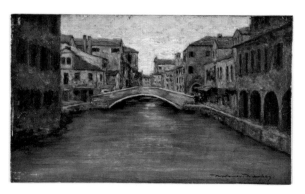

Fig. 14. Mortimer Luddington Menpes, *Rio Vena, Chioggia,* undated

Oil on panel, 8 × 14 cm (3 1/8 × 5 1/2 in.)
Private collection

Venice, the bridges and canals that make it possible to negotiate the city. Seen from water level, the canal dominates the lower two thirds of the vertical composition. The upper part of the print includes the bridge and the flanking structures, the focal point of the design. The simple stone span and the shadowed buildings are balanced below by strongly indicated ripples in the water. Although the expanse of water is wide, the heavily etched horizontal shading makes it an active part of the design. In this impression, the artist added a layer of ink across the surface of the water by selectively wiping the plate, suggesting murkiness and depth.

Menpes depicted the familiar Venetian skyline in two striking images drawn from the southern side of the *Bacino. St. Mark's Basin* (fig. 12) is a view, in reverse, from the island of San Servolo, the site of the old psychiatric hospital. Menpes situated the architectural monuments of Venice midway up the design, balancing the sky and the lagoon. To the right are the warehouses at the back of the island of San Giorgio Maggiore, with the diminutive white lighthouse blocking the viewer's sight of the Libreria di San Marco. The bell towers of San Giorgio on the right and San Marco in the center

are silhouetted against the sky, parallel to the *pali*, the wooden channel posts silhouetted against the water on the left. Menpes executed the second view, *The Riva degli Schiavoni* (fig. 13), looking across the basin from the north side of the island of San Giorgio. The view, also in reverse, stretches from the church of the Pietà on the left, past the bell tower of the church of the Greci and the dome of the church San Zaccaria, to a palace just short of the Rio del Vin. Although the two long horizontal scenes are more detailed views, Menpes's compositions derive from Whistler's evocative etching *Long Venice* (K 212).

Menpes was an accomplished painter and watercolorist as well as printmaker. The exhibition includes *Rio Vena, Chioggia* (fig. 14), a small painting of a Venetian canal in the village of Chioggia in the southern part of the Venetian lagoon. Menpes painted the picturesque scene from the crest of a bridge, looking north, a view that has changed little in the intervening years. In 1887 Menpes traveled to Japan. The trip had a profound impact on his artistic development, and from then on the formal language of his works show the influence both of the American master and of Japanese art, to which

Whistler had introduced Menpes in the 1880s.

The prolific printmaker Joseph Pennell (1860–1926) first came into contact with Whistler's Venetian etchings in 1881, at the premiere American showing of the First Venice Set at the Pennsylvania Academy of Fine Arts. By 1883 Pennell had adopted many of Whistler's compositional formats for his own Venetian and Italian etchings. Pennell, already an excellent draftsman, was influenced by Whistler's delicate line. Pennell also sometimes cut the paper margins from his prints, leaving just a small tab, in emulation of the older master.

Pennell executed two etchings that display Whistler's influence (Wuerth 620, 621). *Rebuilding the Campanile, Venice, #1* and *Rebuilding the Campanile, Venice, #2* (figs. 15, 16) are Pennell's record of the ongoing reconstruction of the bell tower in 1911. The Campanile of San Marco had crumbled to the ground on July 14, 1902, and an international subscription provided the money for it to be rebuilt in the same place and with the same appearance. Pennell depicted the

Fig. 15. Joseph Pennell, *Rebuilding the Campanile, Venice, #1*, 1911

Etching, 31.7 × 23.8 cm (12 1/2 × 9 3/8 in.)
Private collection

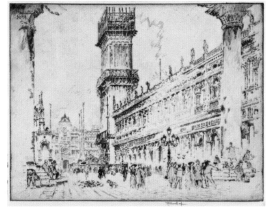

Fig. 16. Joseph Pennell, *Rebuilding the Campanile, Venice, #2*, 1911

Etching, 31.4 × 23.8 cm (12 3/8 × 9 3/8 in.)
Private collection

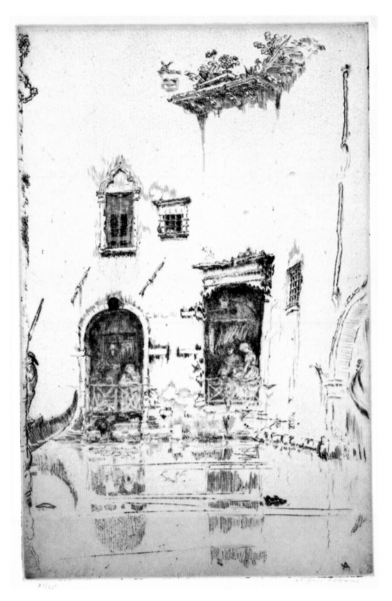

Fig. 17. Clifford Isaac Addams, *A Turning in a Canal*, c. 1914

Etching, 30.2 × 20 cm (11 7/8 × 7 3/8 in.)
Private collection

rebuilding from two different angles, both images drawn from life directly on the plate. His view from the north (fig. 15) is from beneath the arch of the old clock tower; his view from the south (fig. 16), a variation of Whistler's *The Piazzetta* (fig. 1), is from the Molo.

Elizabeth and Joseph Pennell met Whistler in London in 1884. In early 1893 they spent time together in Paris, where Joseph helped Whistler print some of his etchings. The Pennells regularly saw Whistler in London during the last ten years of his life, and after his death they wrote the first comprehensive biography of the artist.

Clifford Addams (1876–1942) was an American student at Whistler's Académie Carmen in Paris in the late 1890s. He and his wife maintained a warm friendship with the artist until Whistler's death, in 1903.[16] Addams had a successful career as a painter and etcher and was a member of the Chicago Society of Etchers, the Philadelphia Society of Etchers, and the Society of American Etchers. His 1914 etching *A Turning in a Canal* (fig. 17) is particularly Whistleresque. Addams focused attention on two doorways onto the canal, a few shadowy figures, and several windows indicating the presence of

the adjacent buildings. The bow and the prow of gondolas intrude from each side of the image, and a drainpipe and cornice provide remaining details. A few lines define the ripples and reflections in the water, completing this understated composition.

Even after his death, Whistler's vision of Venice continued to resonate with succeeding generations of artists visiting the city. American and British artists, in particular, held Whistler in high esteem. Many sought to emulate his example, some by following his presentation and approach, others by echoing the nuances of his economic style. By 1908 the Pennells could write, "And yet to-day, when two or three artists gather together of an evening at Florians, or the Quadri, or the Orientale, it is of Whistler they talk. When the prize student arrives and has sufficiently raved, they say 'Oh, yes, but you will have to do it better than Whistler!'"[17]

In the end, it is Whistler's expressive vocabulary and exquisite sense of design that inform his etchings of Venice. They remain remarkably fresh and original more than one hundred years after the artist's death.

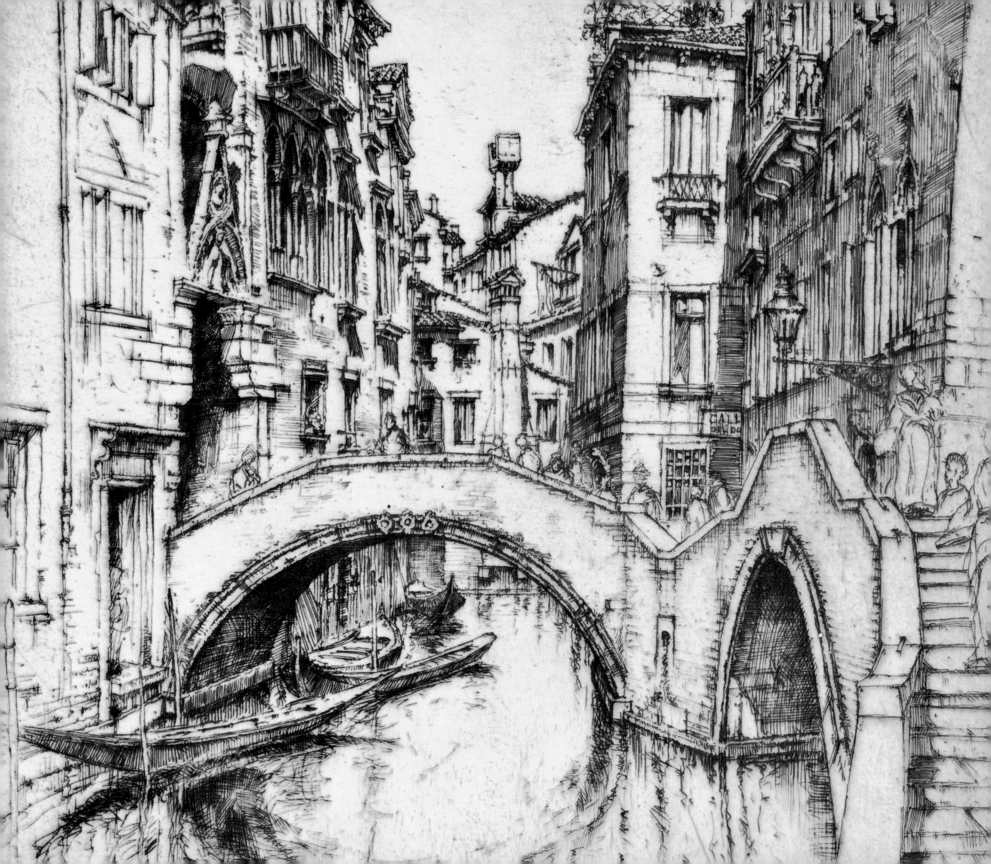

2. Ernest David Roth

Ernest David Roth was born in Stuttgart, Germany, on January 17, 1879.[18] He immigrated to America with his family in 1884, settling on the east side of New York City. After attending public school, Roth worked as an errand boy in a print shop. His interest in prints was sparked when he first saw works by Rembrandt, Dürer, and Whistler. Roth's employer encouraged his curiosity and allowed him to use the shop's extensive library. He studied painting with Edgar M. Ward and George W. Maynard at the National Academy of Design and with F. Louis Mora at the New York School of Art. At the National Academy he also studied etching under James D. Smillie. Roth became a naturalized American citizen in 1905.

Much of Ernest Roth's early work was inspired by travel. He left America in 1905, intending to go to Paris but stopping in Italy on the way. Roth fell in love with the Italian people and landscape, and lived and worked there until 1908, principally in Venice, Florence, and the hill towns of Tuscany and Umbria. He exhibited two etchings in the VII

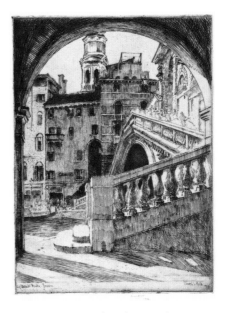

Venice Biennial in 1907—*Near the Rialto, Venice* (fig. 18; pl. 49) and an unidentified print, *Street in Venice*, which Queen Margherita of Savoy purchased.[19] From the sale of these and other prints, Roth was able to visit Constantinople in 1908.[20] In 1912–14, after a four-year stay in New York, he returned to Italy and France with his friend Jules André Smith, drawing and gathering material for etchings. In the spring of 1914, at the age of thirty-five, Roth had his first one-man show in New York at Frederick Keppel & Company. The exhibition included eighty impressions of sixty prints. In the fall of that year, Roth's works also were included in an international exhibition of graphic art at the Lyceum Club in Florence, prompting the director of the prestigious Uffizi Gallery to acquire a dozen of his etchings for the museum.

Fig. 18. Ernest David Roth, *Near the Rialto, Venice*, 1907

Etching, 24.1 × 17.8 cm (9 1/2 × 7 in.)
Private collection

Fig. 19. Ernest David Roth, *Sketchbook*, 1912–14

Collection of Mattatuck Museum, Waterbury, CT

Ernest David Roth, *Ponte del Paradiso* (detail), fig. 47, pl. 68.

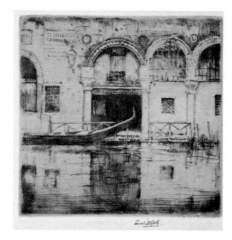

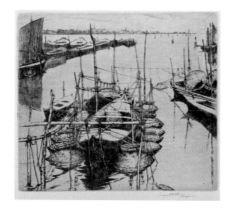

A sketchbook preserved in the Mattatuck Museum traces the artist's itinerary through Italy, Germany, and France on the eve of World War I (fig. 19).

Although Roth studied etching with Smillie at the National Academy, his earliest extant works are from the beginning of his stay in Italy in 1905. Elizabeth Whitmore, the print curator and dealer in Massachusetts who wrote the only monograph on Roth, included a list of twenty-seven prints of Venice and Florence executed during Roth's early years in Italy.[22] The diminutive *Traghetto, Venice (Ca' da Mosto)* (fig. 20; pl. 45) is one of his earliest etchings, made when the novice printmaker was cautiously exploring hatching and crosshatching to render areas of light and tone. In *Drying Nets (Canal di Quintavalle)* (fig. 21; pl. 52), another of Roth's early Venetian subjects, he employed dense networks of crosshatching to create the boats and their shadows in the foreground, and lighter parallel hatching for the hulls and sails in the distance. The water and sky were indicated with a few economic strokes of the needle in these lightly bitten plates.

Roth's rapid development as a printmaker is evident in several etchings from 1906. *The Gate, Venice* (fig. 22; pl. 48), *Reflections, Venice* (fig. 23; pl. 50), and *A Quiet Canal* are quintessentially Whistlerian images of the city.[23] In these small plates, Roth placed the viewer across the canal from waterside façades that have been intentionally cropped, emphasizing the heavily wrought dark shapes of the doors and windows and their reflections in the canal. The influence of Whistler's Venetian subjects and formal language is considerable, but the style is closer to the heavier line work and deeper linear shadows of Whistler's late Amsterdam prints. John Taylor Arms, Roth's friend, colleague, and rival, would later write of these plates, "These last I unhesitatingly place among Roth's finest etchings. They are of the utmost refinement, both of conception and execution, and are a happy blending of tonal feeling and linear charm."[24] Roth also executed a small, undated print at about this time, *Sottoportico* (fig. 24; pl. 46), a Whistleresque exploration of figures cast in the dark shadows of an arch that ends in a small canal. Roth's heavy line and

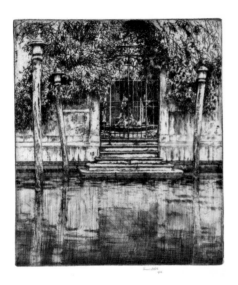

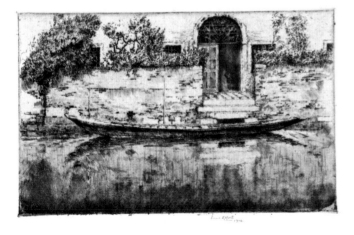

Fig. 26. Michele Marieschi, *The Rialto Bridge from the Riva del Vin*, c. 1737

Oil on canvas, 131 × 196 cm (51 1/2 × 77 1/8 in.) The State Hermitage Museum, St. Petersburg, Russia, photo: private collection

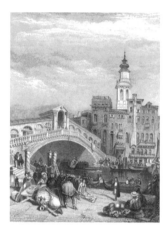

Fig. 27. J. B. Allen after Clarkson Stanfield, *Venice, The Rialto*, 1833 (from *The Life and Works of Lord Byron*)

Steel engraving, 16.5 × 11 cm (6 1/2 × 4 3/8 in.) Private collection

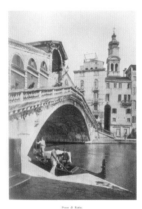

Fig. 28. Ferdinando Ongania, *Ponte di Rialto* from *Calli e Canali in Venezia: Monumenti* (Venice, 1891)

deep biting are clearly visible in the extant copper plate (fig. 25; pl. 47).

In 1907 Roth created a memorable image of the Rialto Bridge that brought him his first measure of recognition. *Near the Rialto, Venice* (fig. 18, pl. 49) is a morning view from beneath the arcades on the Riva del Vin on the San Polo side of the bridge. This view was relatively uncommon, although there are precedents in an eighteenth-century painting by Michele Marieschi (fig. 26), an 1833 lithograph by the illustrator Clarkson Stanfield (British, 1793–1867) (fig. 27), and a contemporary photograph by the Venetian photographer Ferdinando Ongania (Venetian, 1842–1911) (fig. 28). Roth's image is in reverse to the other images (and to the site itself), as he drew his directly on the plate. With only a few notable exceptions, Roth's views of Venice are mostly mirror images. The contrasts between the sunlit areas on the bridge and the paving, as well as the deep shadows of the underside of the bridge and arch, are evidence of Roth's increasing sensitivity to light. He produced four other plates during this time that demonstrate a similar approach, employing heavily wrought designs with sharp contrasts of light and shadow. Two represent arcaded streets in

Venice, and two are images of the cloisters of San Gregorio (fig. 29; pl. 55).[25] Elizabeth Whitmore characterized these plates as "grimly powerful, but they tend to be overloaded. The conception is overloaded—too large a subject crowded into a single plate, carefully studied, drawn with a force-fulness that tries to gain emotional effect by heaping up significant detail without eliminating the insignificant."[26]

Roth defended the careful observations and minute detail of his early work in Venice and Florence in an article by Frank Jewett Mather Jr., published in *The Print-Collector's Quarterly* in 1911. In this first serious assessment of Roth's work, Mather, Marquand Professor of Art and Archaeology at Princeton University, praised the artist's potential, but also suggested he "works more in the spirit of a painter etching than in that of a painter-etcher: he uses line less for its own sake than as a means of achieving tone, and, conversely, where he wants tone he is sometimes careless about the quality and direction of the component lines."[27] Roth responded to this criticism by saying "that he would begin to leave things out after he was sure he could put them in."[28]

Roth returned to America in 1908 to exhibit his etchings, then abandoned printmaking in favor of painting for the next three years. Perhaps in response to Mather's article, Roth returned to Italy in 1912 with his friend and fellow etcher Jules André Smith. They traveled for almost two years collecting material for prints of Florence, Venice, and France. The etchings resulting from this trip constitute the beginning of the mature phase of Roth's career as a printmaker.

Church of the Frari, Venice (fig. 30; pl. 56) is usually considered one of these works, a transitional print showing detailed stonework and heavily shadowed scaffolding. Although dated 1913 in the plate, the exhibition records of the Art Institute of Chicago indicate that an impression was shown as early as 1911, perhaps in an earlier state.[29] This suggests that the artist's initial conception and work on the etching is from his first Italian period. The figures in this work are of minimal interest, a common trait in Roth's work during both early visits.

Roth explored a new aesthetic sensibility in the seven Venetian plates that date from his second visit to Italy. Whitmore noted that these etchings showed a "more selective approach to subject and

Fig. 29. Ernest David Roth, *Cloisters of San Gregorio*, 1907

Etching, 30.5 × 22.9 cm (12 × 9 in.), signed in pencil
Private collection

Fig. 30. Ernest David Roth, *Church of the Frari, Venice*, 1911–13

Etching, 30.5 × 22.9 cm (12 × 9 in.), signed in pencil
Private collection

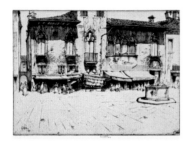

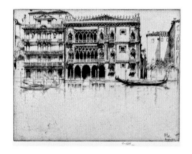

method."[30] Roth abandoned the heavily wrought shadows and tonal approach of his earlier work, instead conceiving his compositions with greater economy. He employed a few lines to suggest broad expanses of sunlight in opposition to a few limited areas of contrasting shadow. A leading print authority of the period suggested that the change was due to the brief time that Roth and Smith allotted to their sketching during their short time in Italy and France.[31] Roth's 1913 *Campo Margarita* (fig. 31; pl. 58) is a notable example of this new approach, with its greater balance between areas of light across the foreground pavement and palace façades, and the richer tones of the roof and cast shadows. Arms later wrote glowingly of this etching, perhaps his earliest print purchase:

> Or San Michele *and* Campo Margherita *[sic] are more refined in their execution, as befitting their subjects, but equally beautiful. Deeply felt and perfectly composed, their rich, mellow color, fine adjustment between freedom and restraint, and consummate craftsmanship, leave nothing to be desired and place these prints among the very best of their time."*[32]

Roth's etching of the *Ca' d'Oro* (fig. 32; pl. 57) from the same year is similarly composed of unarticulated expanses of sky and water surrounding the contrasting light and shadows on the fabric of the Gothic palace's façade. Perhaps because of the building's fame, the artist reversed the image on the plate so that the impression would represent the actual view of the Ca' d'Oro from across the Grand Canal. Some printmakers, John Taylor Arms among them, traced their drawings to accomplish the reversal of the drawing on the plate. Roth sometimes viewed his drawings in a mirror when he desired the correct orientation in his etchings, as seen in a later photograph (fig. 33).[33] His method is

clearly revealed in the preparatory drawing and the plate for the delightful, spare, 1913 etching *Fish Boats, Venice* (figs. 34–36; pls. 59–61). The drawing, with its delicate restraint, contains all the essential information that was transferred to the plate in reverse.

Another etching of the period, *The Iron Grill, Venice* (figs. 37, 38; pls. 62, 63), suggests additional information about the etcher's process. Roth seldom made trial proofs of his prints, and the etchings rarely appear in different states.[34] Instead, he employed different papers and inks to achieve varied expressive results. The two impressions of *The Iron Grill, Venice* included here are on gray and golden paper, respectively. Roth used a dark brown ink to print on the golden paper, giving an effect of summer light. He printed the later impression on gray paper using a rich, black ink, which results in a cooler, more wintry effect.[35] Roth's awareness of the expressive impact of using different papers is seen in the display of twenty Italian etchings in varying impressions in his early solo exhibition.[36] The papers were labeled: "Japan"; "Whatman"; "*petit velin*"; "*verger*"; "Italian"; "Holland"; "old Italian"; "Van Gelder"; and "*vergé ancien*."[37]

Rio de Santa Sofia (fig. 39; pl. 65) is one of only two Venetian plates dated 1914. The view is of the canal of Santa Sofia from the western end of the Rio Terà dei Franceschi, a relatively isolated spot in Cannaregio not far from the church of Santi Apostoli. Typically, Roth's image is in reverse of the actual site, but here, atypically, he has changed one element of the view. The bridge in the distance is the Ponte Priuli, cast in iron at the foundry of San Rocco by the English designer E. G. Neville in 1868. It is seen in an 1891 photograph by Ferdinando Ongania (fig. 40). Yet Roth represented it as a stone bridge, perhaps because the iron grillwork of the balustrades would have been too complicated for the design at this stage of his career. This etching is not included in Whitmore's 1929 list of Roth's plates, nor is it in any of the catalogues of subsequent exhibitions. The rarity of the print is perhaps due to the loss of the plate during Roth's hurried exodus from France in August 1914 on the eve of the outbreak of World War I. The impression included in the exhibition appeared for the first time in Paris in 2010.

Roth's etchings were exhibited in his one-person show at Frederick Keppel & Company in New

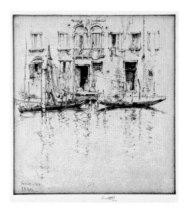

Fig. 35. Ernest David Roth, *Fish Boats, Venice*, 1913

Etching, 18.9 × 17.6 cm (7 1/2 × 7 in.), signed in pencil

Fig. 36. Ernest David Roth, *Fish Boats, Venice*, 1913

Preparatory drawing, 18.9 × 17.6 cm (7 1/2 × 7 in.), signed in pencil

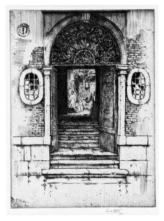

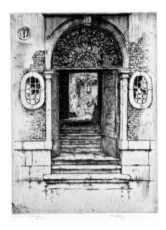

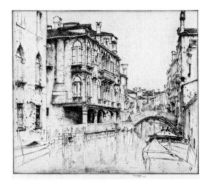

York, March 26–April 18, 1914, while the artist was still in Europe. Keppel displayed eighty prints from sixty plates. The brochure's laudatory introduction was written by the young Carl Zigrosser, then in his early twenties but later to become one of the preeminent print historians of the twentieth century. The checklist of works included a number of complimentary quotes from the Mather article of 1911, among them: "More remarkable technically is *The Gate*, with its canopy of foliage over the shifting reflections in the canal, and its statue glimpsed deep in the court through the gate bars…. It is fit to stand with the best of the Arno pictures as evidence of the seriousness of Roth's talent."[38] Roth had a second solo exhibition at the Keppel Gallery in the autumn of 1915. Frank Weitenkampf wrote an admiring review in *Arts and Decoration* magazine in May 1916 in which he described the recent evolution of the artist's work.[39] Also in 1916, Frederick Keppel & Company published a small booklet on Roth with an introduction by Herbert C. Pell Jr. and the first comprehensive checklist of Roth's etchings. Pell praised Roth's integrity, vision, and technical skills:

To me the great charm of Roth's work is the abso-
lute honesty that it shows from beginning to end.
There are no factitious tricks—no dazzling the
eyes to hide weakness. Throughout we can see the
work of a real artist thoroughly in command of his
implements giving us his idea of an actual thing.
…The Florence and the Venice prints are a series
of portraits quite as much as they are a collection of
views. He has done very few of the great set pieces
of architecture—the stone poses of a triumphant
people attitudinizing for posterity—and he has
avoided filth and the commonplace, choosing his
view at once with the eye of a good artist and of a
decent and sympathetic man. In avoiding post-card
pictures of a city in its Sunday clothes he has not
rushed to the other extreme to present us with a
town in negligée.[40]

Roth also began to attract attention beyond
the prints that were shown at the Keppel Gallery.
In 1914 his *Arch of the Conca, Perugia* (fig. 60) was
awarded the Frank D. Logan Prize by the Chicago
Society of Etchers, an award he won again for *An
Old Palace, Venice (Ca' da Mosto)* (fig. 41; pl. 53) in
1919.[41] Roth contributed twenty-five of his prints

to the Panama-Pacific International Exposition in
1915, including eight of the Venice etchings. The
Jury for Etchings and Engravings, chaired by Joseph
Pennell and including Frank Duveneck and Thom-
as Wood Stevens, awarded Roth a Silver Medal for
his graphics.[42] However, perhaps due to World War
I, Roth executed only two etchings between 1914
and 1920, neither of them Italian subjects.

Roth returned to printmaking in 1921 after an
extended trip to Spain, executing sixteen plates
based on visits to Zaragoza, Cuenca, Seville,
Segovia, Burgos, and Toledo. These prints were
the basis of an exhibition at Keppel & Company
in December 1921. Frank Jewett Mather Jr. wrote
the introduction to the accompanying brochure in
which he praised the etchings for
their probity and compositional
ease, adding, "Roth's technical
mastery of the etched line seems
to be complete."[43]

Over the next two years
Roth produced only one plate,
Roosevelt House, N.Y. In 1924
the printmaker, then in his
mid-forties, returned to his much

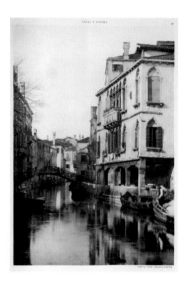

Fig. 40. Ferdinando Ongania, *Rio de
S. Sofia* from *Calli e Canali in Venezia:
Monumenti* (Venice, 1891)

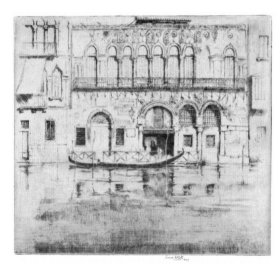

Fig. 41. Ernest David Roth, *An Old Palace, Venice
(Ca' da Mosto)*, 1907

Etching, 20.3 × 22.9 cm (8 × 9 in.), signed in pencil
Private collection

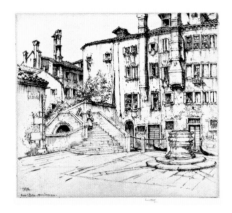

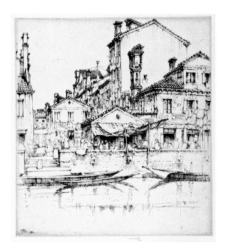

loved Italy for a year, etching and preparing drawings for future prints. The plates resulting from this visit to Venice, Verona, Florence, and the hill towns of central Italy, are among the high-water marks of Roth's career. These etchings are characterized by their larger size, their simply articulated yet monumental forms, their compositional balance, and the assurance of their draftsmanship. The eight prints of Venice constitute the culmination of Roth's engagement with the lagoon city, where he began his printmaking career. Most of the subjects are far from the tourist center of the city.

In the 1924 *Campo San Boldo* (fig. 42; pl. 66) Roth depicts a picturesque small square at the western edge of the San Polo quarter, not far from the large square of San Giacomo dell'Orio. Under an even, overall sunlight, the mass of the Ponte San Boldo on the left balances the simple shape of the substantial wellhead in the middle of the square. A few discrete prows and a balustrade denote the presence of a narrow canal beyond the wellhead, and a few lines on the pavement are sufficient to indicate the cistern below the square. The windows and doors and the roof tiles and chimneys of the surrounding buildings gave Roth ample opportunity to exercise his love of detail. *Campo San Boldo* is one of only two etchings from this series that represent the correct orientation of the site, not its mirror image.

Roth's other 1924 etching is *Fondamenta Rielo*, *Venice* (fig. 43; pl. 67), a quay on the Rio de San Nicoló in the poorer section of the city at the western end of the Dorsoduro district. In the foreground, a few *sandolos* cast minimal shadows, revealing the low water level of the adjacent canal. The center of the composition is dominated by a small street market with an awning strung over the quay. The architectural details are simply defined, with two typical Venetian chimneys silhouetted against the blank wall of the tall building in the background. The precisely defined roof tiles of the building on the left and right set off the clarity of Roth's handling of the architectural setting. Arms wrote of this print, "*Fondamenta Riello* [sic] is a gem and in its sheer exquisiteness, subtlety, and lightness of touch, is a symbol of Roth's work on the copper plate as a whole."[44]

Several of Roth's 1925 etchings of Venice rank among the most outstanding plates of his oeuvre. He chose a narrow waterway in the San Polo district for his quintessential Venice canal scene, the *Rio della Pergola* (fig. 44; pl. 70). The printmaker adopted a slender rectangular format to emphasize the constricted sense of many of the city's back canals and waterways, and employed the loose, sketchy reflections in the water to contrast with the more structured lines of the above architectural details. The example included here is an extremely rich, early impression taken while the plate was freshly etched. As *Rio della Pergola* embodies Roth's summation of Venetian waterways, his *Street in Venice* (fig. 45; pl. 69) represents the artist's most mature interpretation of the Venetian *calle*. Roth viewed the scene looking southwest from just beyond the intersection of the Rio Terà and the Calle Secondo dei Saoneri. He captured the picturesque dilapidation of the brickwork—exposed through the loss of its surface plaster—of the buildings to the left. The bell tower of the monumental Church of the Frari rises above the residences and Venetian arcades that dominate the center of the composition. Both etchings are mirror images of the actual views.

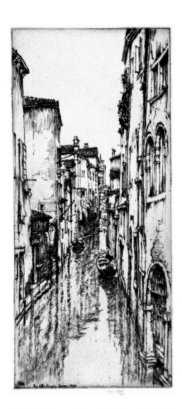

Fig. 44. Ernest David Roth, *Rio della Pergola*, 1925

Etching, 33.7 × 15.2 cm (13 1/4 × 6 in.), signed in pencil
Private collection

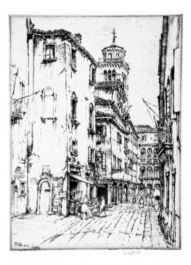

Fig. 45. Ernest David Roth, *Street in Venice*, 1925

Etching, 24.1 × 17.8 cm (9 1/2 × 7 in.), signed in pencil
Private collection

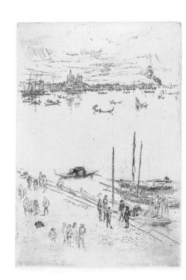

Fig. 46. James McNeill Whistler, *Upright Venice*, 1880

Etching and drypoint, 26.2 × 20.3 cm (10 5/16 × 8 in.)
Rosenwald Collection, National Gallery of Art, Washington, DC

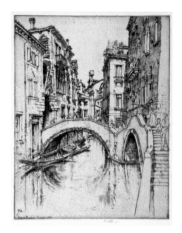

Roth's *Salute Seen from the Giudecca* is a rear view of Baldassare Longhena's Baroque architectural masterpiece, viewed from across the broad expanse of the Giudecca canal.[45] The etcher contrasted the almost empty lower half of the image as a foil to the precise line work of the architectural elements in the upper register. Roth's daring use of the unbitten portion of the plate is a visual homage to Whistler's image of the first state of *Upright Venice* (fig. 46).

In *Ponte del Paradiso* (fig. 47; pl. 68) Roth rendered the two adjacent bridges at the intersection of canals of the Rio del Mondo Novo and the Rio del Pestrin near the square of Campo Santa Maria Formosa in the Castello district. As with *Campo San Boldo*, Roth reversed the design on the plate to render an accurate view of the scene. The view includes the pinnacle from a destroyed local palace that was atypically placed over the end of the Calle del Paradiso. In the foreground on the right are seen several people crossing the Ponte del Preti. Placed along the edge of the plate, they constitute less of a distraction from the architectural motifs than they might have otherwise. The human figure was never one of Roth's strengths. Similar to his

Fondamenta Rielo, the artist emphasizes the monumental forms of the architecture in the middle ground, in contrast to the minimal line work in the reflections in the water and the unbitten area of the sky. John Taylor Arms wrote perceptively of this group of Venice etchings:

> . . . in Fondamenta Riello [*sic*], Porta [*sic*] del Paradiso, and Campo San Boldo, a change becomes apparent in Roth's approach and his draughtsmanship. His plates become large, tonal value is subordinated to linear structure, and his line, that unfailing index of an etcher's sensitivity, becomes less rigorously uncompromising and assumes a freer, more supple quality. Perhaps the subject dictated this, for many men have rendered Venice in many ways. In the fairy city of the Adriatic, Roth always seems to feel light, airiness, and the decorative element. To him, she is still a queen with a jeweled crown, and when he sings her praises it is with the sonnet rather than the ode.[46]

The Stones of Venice of 1926 (figs. 48, 49; pls. 71, 72) is one of Roth's largest Venetian plates, a depiction of the corner of the Palazzo Mastelli

looking across the Rio della Madonna dell'Orto in the northern section of Cannaregio. The title of the print alludes to John Ruskin's famous work, a study of the successive styles of the most significant architectural achievements in the city. Roth, perhaps ironically, set off the formidable grandeur of the Gothic fourteenth-century palazzo against the modest adjacent residence, with its crumbling stucco, exposed brick, and picturesque laundry. Arms wrote of this etching, "This plate aptly illustrates that other quality which I always associate with the grace of Roth's work—its elegance."[47] The two impressions included in the exhibition are from different states of the etching, printed on different color papers, and with only slight changes—the artist extended a few shadows and added a bit of reflection. However, the mood of the two impressions differs significantly owing to the color of the ink and the paper. The difference is in the description of the rich, golden light of summer in contrast to the silvery gray light of winter. Whitmore reserved special praise for this plate:

> *So in* The Stones of Venice *the light that*
> *glows on the side of the building, that quivers back*

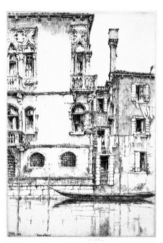

Fig. 48. Ernest David Roth, *The Stones of Venice*, 1926

Etching, printed on buff paper, 33.7 × 23.5 cm (13 1/2 × 9 1/4 in.), signed in pencil
Private collection

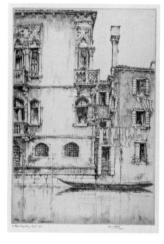

Fig. 49. Ernest David Roth, *The Stones of Venice*, 1926

Etching, printed on gray paper, 33.7 × 23.5 cm (13 1/2 × 9 1/4 in.), signed in pencil
Collection of Mr. and Mrs. Robert Martin

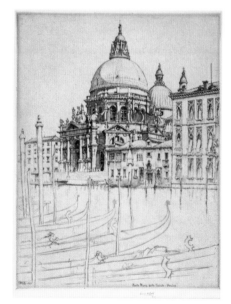

Fig. 50. Ernest David Roth, *Santa Maria della Salute*, 1937

Etching, 24.1 × 22.9 cm (9 1/2 × 9 in.), signed in pencil
Private collection

from the water into the rich shadows, that flows over the deeper-toned plaster of the right-hand palazzo and bathes softened, crumbling carving, is a matter of wise contrasts; sharp darks in the windows that inclose [sic] the great space of unbroken white give glow; the frayed, lightly bitten edge of the shadow under the cornice gives lambency.[48]

In January 1926 the Division of Graphic Arts at the Smithsonian Institution gave Roth a solo exhibition. The exhibition of ninety-six prints concluded with *The Stones of Venice*. In the introduction to the accompanying brochure, the unidentified author "B. K." wrote, "Neither extravagant or spectacular, without artifice, his plates are brilliant in effect, true and faithful in design, and bring to the mind many significances and meanings that in such work are usually wanting."[49]

Roth rarely returned to Venice as a subject during the remaining twenty-five years of his career. Two notable exceptions are the 1937 *Santa Maria della Salute* (fig. 50; pl. 73) and the 1941 *Porta della Carta* (fig. 51; pl. 74). He had first depicted the church of the Salute from the northeast in a 1914 etching, a plate that was damaged and consequently

cut down.[50] For the later print, the artist changed his viewpoint, now looking southeast from across the Grand Canal. His mature style gives the Salute a more monumental presence than it had in the earlier work. The Porta della Carta is the ceremonial entrance to the Ducal Palace from the Piazzetta on the western side of the building. The entrance was a common subject for artists, and precedents existed in photography and etching, including a print by Mortimer Menpes (fig. 52). In 1930 John Taylor Arms had depicted the entrance in one of his most celebrated etchings, *La Porta della Carta, Venezia* (fig. 53; pl. 3). Roth's etching may be seen as a response to the obsessive detailing in Arms's version of the same subject: in comparison, it

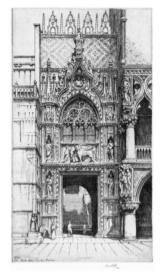

Fig. 51. Ernest David Roth, *Porta della Carta*, 1941

Etching, 35.6 × 20.3 cm (14 × 8 in.), signed in pencil
Private collection

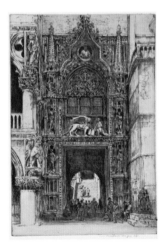

Fig. 52. Mortimer Luddington Menpes, *Porta della Carta*, c. 1910

Etching, 29.6 × 20.2 cm (11 5/8 × 7 7/8 in.)
Private collection

is restrained in its economic suggestion of the pavement and the fabric of the surrounding buildings. Roth evoked the light and shadow of the sculptural façade, whereas Arms defined each minute detail. The relationship between the two artists and their works is explored more fully in the next chapter.

Ernest Roth continued to produce etchings of distinction for another fifteen years, but never returned to his favorite city. A reviewer for the annual *Contemporary American Etching* of 1932 summed up his achievement in rendering the fabled city:

> *Should Florence and Venice disappear from the face of the earth, in a moment's time we would have a most excellent conception of what they had both looked like from every angle. Ernest Roth has etched these two cities from every vantage point. He is a stickler for detail and his tone is a most delicate one, a combination necessary for a successful plate.*[51]

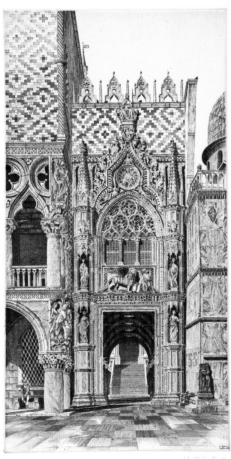

Fig. 53. John Taylor Arms, *La Porta della Carta, Venezia*, 1930

Etching, 31.5 × 16.7 cm (12 3/8 × 6 9/16 in.), signed with Arms's estate stamp
Private collection

Ernest Roth and Jules André Smith in Venice

Roth's close friend and early traveling companion Jules André Smith was born in Hong Kong on December 31, 1880.[52] Smith attended high school in New York City, followed by study at Cornell University, where he earned both a bachelor and master's degree in architecture. He was largely self-taught as a printmaker. His earliest dated plate is from 1908. According to a mutual friend, Frank Besedick, Roth met Smith in the architectural office where he worked for Robert Dunthorne and Sid Ross.[53] The letters preserved in the Mattatuck Museum attest to a close and lifelong friendship.

Roth and Smith traveled through Italy and France together in 1912–14, executing drawings that later became the basis for prints. Smith produced a series of approximately twenty-five etchings of Venice at this time, some clearly drawn from the same vantage point as Roth. Examples include two Smith etchings of the Church of Santa Maria della Salute, one from the Giudecca that parallels Roth's etching *Venice from the Redentore* and another that is almost identical to the 1914 *Santa Maria della Salute*.[54] While Smith's compositions of Venice are similar to those of Roth, his etching style was completely different. Smith concentrated on the outlines and contours of architecture, keeping shading and tone to a minimum. His Whistler-like emphasis on a central motif also diverges from Roth's sense of design. The formality of Smith's line, however, is in complete contrast to Whistler's sketchy informality, as may be seen in two works with a similar subject: Smith's 1912 *The Riva with La Pietà* (fig. 54; pl. 77) and Whistler's *Riva, No. 2* (fig. 3). Smith's is a view of the church of the Pietà on the quay of the Riva degli Schiavoni. He employed a few lines to suggest the pavement in the foreground. Individual lines define each step of the bridge, each window, each of the church's great columns, and its entablature. In comparison to Whistler's *Riva, No. 2*, Smith rendered his image more carefully, showing little interest in the reproduction of light and atmosphere. His Venice is bathed in a blazing sunlight that obliterates the shadows. Moreover, Smith reversed his drawings onto the copper plates so that all of his Venetian views reflect the actual topography of the city. His 1913 *Palaces and Barges* (fig. 55; pl. 78) is a view from the Custom's House looking

across the Grand Canal toward the monumental core of the city. In this composition, the artist plays the verticals of the barge's masts in the foreground against the mass of St. Mark's bell tower. Smith uses a dense parallel hatching to create the darker underside of the ship, but avoids any other suggestion of the aspects of light and shadow. Unusually, the artist often signed his early etchings in pencil, as here, on the printed image.

In addition to having several one-person exhibitions between 1914 and 1919 at the Arthur H. Hahlo Galleries in New York, Smith also exhibited fifteen of his etchings at the Panama-Pacific International Exposition in San Francisco in 1915. He was awarded a Gold Medal by the exposition jury for his contributions, which included a dozen of his Venetian etchings.[55] His later prints diverged from the view-etching of his earlier work, becoming increasingly abstract.

Fig. 54. Jules André Smith, *The Riva with La Pietà*, 1912

Etching, 21.6 × 20.3 cm (8 1/2 × 8 in.), signed in pencil
Private collection

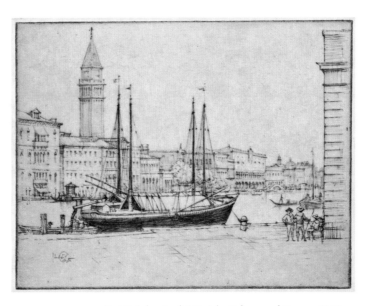

Fig. 55. Jules André Smith, *Palaces and Barges*, 1913

Etching, 16.5 × 21.6 cm (6 1/2 × 8 1/2 in.), signed in pencil
Private collection

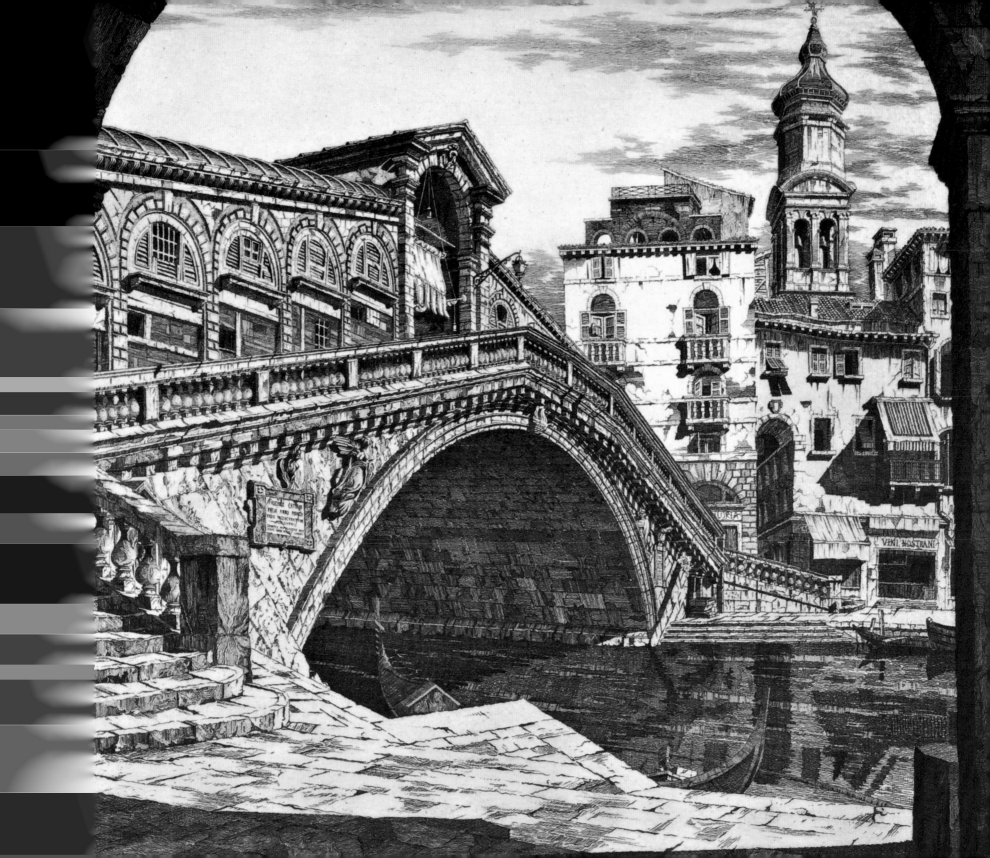

3. John Taylor Arms

John Taylor Arms is the best-known American landscape etcher of the first half of the twentieth century. He was born in Washington, DC, attended the Lawrenceville Academy, and studied architecture at Princeton University prior to transferring to the School of Architecture at the Massachusetts Institute of Technology in 1907.[56] Arms earned his undergraduate degree in 1911 and received his Master of Science degree in 1912, when he was hired by the architectural firm of Carrère and Hastings in New York. The following year he married Dorothy Noyes, a talented writer and his frequent collaborator during their forty years together. For Christmas in 1913 she gave him a small etching kit.[57] Arms's earliest prints date to 1915–16, prior to World War I during which he served in the United States Navy. About this time he also began to collect prints, eventually amassing a collection of more than five thousand impressions.[58]

Among Arms's early purchases was a print by Ernest Roth, *Campo Margarita* (fig. 31; pl. 58), which he acquired in 1913, the year he received the etching kit from his wife. Arms was friendly with Roth early in his career as a printmaker, as evidenced by the 1916 etched Christmas card from Roth to Arms in the College of Wooster's collection. It was not a coincidence that Arms began producing his own etched Christmas cards the same year. They were close friends, colleagues, and artistic rivals until Arms died, in 1953.

After his return from the war, Arms gave up his architectural practice to devote himself to printmaking. His early prints of picturesque views in France and Italy were rendered in the same sketchy drawing style that Whistler had introduced into etching in the nineteenth century. As Judith Goldman writes:

> For decades, Whistler's influence hung over American etching like a thick fog. But the innovations he had brought to etching—the spare, active line, centered compositions, blank spaces that suggest an expansive scale, variations in tone and printing—became, in the hands of lesser graphic artists, a mannered poetry of decay.[59]

John Taylor Arms, *Il Ponti de Rialto, Venezia* (detail), fig. 65, pl. 2.

Arms credited his early inspiration to Whistler and Charles Meryon (French, 1821–1868), as well as to his friend and contemporary Eugene Higgins (American, 1874–1958). He also would have

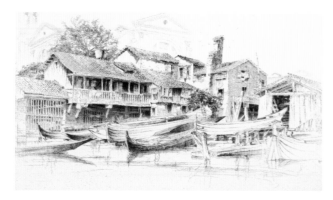

known the etchings of Joseph Pennell, Ernest Lumsden, Donald Shaw MacLaughlan, the expatriate Herman Armour Webster, and Ernest David Roth, all of whom emulated Whistler's style to some degree. In 1919–20, Arms experimented with drypoint, aquatint, lithography, and mezzotint before settling on etching as his primary technique. Perhaps etching appealed to him most because of his own acuity of vision—his extraordinary 20/10 eyesight was the subject of several studies at the Mayo Clinic. Only in 1921 did Arms begin to develop his mature style, as seen in his New York plates *Cobwebs* (F 95) and *An American Cathedral* (F 107).[60] These images are characterized by a greater attention to detail and precision of line, and to more finished compositional formats.

Many of Arms's prints from the 1920s were based on European trips with his wife and family to explore the Gothic architecture of England, France, Italy, and Spain. Whereas Roth had fallen in love with Italy on his first trip to Europe in 1905, Arms preferred the architecture of France and England in the early part of his career. Although he went to the Italian Lake District as early as 1919, and executed prints of Lake Maggiore and Lake Como, Assisi, Fiesole, and Florence, he does not appear to have traveled to Venice until 1926. Nonetheless, "The city of Venice captured Arms' imagination in a way that no other city did."[61] The ten etchings of Venice that Arms produced between 1926 and 1935 represent one of the outstanding achievements in twentieth-century printmaking, not to mention one of his great personal accomplishments.[62] The artist included nine of the ten etchings in the list of his preferred plates.[63] As we will see, many of the subjects were inspired not only by the beauty of the actual sites, but also by Arms's knowledge of other printmakers working with the same motifs and by contemporary photography.

The Boatyard, San Trovaso of 1926 (fig. 56; pl. 1) was Arms's earliest etching of Venice. The subject

is an old *squero*, the boatyard in front of the Church of San Trovaso in the Dorsoduro district of the city.[64] For the drawing, Arms sat on the Fondamenta Nani, across the canal of the Rio San Trovaso. The artist transferred the drawing directly onto the plate, resulting in a print that is a mirror image of the actual site. In the foreground are gondolas, beached for caulking or repair, hauled onto the raked area adjacent to the water and sheds. Behind the boats, Arms depicted the undulating rooftops of the dilapidated wooden structures. In the background behind the *squero*, the bell tower and dual façades of the church are faintly visible. The ramshackle yet picturesque buildings have attracted painters and printmakers throughout the last one hundred and fifty years. In fact, Ernest Roth depicted the same *squero* nineteen years earlier in one of his earliest Venetian prints (fig. 57; pl. 54). Both images are in reverse orientation. Roth sat farther north on the *fondamenta* but brought the boatyard closer to the viewer. His sketchier style evokes the cluttered appearance of the boatyard and de-emphasizes the gondolas, as opposed to the clearly defined objects and space in the etching by Arms. Although Arms has his own style, and his etchings

of Venice helped establish his reputation as one of America's leading printmakers, his repetition of an earlier subject by Roth is fairly common. Of Arms's ten published prints of Venice, fully half of them repeat subjects found in earlier prints by Roth. This source of inspiration, however, has yet to be fully acknowledged and understood.

As mentioned above, Arms knew Roth's work from the time that he began his career, and there is abundant evidence of their friendship. In the Arms collection at the College of Wooster are etched Christmas cards from Roth dating from 1916 through 1940, many with personal salutations. Arms's inventory at Wooster lists gifts of prints from Roth stretching from 1917 to 1952, the year before Arms's death. It is likely that Arms gave Roth regular gifts of prints, although Roth's personal collection has not survived. In Arms's studio in Fairfield Hills were print storage boxes containing the names of museums, libraries, friends, and family members who regularly received prints from Arms. Roth, who often assisted Arms in meeting printing deadlines and is credited with printing the small edition of *Chicester* (F 341) in 1940, is among the dozen artists who were designated for such prints.[65]

Fig. 57. Ernest David Roth, *Boatyard at San Trovaso (Squero)*, 1907

Etching, 21.6 × 19 cm (8 1/2 × 7 1/2 in.), signed in pencil
Private collection

57

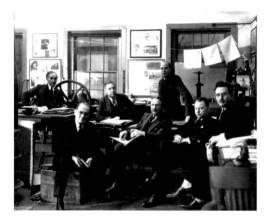

Fig. 58. Unidentified photographer, *Printmakers Meeting in Ernest Roth's Studio*, undated. Ernest Roth is on the left behind the press, with John Taylor Arms seated near him in the background and Rockwell Kent standing.

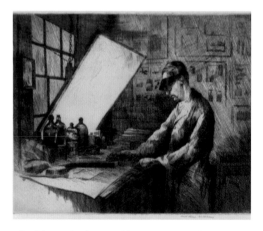

Fig. 59. Keith Shaw Williams, *Portrait of Ernest David Roth*, 1941

The two printmakers were members of the Salmagundi Club and council members of the Society of American Etchers, which met routinely in Roth's New York studio on West Fourteenth Street (fig. 58). Arms moved to Fairfield Hills, Connecticut, in 1919. Roth's summer home, and later residence, was in West Redding, about thirteen miles away. The two visited each other— and each other's studios—often, and numerous entries in Arms's diaries attest to their close friendship. They juried print exhibitions together at the National Academy of Design. Roth and another printmaker, Arthur Heintzelman, even went to see the Arms off on their trip to Europe in March 1936. From the diaries, it appears that Arms often took Roth to dinner in the 1930s, to the National Institute of Arts and Letters, to the Salmagundi and Lotos Clubs, to the Horn and Hardart automat,

to Schraffts and to Longchamps, perhaps because Roth was not earning well during the early years of the Depression. Arms was known for his generosity to struggling artists, sometimes taking the entire governing council of the Society of American Etchers to dinner before its annual meetings.[66]

As with many friendships among colleagues, however, there was also a degree of professional jealousy. Keith Shaw Williams (1905–1951) was a contemporary printmaker who knew both artists. Williams etched portraits of many printmakers, including Roth (fig. 59). Williams's journal and unpublished notes for essays on Arms and Roth, preserved in the Archives of American Art, indicate that Roth was sometimes jealous of Arms. Williams also relates an incident about Arms appropriating an image from a Roth drawing.[67] Although Arms was the more esteemed artist, he clearly borrowed liberally from other printmakers. An investigation of their respective oeuvres reveals many instances in which Arms rendered the same Italian subject that Roth had treated earlier. Notwithstanding the Williams notes, the borrowing may not have been entirely surreptitious. Since Roth had lived in Italy and knew it well, and since Arms would have been

familiar with specific Roth etchings, it is conceivable that he solicited Roth's advice in selecting picturesque motifs.

From 1912 to 1914, Roth etched a series of views of Italian hill towns, including Fiesole, San Gimignano, and Perugia (fig. 60). On his European trip of 1923–24, he returned to the hill towns, depicting Orvieto, San Gimignano, and Siena (fig. 61). Arms, in 1925, also visited Fiesole, San Gimignano, Perugia (fig. 62), Orvieto, and Siena (fig. 63). A comparison of the prints executed on their respective trips is revealing. Arms's 1926 etching *Arch of the Conca, Perugia* repeats the composition of Roth's earlier 1913 view of the scene. Arms worked a few steps closer, adding a more detailed rendering of stucco and stone. Arms already owned an impression of the Roth print, which he had purchased directly from the artist.[68] *La Torre del Mangia, Siena* is Arms's 1927 mirror image of the 1924 etching by Roth (figs. 61, 63), both of which parallel an 1883 etching by Joseph Pennell (W 84). The Roth prints are in his sketchier style: more evocative of the atmosphere, with less emphasis on the architectural details. As a trained architect, Arms rendered the townscape in great detail,

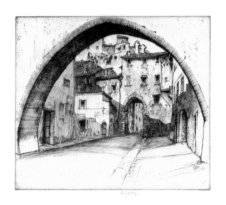

Fig. 60. Ernest David Roth, *The Arch of the Conca, Perugia,* 1913

Etching, 21.6 × 25.4 cm (8 1/2 × 10 in.)
Private collection

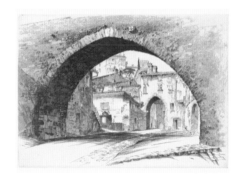

Fig. 62. John Taylor Arms, *Arch of the Conca, Perugia,* 1926

Etching, 26.2 × 37.2 cm (10 1/4 × 14 5/8 in.)
Private collection

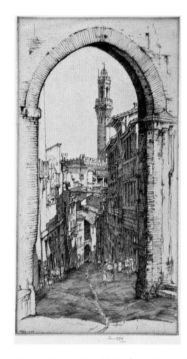

Fig. 61. Ernest David Roth, A *Street in Siena,* 1925

Etching, 30.5 × 15.9 cm (12 × 6 1/4 in.)
Private collection

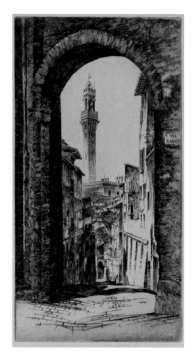

delineating each stone with precision. Were Arms and Roth involved in a friendly rivalry of one-up-manship, to suggest the superiority of one approach over the other? In the absence of documentation we must draw our own conclusions.

Arms returned to Italy in 1929, staying with his wife, Dorothy, at the Hotel Regina in Venice beginning on September 28. They were collaborating on a book project, *Hill Towns and Cities of Northern Italy* (published in 1932), with text written by Dorothy and reproductions of fifty-six prints and drawings by Arms, that he had executed between 1925 and 1930.[69] Images from the hill towns of Umbria and Tuscany in central Italy, to Lake Como and Varese in the north are included. The book reproduces nine etchings of Venice, including *The Boatyard, San Trovaso* (fig. 56), and four additional drawings, one of which, *The Grand Canal*, was the basis for the 1935 masterpiece *Venetian Mirror* (fig. 64; pl. 8). An examination of the Arms etchings and drawings reveals a clear indebtedness to the earlier work of Ernest Roth as well as to photographs of Venice by Ferdinando Ongania.

The 1930 *Il Ponte di Rialto, Venezia (Shadows of Venice)* (fig. 65; pl. 2) is a view of the Rialto Bridge from under an arch on the Riva del Vin, the same location Roth had used in his *Near the Rialto, Venezia* of 1907 (fig. 18; pl. 49). As opposed to Roth, Arms reversed the composition on the plate so that the printed image would show the true orientation of the view.[70] Roth's earlier plate evoked the atmosphere of this picturesque view, while Arms's greater precision describes the bright afternoon sunlight playing over the surfaces and textures of the stones, the boats, and the canal. In an article on her husband's work in the *Print Collector's Quarterly* in 1934, Dorothy Arms stated her interpretation:

> *In them is no effort to portray the pageantry of history's most colourful city by means of the more usual freer treatment intended to suggest sunshine, white walls, and glistening water, but rather the sadder side of a ghostly place is revealed in the texture of crumbling stone and in built-up, luminous blacks. In* Shadows of Venice *the myriad lines which make up the forbidding arch framing the Rialto Bridge and the gloomy depths beneath its span are not employed as a* tour de force *but to give a sense of the tragedy and bitter cruelty which doomed the great republic to ultimate failure.*[71]

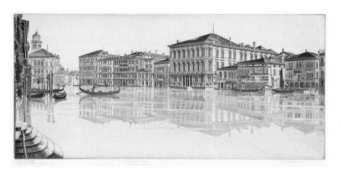

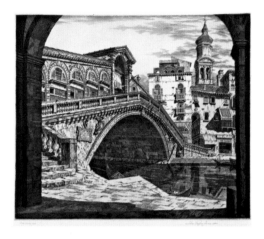

The accurate appearance of the bridge, the extraordinary architectural precision, and Arms's detailed line work lead one to assume his is a truthful representation. Both artists' etchings of this subject may have been inspired by a photographic illustration in the popular 1891 volume published by Ferdinando Ongania, *Calli e Canali in Venezia*.[72] Ongania's photograph (fig. 28), however, reveals that the building on the opposite bank, seen below the bell tower of San Bartolomeo on the Riva del Ferro, in fact has five floors, as depicted by Roth, not four, as depicted by Arms. Yet the extraordinary detail of the Arms etching suggests to the viewer that it is the more accurate representation. Arms is one of a number of printmakers who portrayed this popular view, including the British artists Andrew Affleck (1869–1935) and Nelson Dawson (1859–1941), the Canadian Donald Shaw MacLaughlan, and the Czech-American artist Jan Vondrous (fig.

66; pl. 80). It was Roth, however, that first introduced this unusual acute viewpoint of the Rialto Bridge into etching.

Both Arms and Roth appear to have been familiar with the Ongania *Calli e Canali in Venezia* volume of photographs that included the view of the Rialto. Perhaps one of them owned it, or it might have been brought to their attention by their Venetian friend Fabio Mauroner. Eight motifs found in Roth prints appear in the photography volume. That same number can be related to Mauroner etchings. Fully half of the Venice etchings by Arms parallel the Ongania photographs.[73]

Another Arms etching that demonstrates his relationship to Roth's earlier designs is the 1930 *Porta del Paradiso, Venezia* (fig. 67; pl. 4).74 In 1925 Roth portrayed this same double bridge (fig. 47; pl.

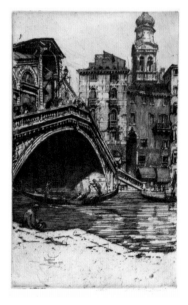

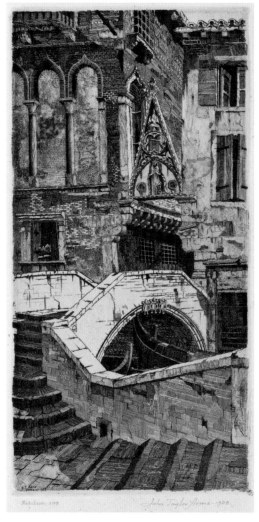

68) at the intersection of the Rio del Mondo Novo and the Rio del Pestrin near Campo Santa Maria Formosa. The scene includes splendid examples of Venetian architectural details—the *barbacani* that extend the width of the upper floors over the alleys in a traditional Venetian house, and the unusual pinnacle placed over the end of the Calle del Paradiso. Arms drew the preparatory sketch from the Ponte del Preti, a bridge seen in the foreground of Roth's etching. Using a tracing of the drawing (fig. 68), Arms transferred the design directly to the plate, reversing the orientation of the actual site in the impressions. Perhaps this was a strategy to avoid the inevitable comparisons to Roth's earlier etching, which had been published in the Whitmore monograph of 1929.[75] Arms's compositions reverse those of Roth in three of the Venetian prints and in several images of Italian hill towns. His style in all of them retains

the tight, precise, descriptive line that records the intricate tonal variations across the surfaces of stone and brick, whereas Roth's images emphasize space and atmosphere.

Venetian Filigree, also called *Ca' d'Oro, Venezia* (fig. 69; pl. 6) is one of Arms's most celebrated etchings, executed in 1931. The subject is the façade of one of the most famous and revered of all Venetian Gothic palaces, the once gilded "House of Gold." In this etching, Arms gave full rein to his incredible talent for describing the richness of the architectural elements, from the marble facing to the tracery of the roofline, from the rich shadows of the balconies, to the

delicate reflections of the façade on the Grand Canal in the foreground. Dorothy Arms wrote of this print, "In *Venetian Filigree* the sharply cast shadows of tiny sculptured balls, the intricate motives of pinnacles and loggias, the very veining of marble walls, are all rendered with a sure feeling for the originals which goes beyond reproduction and becomes interpretative of a people and of a civilization."[76] As Saville recognizes, however, "In this luminous image of shuttered doors, darkened balconies, and silent reflection, Arms emphasized the palazzo's rich repetition of pattern and cursive design."[77] Saville suggests that Arms all but eliminated the sense of three-dimensionality in the print, flattening the image to an almost abstract pattern. This abstraction is in direct contrast to the strategy of Roth, who had depicted the same motif at an earlier time.

Roth's 1913 *Ca' d'Oro* (fig. 32; pl. 57) is a more distant view, conceived from the Riva de l'Ogio across the Grand Canal. Roth's more spacious view emphasizes the context of the Ca' d'Oro, both the greater expanse of the Grand Canal in front of the façade and the details of the adjacent palaces. Reflections are minimized, although nearly half the composition is devoted to the canal and the few boats in the water. Roth evoked the architecture of the great Gothic structure and its unique setting, while Arms, working from the same spot, described its fabric in extraordinary detail. The quality of Arms's line work provoked both admiration and criticism from the time of its inclusion, in 1932, in the annual volume *Fine Prints of the Year*.[78] The critic Harold Baily acknowledged the genius of Arms's draftsmanship in the play of sunlight and shadow in the etching (it won first prize at the First International Exhibition of Prints in Chicago in 1932), but expressed reservations about the artist's obsessive approach:

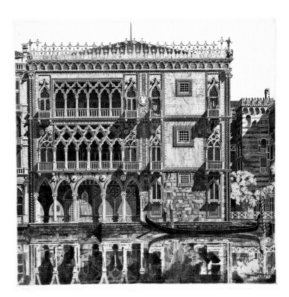

Fig. 69. John Taylor Arms, *Venetian Filigree (Ca' d'Oro, Venezia)*, 1931
Etching, 27.9 x 26.7 cm (11 x 10 1/2 in.)
Collection of Charles Rosenblatt

Mr. Arms has proven again and again that he can put everything into an etching with skill and patience which must be the despair of his disciples, but I hope the next prize he wins will be for once leaving nearly everything out. He should for a change allow the lovers of his prints the play of

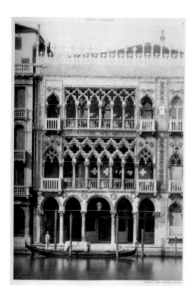

Fig. 70. Ferdinando Ongania, *Palazzo detto della Ca' d'Oro sul Canal Grande* from *Calli e Canali in Venezia: Monumenti* (Venice, 1891)

their own imaginations and make it plain, great artist that he is, notwithstanding his early training as an architect, that his genius is not bounded by a T-square and a triangle.

Arms's stunning etching also uses a motif that possibly was suggested by an Ongania photograph (fig. 70). Most artists concentrating on a façade along the Grand Canal did so from the opposite bank, like Roth, recognizing the importance of the body of water in the foreground. Like the Ongania photograph, Arms's *Venetian Filigree*, which he drew on site, de-emphasizes the Grand Canal, pulling the façade of the Ca' d'Oro up against the picture plane so that the viewer is confronted by the wealth of surface decoration and patterns of stonework. The artist may well have used photographs of the palazzo when developing the details of the image on the plate.

Arms and Roth generally avoided the most popular and clichéd views of Venice, as Whistler and his followers had in an earlier generation. However, occasionally a popular motif was too compelling to avoid, as in Arms's 1930 *La Porta della Carta, Venezia* (fig. 53; pl. 3), sometimes called

The Enchanted Doorway, Venezia. The subject is the ceremonial western entrance to the Ducal Palace from the Piazzetta in late afternoon. Although the image is in reverse, Arms transcribed all of the intricate details of the entrance. On the left, in loving and precise detail, are the bricks of the upper story of the façade of the palace, the stonework on the balcony, the sculptures, and Gothic tracery decorating the façade. The deep shadows of the balcony and doorway set off the brilliant light playing across the pavement in the foreground and the steps of the Scala dei Giganti, seen through the archway. On the right, Arms represented the corner of the Basilica of San Marco, with its richly patterned marble surface and the edge of the southern dome. Arms included the four porphyry tetrarchs on the lower right, huddled together, balancing the figure seated under the arcade on the left. In contrast to his approach to the Ca' d'Oro, Arms emphasized the depth of the space in the center of the image, the recession established by the orthogonals of the foreground pavement stones, and the angle of the vault below the arch. The artist maintained the delicate equilibrium between surface design and illusionistic space in this masterful work. Describ-

ing Arms's achievement in 1931, the eminent critic Elizabeth Luthor Cary wrote:

> The Doorway, *a miracle of closely observed and precisely rendered detail, is a record not only of historical significance, but of the impression made by the ornament of early architecture upon a mind trained to appreciate its indissoluble relation to the structure of the building upon which it is found.*[79]

Arms occasionally printed a portion of an edition on a pale green or pale blue paper, as seen in the brilliant impression in the exhibition. Roth must have been particularly impressed by this design, since it is the one instance we have of the older artist repeating a Venetian subject first realized by Arms. Roth's 1941 *Porta della Carta* (fig. 51; pl. 74) was a more economical rendering of the subject, acknowledging the presence of the structures without Arms's attention to surface tone and detail. Roth emphasized the sculptural volume of the building using light rather than surface texture to convey the same time of day. Here, he also reversed the composition on the plate in order to have the print represent the site's true orientation and, perhaps, to minimize the comparisons with one

of Arms's most famous prints. A strikingly similar image of the Porta della Carta was published in Ongania's *Calli e Canali in Venezia* (fig. 71).

Arms's brilliance at describing the subtle variations of light playing across varied and intricate surfaces is at the core of his achievement in his 1931 *Palazzo dell'Angelo* (fig. 72; pl. 5). The subject is far from the Grand Canal, an obscure façade in another part of Venice. As in *Venetian Filigree*, Arms precisely rendered the tones and surface of each brick and stone, of every shadow and reflection; his obsessive delineation of every detail of this obscure palace borders on *horror vacui*. Yet Dorothy Arms, undoubtedly echoing her husband's sentiments, insisted on the print's symbolic meaning:

> The Palazzo dell'Angelo *is a symbol of a bygone age, not just a picturesque palace above a slow-moving canal. Its inner court is peopled with the mournful ghosts of a dead nobility, and the leaning "pali," etched with such loving attention, seem sentinels of a past which has tottered to beautiful ruin.*[80]

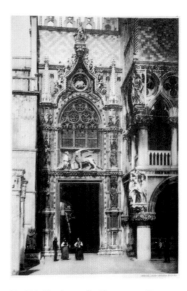

Fig. 71. Ferdinando Ongania, *Porta della Carta e angolo del Palazzo Ducale* from *Calli e Canali in Venezia: Monumenti* (Venice, 1891)

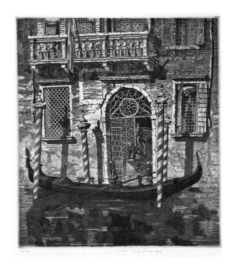

Fig. 72. John Taylor Arms, *Palazzo dell'Angelo*, 1931

Etching, 18.5 × 17.1 cm (7 1/4 × 6 3/4 in.), signed in pencil
Private collection

Contemporaneously, Arms was exploring a different approach to his Venetian imagery, a longer, more panoramic view of the fragile city. His diaries record that on August 26, 1930, he "mounted a fresh piece of paper and set out for San Giorgio Maggiore, where I started a drawing of the 'skyline of Venice.'"[81] *La Bella Venezia* (fig. 73; pl. 7) is one of the artist's outstanding achievements, a broad view of the familiar profile of Venice as seen from the square in front of the church of San Giorgio Maggiore across the *Bacino*. The artist represented each building, every detail, with unparalleled clarity, as seen looking north from San Giorgio. Saville recognized that Arms "flattened the sense of space, and daringly placed the line of buildings across the upper third of the plate."[82] One of Arms's heroes, Whistler, did similar long views of Venice in 1880, including the *Long Lagoon* (K 212) and *Little Venice* (K 183), but these are atmospheric images of the city rendered from his rooms on the Riva degli Schiavoni. The closer parallel is to the two views by Whistler's Australian follower Mortimer Menpes (figs. 12, 13). Although these were

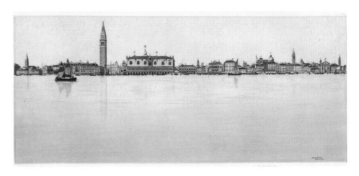

Fig. 73. John Taylor Arms, *La Bella Venezia*, 1931
Etching, 18.5 × 41.9 cm (7 1/4 × 12 1/2 in.)
Collection of Charles Rosenblatt

done from farther east, one from San Giorgio and the second from the adjacent island of San Servolo, they reflect a similar approach in format and design.

Venetian Mirror (fig. 64; pl. 8) is the last and most famous of Arms's Venetian prints. The drawing for it (fig. 74), reproduced in *Hill Towns and Cities of Northern Italy*, was done in 1930, but the plate was not drawn and etched until 1935. Arms's diaries relate the long hours he devoted to tracing, drawing, and executing this print.[83] The view looks east from the Ca' del Duca on the San Marco side of the Grand Canal. As before, Arms rendered the architecture with stunning clarity, from the neo-Gothic Palazzetto Stern on the left to the great turn in the Grand Canal (the *volta*) on the right. The large Baroque palace in the center of the opposite

bank of the canal is the Ca' Rezzonico, constructed between 1667 and 1758 after designs by Baldassare Longhena and Giorgio Massari.[84] The large building along the right edge of the print is Ca' Balbi, a late sixteenth-century palace designed by Alessandro Vittoria, better known today as a Renaissance sculptor than architect. Behind Ca' Balbi is the bell tower of the Church of Santa Maria Gloriosa dei Frari. The slightly smaller building to the left of Ca' Balbi is Ca' Foscari, home of a historically powerful Venetian family and today the seat of the University of Venice. In the drawing, Arms shows only moderate interest in the reflections, instead concentrating on the elements of architecture. In the etching (a mirror image of the site), Arms eliminated the two boats in the foreground of the drawing and lavishes attention on the architectural façades and on the reflections across the Grand Canal. The Grand Canal is rarely, if ever, sufficiently tranquil to permit such exacting reflections, but Arms suggests this possibility through his extraordinary details. In fact, Arms rendered the reflections by turning over the tracing paper and re-tracing the architecture he had initially drawn, now as the reflections of the buildings in the canal. The reflections in the water,

seen at an angle, should be distorted but here, based on the re-tracing, achieve a sense of hyper-realism. The title of the etching refers to both the reflections in the water and the reversal of the image.

Arms never returned to the subject of Venice in his later work, except for some of his quickly sketched demonstration plates. However, *Hill Towns and Cities of Northern Italy* shares the experiences of John Taylor Arms and his wife, Dorothy, and their reactions to the beauty and inspiration of Venice. Despite Arms's absence from Venice, his friendship with Fabio Mauroner continued until the latter's death in 1948. Arms met Mauroner in 1926 during the first trip to Venice, perhaps through their mutual friendship with Ernest Roth.[85] On

Fig. 74. John Taylor Arms, *Venetian Mirror*, 1930

Graphite, 16.3 × 36 cm (6 7/16 × 14 3/16 in.)
Rosenwald Collection, National Gallery of Art, Washington, DC

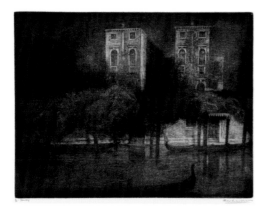

Fig. 75. Fabio Mauroner, *Palazzo Clary—Rio Ognisanti*, 1920

Mezzotint, 22.8 × 30.3 cm (9 × 11 7/8 in.), signed in pencil
The Trout Gallery, Dickinson College, Carlisle, PA, 2011.3.4

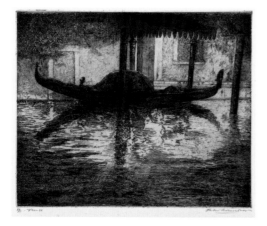

Fig. 76. Fabio Mauroner, *A Gondola*, 1931

Etching, 16.5 × 20.2 cm (6 1/2 × 8 in.), signed in pencil
The Trout Gallery, Dickinson College, Carlisle, PA, 2011.5.3

November 4, 1929, Arms recorded:

*At four thirty I came home, dressed and
we went to tea at the home of Fabio Mau-
roner and his wife. They have a charming
little house at 1 1 1 1 Fondamenta
Bonlini, San Trovaso, and are altogether
delightful people. She is a Spaniard, niece
of the great Fortuny and daughter of the
artist Madras. She is lovely to look at
and charming of manner. We had a jolly
time talking Italy and Spain and looking
at his prints. Some of them are fine and
his pencil drawings are lovely. They are
going to dine with us tomorrow night.*[86]

Additional diary entries recount other meetings. In Arms's studio in Connecticut was a box reserved for prints for Fabio and Cecilia Mauroner, mysteriously labeled "New Jersey." In the Arms collection at the College of Wooster are forty-two prints by Mauroner, all but one of them gifts from the Venetian artist to his American friend. The earliest, a print and a drawing, date to 1929. Twelve are from a large gift in 1930, seven from 1935, and ten are from the last gift, in 1939, when Mauroner ceased printmaking. All have personal salutations; many were Christmas gifts. In some instances the prints are dedicated to "Zuane," the Venetian name for John. The warmth of their relationship is evident also in Mauroner's personal print collection, given by his family to the civic museum in Udine.[87] Five Arms prints are in the Mauroner collection, including *Venetian Filigree*, all with personal dedications, two signed "Zuane."

In *Hill Towns and Cities of Northern Italy*, following a passage on some of the most interesting and impressive Venetian palaces that they had visited, Dorothy writes a secret homage to their friendship with the Mauroners:

*The mental picture which we most love is that of
a little house near San Trovaso. Here the canal
is one of the quietest of all Venice; and from its
mysterious depths it reflects dark barges moored
against the fondamenta, the elaborate entrance to a
palace, and a few star-points of light. Within the
house are found contentment and the true spirit of
hospitality. We remember happy hours in a high,*

68

wide studio; beauty about us; and conversation,
now grave, now gay. We remember a small garden
where salvias and tomatoes grew side by side, and
Spanish melons ripened in the sun. But most of
all we remember, as one recollects a splash of vivid
color or a chord of pure harmony, the very essence of
friendship.[88]

Mauroner recorded these views of the canal in his *Palazzo Clary—Rio Ognisanti* (fig. 75; pl. 30) and *A Gondola* (fig. 76; pl. 39). The mutual sentiments of friendship are recorded in dedications on the prints and in Dorothy's prose.

John Taylor Arms and Louis Rosenberg

A close friend of John Taylor Arms, Louis Conrad Rosenberg, was another notable architectural printmaker of the 1920s and 1930s who had his own particular vision of Venice. His early drypoints of Venice, several of which were purchased by Arms in the 1920s, may have helped motivate Arms to create his individual approach to the city.

Rosenberg was born in Portland, Oregon, in 1890. He was a precocious draftsman and by the age of sixteen had already begun working with local architects.[89] In 1912 he was awarded a scholarship by the Architectural Club of Portland, money he used to attend the Massachusetts Institute of Technology (MIT). He graduated in the spring of 1914, having earned the MIT Traveling Fellowship in Architecture, which was postponed due to the outbreak of World War I. Rosenberg returned to Portland to work as an instructor at the University of Oregon. In 1917 he joined the United States Army, serving in France until 1919. After the war, Rosenberg used the fellowship to visit various parts of Europe and North Africa, and he produced numerous sketches throughout the journey. In the winter of 1921–22 he was a fellow at the American Academy in Rome, where he came into contact with the Canadian-born expatriate printmaker Robert Fulton Logan (1889–1959) and the British etcher William Walcot (1874–1943).[90] Logan had studied under Frank Armington (1876–1941) in Winnipeg, and later under the American printmaker Frank Benson (1862–1951) at the School of the Museum of Fine Arts, Boston. Rosenberg created his first plates under Logan's guidance, a series of eight etchings

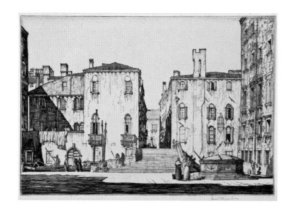

Fig. 77. Louis Conrad Rosenberg, *Campo dei Gesuiti, Venice,* 1927

Drypoint, 17.8 x 26.3 cm (7 x 10 3/8 in.), signed in pencil
Private collection

of Rome. Returning to New York in 1922, Rosenberg joined the architectural firm of York and Sawyer. In 1923 he executed three more prints of European subjects: the towers of San Gimignano, the bridge of Sospel, and a moorish archway in Toledo. As his prints began to attract favorable attention, Rosenberg devoted less time to his architectural practice and more to his printmaking career.

One of the partners in the firm, Philip Sawyer, was friends with the distinguished British architectural printmaker Sir David Muirhead Bone (1876–1953). Bone was greatly impressed by Rosenberg's drawings and early etchings and persuaded him to consider a career as a printmaker.[91] In the summer of 1924, on Bone's recommendation, Rosenberg interrupted his work as an architect to attend the School of Engraving at the Royal College of Art in London. There he studied with the eminent printmaker Malcolm Osborne (1880–1963), one of the leaders of the British school of architectural printmakers. As a result, in the second half of 1924 Rosenberg

produced twelve plates, including his first drypoints. The following year he executed seventeen prints of North Africa, Spain, and France, eventually producing one hundred and eighty prints over a twenty-year period.

Sometime in the first half of 1925 Rosenberg made his first trip to Venice. His earliest Venetian print captures the Ponte Cavallo and the canal of the Rio dei Mendicanti, the bridge in front of the church of San Zanipolo, and the civic hospital.[92] The drypoint was done for the periodical *The Architectural Forum* in an edition of six hundred impressions, an extraordinary number for a young printmaker.[93] In the spring of 1927 Rosenberg was back in Italy working from drawings of Constantinople as well as on plates of Rome and Venice. Though Rosenberg clearly preferred the monuments of ancient and Baroque Rome, his 1927 etchings of Venice have their own particular charm.

Rosenberg's *Campo dei Gesuiti, Venice* (fig. 77; pl. 42) is a view in a little traveled part of Cannaregio, looking past the ancient wellhead toward the steps of the bridge of the Gesuiti. The drawing for the drypoint was transferred directly to the plate, so we see a mirror image of the site, little changed today.

The scene is replete with elements of the daily lives of Venetians. In the early afternoon, women stand and talk while a few figures lounge on the steps, and boatmen make their way along the canal of Santa Caterina. To the right of the wellhead, a figure stands tending to a basket that was lowered from an open window, and beyond the bridge are vestiges of a religious procession. Salaman wrote admiringly of the "charmingly casual aspect of the place."[94] In the summer after his return to England, Rosenberg executed two more prints based on his Venetian drawings. *Loggia of the Doge's Palace, Venice* (fig. 78; pl. 44) is a reversed view of the northwest corner of the façade, adjacent to the Porta della Carta, drawn from the shadow of the bell tower of San Marco. Rosenberg emphasized the Gothic arch of the arcade and a double bay of the trefoil arches of the loggia above, extracting these elements to represent the overall decoration of the palace. He allowed portions of the building, including the doorframe, the brickwork of the upper stories, and the additional arcades, to dissolve into sunlight at the edges of the composition. Salaman wrote of this print:

In the beautiful little plate Loggia of the Doge's Palace, Venice, *he has, with exquisite suggestions of the various textures of material, depicted the rich Gothic details of the early fifteeth-century [sic] arcade, with the columns and the curiously attractive figures in the capitals representing the Judgment of Solomon, and the sculptures that adorn one side of the famous Porta della Carta.*[95]

The same visit resulted in the largest, most conventional of Rosenberg's views of the city, the *Grand Canal, Venice* (fig. 79; pl. 43). The artist's view is looking northeast toward the Rialto Bridge from the San Marco side of the canal; the bell tower of San Bartolomeo punctuates the skyline on the right side of the composition. On the left, early afternoon light casts the façade of the Palazzo Coccina Tiepolo Papadopoli and the adjacent buildings into shadows that Rosenberg represents with rich drypoint hatching. The imposing Renaissance façade of the Palazzo Grimani, closest to the viewer, is crisply delineated in bright

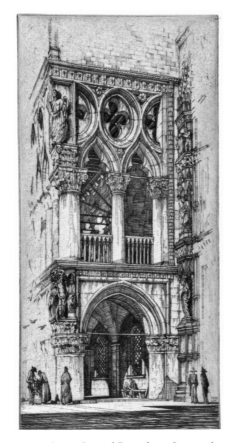

Fig. 78. Louis Conrad Rosenberg, *Loggia of the Doge's Palace, Venice*, 1927

Drypoint, 27.9 × 13.6 cm (11 × 5 3/8 in.), signed in pencil
Private collection

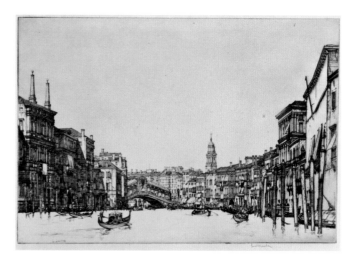

Fig. 79. Louis Conrad Rosenberg, *Grand Canal, Venice,* 1927

Drypoint, 22.3 × 35.2 cm (8 13/16 × 13 7/8 in.), signed in pencil
Private collection

sunlight. John Taylor Arms admired this print, commenting, "The like wizardry of drawing is seen in the long, sweeping curve of the façades that line the right-hand side of the *Grand Canal,* with the gradual diminuendo of values emphasized by the crescendo of the contrasting vigorous darks at the left."[96]

In 1925 John Taylor Arms purchased three of Louis Rosenberg's prints out of an exhibition of the Boston Society of Etchers at the Brooklyn Museum. Arms and Rosenberg may have met as early as 1912 at MIT, but their relationship only blossomed in the mid-1920s. Arms purchased *Chatelet, Vitre* [sic] (M 14) directly from Rosenberg in 1926. In 1928 he purchased *Campo dei Gesuiti,* his first of Rosenberg's Venetian prints, from Frederick Keppel & Company. The following year he purchased *Loggia of the Doge's Palace, Venice.*

In 1928 Rosenberg and his wife, Marie, purchased land in Greenfield Hill, a historic neighbor-hood in Fairfield, Connecticut, where they built a house designed by Rosenberg. Their home was within three miles of Arms's house, Millstones. Arms's diaries record regular visits from the Rosen-bergs, and Louis often drove into New York City with Arms. Their friendship was such that when Louis went off to serve in World War II, his wife moved into the apartment above Arms's garage.[97]

Rosenberg and Arms exchanged prints on a regular basis—one of the storage boxes in Arms's studio was labeled for the Rosenbergs—and Arms eventually owned more than ninety of Rosenberg's prints, including five of the seven Venetian sub-jects. A tireless promoter of contemporary print-making, Arms wrote an extended appreciation of Rosenberg's talent for *Prints* magazine in 1935:

Three things seem to me outstanding in Rosenberg's art; his ability to extract from a scene its most per-sonal and characteristic essence, the fine restraint of his expression, which imparts to everything he does that indescribable quality we call "style", and the exquisite purity of his draughtsmanship. He never overloads his plates, nor are they ever meager, he is a master of composition, and he is always fully aware

of the potency of blank spaces. Trained as an archi-
tect, he knows architectural forms, proportions, and
scale—a knowledge too often lacking among the
workers in this field of subject matter.[98]

For the Rosenberg article, published in May 1935, Arms necessarily conceived of and wrote the essay the previous winter. In January, 1935 Arms began work on his final etching of Venice, *Venetian Mirror* (fig. 64; pl. 8), four years after his last prints of the city. In Arms's view of the Grand Canal, its spaciousness and restraint are unlike the heavily wrought style of so many of his other Venetian prints, including *The Enchanted Doorway* and *Venetian Filigree*. His study of Rosenberg's work may have contributed to his return to one last Venetian subject. Both artist's images of the Grand Canal are characterized by "fine restraint," "potency of blank spaces," and an "exquisite purity of draughtsmanship."

Rosenberg produced his final drypoint of Venice in October 1935, perhaps in response to Arms's praise of his Venetian images. His *Piazza Santa Maria Formosa, Venice* (MacMillan 120) was selected by the distinguished print historian Campbell

Dodgson, previously keeper of prints and drawings at the British Museum, to be included in the 1936 volume of *Fine Prints of the Year*.[99] Dodgson considered the line of bridges and façades on the canal of Santa Maria Formosa "an arrangement resulting in a certain monotony in the composition."[100] Despite Dodgson's reservations, the play of light and shadow across the Renaissance Palazzo Malpiero on the left and on the back of the church enliven the scene. This view was among the last in Rosenberg's etching career. With the advent of World War II and changes in the art market, Rosenberg returned to his career as an architect, retiring from printmaking in 1946. An exhibition in February 1956 at the Charles Hayden Memorial Gallery of MIT in Cambridge brought together the work of four alumni printmakers: Samuel Chamberlain, George C. Wales, John Taylor Arms, and Louis Rosenberg.[101] Twenty prints by each artist, including a selection of Venetian etchings by Rosenberg and Arms, were shown.

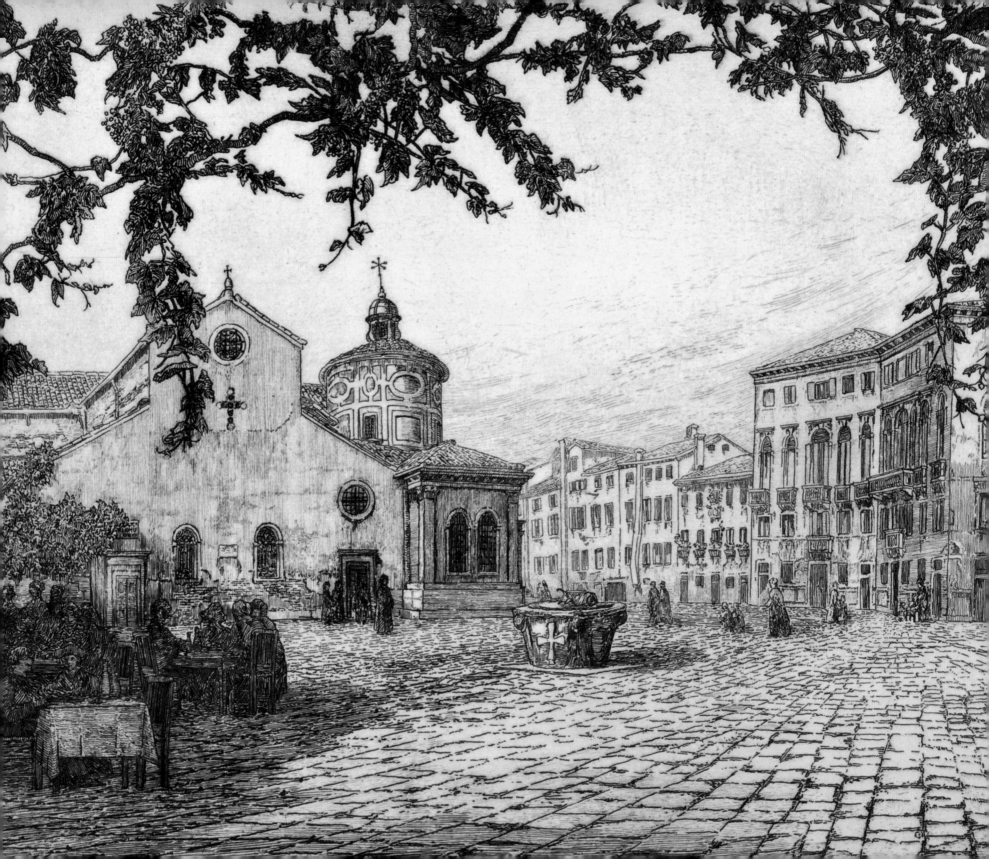

4. Fabio Mauroner

Fabio Mauroner was a friend and colleague of Ernest Roth and John Taylor Arms over the course of many years. He was born on July 22, 1884, in Tissano in the province of Udine in northern Italy.[102] In 1904 he went to Rome, where he studied with the watercolorist Enrico Nardi. Mauroner encountered etching in Rome at an exhibition of works by the British printmaker Edward Millington Synge. In 1905 he moved to Venice and took classes at the Accademia dei Belli Arte, sharing a studio near the church of San Sebastiano with the young avant-garde painter Amedeo Modigliani. The following year Mauroner studied printmaking with Synge when the expatriate opened a new studio near the church of San Trovaso. Synge had printed with Frederick Goulding in London, a famous printer who was working with the widely admired artist Frank Brangwyn. Goulding had worked with Whistler as well as some of Whistler's followers, connecting the older generation of British and American view etchers of Venice to the younger one. Mauroner always referred to Synge as his master, and a

number of Mauroner's early works relate to the subjects and designs of the older artist. The early Mauroner drypoint (fig. 80) of the thirteenth-century Byzantine Ca' da Mosto, one of the earliest surviving palaces in Venice, was also etched by Synge in the same period (fig. 81; pl. 79). Synge's etching has the assuredness of a mature master, with the high placement of the truncated façade and the expanse of water barely suggested below, in Whistleresque detail. Whistler had represented this well-known building in pastel in 1879–80 (*The Palace; white and pink*, MacDonald 758), and two of the artists in his circle, Robert Blum and Joseph Pennell, had also etched images of the water entrance to the ancient palace that is across the Grand Canal from the Rialto

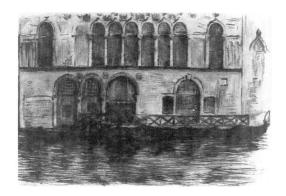

Fig. 80. Fabio Mauroner, *Ca' da Mosto*, c. 1906
Drypoint, 6.7 × 10.4 cm (2 5/8 × 4 1/8 in.)
Private collection

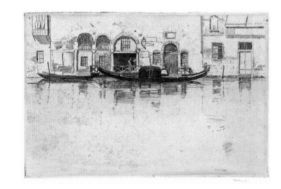

Fig. 81. Edward Millington Synge, *Ca' da Mosto*, 1906
Etching, 15.7 × 23.8 cm (6 1/8 × 9 3/8 in.), signed in pencil
Private collection

Fabio Mauroner, *The Rialto Market, Trattoria "La Vida"* (detail), fig. 92, pl. 33

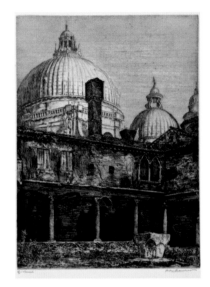

Fig. 82. Fabio Mauroner, *The Cloisters of San Gregorio*, 1907

Etching, 30.7 × 23 cm (12 1/8 × 9 in.), signed in pencil
The Trout Gallery, Dickinson College, Carlisle, PA, 2011.3.3

markets. Mauroner's image was a rudimentary attempt by a young printmaker still struggling with control of the drypoint needle.

Shortly after Modigliani and Synge departed from Venice, Mauroner became close friends with Ernest David Roth, a young American etcher whom he greatly admired. The two artists remained good friends for the rest of their lives. In his unpublished autobiography, Mauroner described Roth as "[s]erious, shy, and modest, despite the success that his passionate work later received."[103] They worked together, often only stopping for a single evening meal in an inexpensive trattoria on the Salizzada San Lio, not far from the house where Canaletto was born.[104] Roth also depicted the dilapidated Ca' da Mosto in two early etchings (figs. 20, 41; pls. 45, 53). It seems possible that he worked with Synge at the beginning of his career, although he never mentioned their relationship. Roth's diminutive etchings reverse the view,

whereas those by Synge and Mauroner do not.

Mauroner would have seen many of Roth's early prints, including *Near the Rialto, Venice* (fig. 18; pl. 49) and *A Street in Venice*, both shown in the 1907 International Biennale.[105] Roth was instrumental in introducing Mauroner's work to an American audience. In Mauroner's personal print collection, preserved in Udine, are thirteen prints by Ernest Roth, many with individual salutations, including eight Christmas cards. Mauroner himself had produced an etched Christmas card as early as 1906, perhaps the immediate inspiration for Roth's, and later Arms's, employment of the medium in holiday greetings.

In 1907 Roth and Mauroner etched similar plates of two other obscure views: the cloister of San Gregorio (figs. 29, 82; pls. 55, 29) and the Canal di Quintavalle (figs. 83, 21; pls. 26, 52). The deconsecrated cloister, situated on the Grand Canal adjacent to the church of Santa Maria della Salute, was a thirteenth-century Gothic Benedictine abbey that became a municipal depot in the nineteenth century. The picturesque interior attracted other graphic artists and photographers in the nineteenth and early twentieth centuries, including Myles

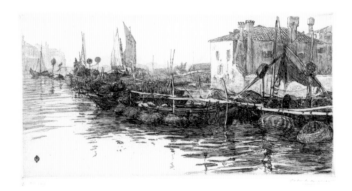

Fig. 83. Fabio Mauroner, *Canal di Quintavalle*, 1907

Etching, 12 × 23.8 cm (4 3/4 × 9 3/8 in.), signed in pencil
The Trout Gallery, Dickinson College, Carlisle, PA, 2011.1.5

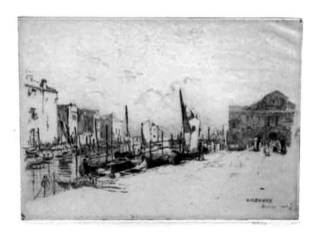

Fig. 84. Edward Millington Synge, *Fishing Boats, Venice*, 1906

Etching, 17.6 × 25.3 cm (6 15/16 × 10 in.)
Private collection

Fig. 85. Ferdinando Ongania, *Chiostro dell'Abazia di S. Gregorio* from *Calli e Canali in Venezia: Monumenti* (Venice, 1891)

Fig. 86. Ferdinando Ongania, *Rio o Canale di S. Pietro di Castello* from *Calli e Canali in Venezia: Monumenti* (Venice, 1891)

Fig. 87. Fabio Mauroner, *Bridge of the Dead (Ponte dei Morti)*, 1906

Etching, 12.3 × 27.9 cm (4 7/8 × 11 in.), signed in pencil
The Trout Gallery, Dickinson College, Carlisle, PA, 2011.1.4

Birket Foster (1825–1899) and the Canadian etcher Clarence Gagnon (1881–1942). Roth depicted the cloisters in three early etchings, two with vertical formats and one horizontal.[106] Mauroner and Roth drew their prints from similar spots, looking southeast with just a corner of the Salute seen above the courtyard.

More surprising is the similarity between the two views of the Canal di Quintavalle. Each artist depicted the fishing boats and crab traps used by the Venetians to capture *moeche*, the delicate, small, soft-shell crabs that inhabit the lagoon. These are possibly two views of the same sight from different angles. This waterway is at the extreme eastern end of Venice, at the tip of Castello on the southern edge of the island of San Pietro. The canal was in a working-class district of fishermen, leading from boatyards out into the lagoon in the direction of the island of Vignole and the Lido. It is unimaginable that Roth would have chosen this area without the advice of a resident. Synge, who etched a similar subject (fig. 84) may have also worked with the younger artists at this site. The three printmakers may also have taken inspiration from the 1891 Ongania volume *Calli e Canali in Venezia*, in which

plate 36 is a view of the corner of the cloisters (fig. 85) and plate 72 is a view of fishing boats and crab traps on the canal of San Pietro, taken from its intersection with the Canal di Quintavalle (fig. 86). Frank Duveneck was the only other noted printmaker who had worked in the area earlier, etching *San Pietro in Castello* (Poole 18) in 1883.

Mauroner's earliest prints demonstrate his predilection for aspects of Venetian life more familiar to residents than visitors. His 1906 *Bridge of the Dead (Ponte dei Morti)* (fig. 87; pl. 25), a mirror image, represents a procession of mourners across the pontoon bridge constructed each year on November 2, All Soul's Day. The temporary span connects the Fondamente Nove, the quay on the northern side of the Cannaregio district, to the cemetery island of San Michele. As in most of his early views. Mauroner's early etching *Vespers in Basilica San Marco* (1906) also attests to his experience as a Venetian resident, concentrating on the activities of the devout rather than on the picturesque aspects of the church's interior. Mauroner returned to the subjects of the daily life and religious rites of native Venetians throughout his career.

At the same time, other Mauroner prints were

closer to the approach of Whistler and Roth in their attempts to capture picturesque aspects of the Venetian cityscape. In the 1907 etchings *Il Traghetto* (fig. 88; pl. 27) and *The Four Bridges* (fig. 89; pl. 28) Mauroner captured typical elements of Venetian views—canals, gondolas, and bridges. *Il Traghetto* portrays one of the gondola ferries used at strategic points along the Grand Canal to take people to the opposite bank. The *traghetto* depicted is the ferry at Campo Santa Maria del Giglio. *The Four Bridges* represents a water-level view under the Canonica Bridge from the quay alongside the church of San Apollonia. Both of these prints show a mirror image of the actual scene, typical of Mauroner's early work. Whistler and other foreign artists worked for collectors and admirers who were thousands of miles away and generally less concerned with correctly oriented views. In later work, however, Mauroner most often reversed the drawing on the plate, to provide an accurate view when printing for his predominantly local clientele. Other early Mauroner prints capturing distinctive Venetian views in reverse include the 1911 *The Great Door of the Servi* (Reale 39) and the 1913 *Corte Bottera* (Reale 46). In these and other prints

of the period, Mauroner often left a thin veil of surface ink on the copper plates suggesting a gray, moody atmosphere to his scenes.

In the years just before and after World War I, Mauroner's house and studio became a popular destination for both Italian and foreign printmakers visiting Venice. In this regard, Mauroner's studio had an analogous position to Ernest Roth's studio in New York and to John Taylor Arms's home in Connecticut. In addition to Roth's return to Venice with his friend Jules André Smith in 1912–14, the English artists Albany Howarth and Nelson Dawson visited Mauroner around the same time. After the war, Mauroner sometimes printed and worked with the Italian printmakers Antonio Carbonati, Emanuele Brugnoli, and Benvenuto Disertori.

In 1914 Mauroner entered the military, interrupting his career

Fig. 88. Fabio Mauroner, *Il Traghetto*, 1907
Etching and drypoint, 23 × 30.2 cm (9 × 11 7/8 in.), signed in pencil
The Trout Gallery, Dickinson College, Carlisle, PA, 2011.3.1

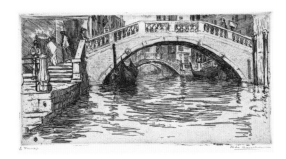

Fig. 89. Fabio Mauroner, *The Four Bridges*, 1907
Etching and drypoint, 11.8 × 22.8 cm (4 5/8 × 9 1/4 in.), signed in pencil
The Trout Gallery, Dickinson College, Carlisle, PA, 2011.3.2

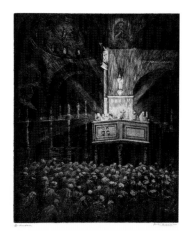

Fig. 90. Fabio Mauroner, *Benediction of the Holy Relics*, 1920

Etching and drypoint, 26.4 × 22.6 cm (10 3/8 × 8 7/8 in.), signed in pencil
The Trout Gallery, Dickinson College, Carlisle, PA, 2011.3.5

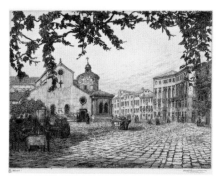

Fig. 92. Fabio Mauroner, *Trattoria "La Vida" (Campo San Giacomo dell'Orio)*, 1924

Etching, 22.7 × 30.2 cm (8 7/8 × 11 7/8 in.), signed in pencil
The Trout Gallery, Dickinson College, Carlisle, PA, 2011.4.2

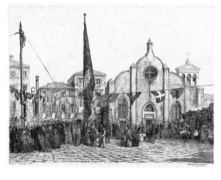

Fig. 93. Fabio Mauroner, *La Sagra (Campo San Giovanni della Bragola)*, 1924

Etching, 22.3 × 30.1 cm (8 3/4 × 11 7/8 in.)
Private collection

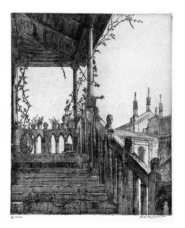

Fig. 91. Fabio Mauroner, *A Venetian Loggia (Ca' Loredan ai SS. Giovanni e Paolo)*, 1923

Etching, 24 × 20 cm (9 1/2 × 7 7/8 in.), signed in pencil
The Trout Gallery, Dickinson College, Carlisle, PA, 2011.4.1

as a printmaker for six years. When he returned to Venice in 1919, he moved into the house at 1111 San Trovaso where he remained for the rest of his life. Mauroner's postwar prints evidence his darker mood and the effects of the war. He continued his preoccupation with subjects of local interest, as seen in the 1920 *Benediction of the Holy Relics* (fig. 90; pl. 31) and the two darkest prints of his career, *Palazzo Clary—Rio Ognisanti* (fig. 75; pl. 30), and *Il Ghetto* (Reale 50). *Palazzo Clary* was Mauroner's sole experiment in mezzotint, a nocturnal view looking across the canal from the new house. He also experimented with dark effects in his view of

the Ghetto, using aquatint and abrading the plate to produce the rich *ombra* of night.

During the early 1920s Mauroner traveled around the Italian peninsula, as far as Capri, and to Tunisia and Turkey. In 1923 he took up the subject of his adopted city again, producing some of the most significant etchings of his career. Mauroner explored the life of the city in a series of large prints that included *A Venetian Loggia (Ca' Loredan ai SS. Giovanni e Paolo)* (fig. 91; pl. 32), *The Rialto Market, Trattoria "La Vida" (Campo San Giacomo dell'Orio)* (fig. 92; pl. 33), *La Sagra (Campo San Giovanni della Bragola)* (fig. 93), *The Procession (Santa Maria della*

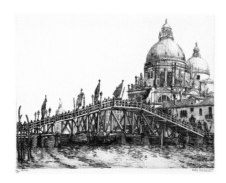

Fig. 94. Fabio Mauroner, *The Procession (Santa Maria della Salute)*, 1924

Etching, 22.5 × 30 cm (8 7/8 × 11 3/4 in.), signed in pencil
The Trout Gallery, Dickinson College, Carlisle, PA, 2011.4.3

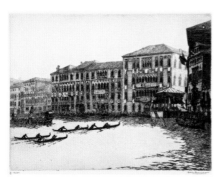

Fig. 95. Fabio Mauroner, *La Regatta (San Tomà)*, 1924

Etching, 22.9 × 30.2 cm (9 × 11 7/8 in.)
Private collection

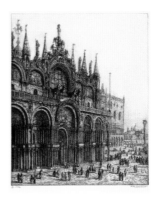

Fig. 96. Fabio Mauroner, *Basilica of San Marco*, 1926

Etching, 30.2 × 25.2 cm (11 7/8 × 9 15/16 in.), signed in pencil
The Trout Collection, Dickinson College, Carlisle, PA, 2011.4.4

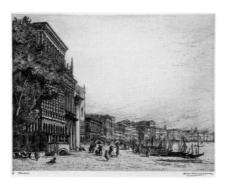

Fig. 97. Fabio Mauroner, *La Riva degli Schiavoni*, 1926

Etching, 22.7 × 30.2 cm (8 7/8 × 11 7/8 in.), signed in pencil
The Trout Gallery, Dickinson College, Carlisle, PA, 2011.4.5

Salute) (fig. 94; pl. 34), and *La Regatta (San Tomà)* (fig. 95).[107] In these works Mauroner created architectural views that allowed for greater compositional spaciousness than is seen in his earlier work. The subjects are situated between a few essential foreground details and the broad open areas of the sky. His greater economy of line and his balance between line work and open spaces place these among his most impressive prints. *La Vida* is exceptional in this group. He used the trellis above to frame both the sky and the view of his favorite restaurant in Venice on the square of San Giacomo dell'Orio.

From 1925 to 1930 Mauroner rendered views of monumental Venice, a tradition that was initiated by Gaspar Vanvitelli and continued by Carlevarijs and Canaletto well into the eighteenth century. Throughout his career Mauroner was aware of the great epoch of the Venetian *vedute*, represented in the paintings and prints of Canaletto, Marieschi, Bellotto, and Guardi. Some of Mauroner's most significant achievements are in that vein—the *Basilica of San Marco* (fig. 96; pl. 35), *La Riva degli Schiavoni* (fig. 97; pl. 36), *Morning at the Rialto* (fig. 98; pl. 37), *Il Molo* (fig. 99; pl. 38), *La Piazzetta* (fig. 100), and *Canalazzo (The Grand Canal)* (fig. 101).[108]

During this time Mauroner also began to explore

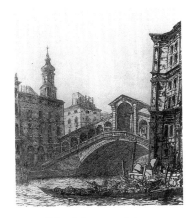

Fig. 98. Fabio Mauroner, *Morning at the Rialto*, 1929

Etching, 25 × 22.2 cm (9 3/4 × 8 3/4 in.),
signed in pencil
The Trout Gallery, Dickinson College,
Carlisle, PA, 2011.5.1

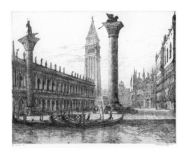

Fig. 99. Fabio Mauroner, *Il Molo*,
1930

Etching, 30.2 × 39 cm (11 7/8 × 15 3/8 in.),
signed in pencil
The Trout Gallery, Dickinson College,
Carlisle, PA, 2011.5.2

views of some of the other islands of the Venetian lagoon—Burano, Torcello, and San Francesco del Deserto. *Venezia from Vignole* (fig. 102; pl. 40) is representative of this group: a foreground copse of trees on one side of a view that gives way to a long silhouette of the islands and towers in the distance. Whistler's distant views of the lagoon, *Long Lagoon* (K 212) and *Little Venice* (K 183), are precedents for Mauroner's approach in these etchings.

In the last decade of his etching career, Mauroner drew a number of smaller plates that captured intimate aspects and angles of Venetian life. The 1931 *A Gondola* (fig. 76; pl. 39) is another view from his house in San Trovaso. It is a simple view, across the quiet canal, of the quintessential Venetian craft moored under a metal awning behind the Palazzo Clary. A few mooring poles provide the vertical balance to the horizontals of the gondola, the awning, and the reflections in the water. *The Madonna of the Gondoliers* (fig. 103; pl. 41) depicts the votive image on a corner of the Bridge of Straw on the Riva degli Schiavoni. The intimacy of the view suggests a fragment of Venetian everyday life, a detail that normally goes unnoticed against the monumental Ducal Palace and the State Prisons

presented in the background.

In 1938, anguished by the worsening political situation in Italy and suffering from bouts of depression, Mauroner ended his printmaking career—after having produced approximately one hundred and thirty prints—and spent the last ten years of his life researching and writing about the great Venetian Renaissance and Baroque printmakers. Mauroner's prints were exhibited regularly in Venice in the summer shows at Ca' Pesaro beginning in 1909, and in the Venice Biennales starting in 1922. In 1948, the year of his

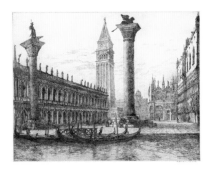

Fig. 100. Fabio Mauroner, *La Piazzetta*,
1925

Etching and drypoint, 30.2 × 27.8 cm (11 7/8 ×
10 15/16 in.)
Private collection

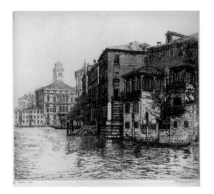

Fig. 101. Fabio Mauroner, *Canalazzo (The Grand Canal)*, 1925

Etching, 22.6 × 25.5 cm (8 7/8 × 10 in.)
Private collection

death, the Venice Biennale exhibited a selection of ten of his etchings, including six of the Venetian prints.[109]

Mauroner achieved a measure of fame in the United States as well. His prints were included in eight of the ten *Fine Prints of the Year* volumes published from 1929 to 1938. Three of his Venice prints were shown in the exhibition of the Chicago Society of Etchers in 1925, the same year he had his first American one-man exhibition, at the Ehrich Gallery in New York City.[110] He also had an exhibition at the Seattle Fine Arts Society in 1926.[111]

Mauroner's last exhibition was organized by Elizabeth Whitmore, the founder of The Print Corner in Hingham Center, Massachusetts. Whitmore was a freelance curator and the author of the only monograph on Ernest David Roth. She was a tireless promoter of Mauroner and other printmakers of the era, including Roth and John Taylor Arms, and she regularly exhibited Mauroner's etchings in her galleries and in other Massachusetts venues. Whitmore arranged for the exhibition of Mauroner's work at Wellesley College from March 1 through 10, 1938. She invited Mauroner's old friend John Taylor Arms to write the introduction to the brochure. In his tender appreciation Arms wrote:

The world of prints today is full of clever things by clever men, of dashing, striking things that catch the passing eye, but yield little to the studious one. Fabio Mauroner's work is not of this class. A sensitive, thoughtful man, he brings to the copper a healthy respect for one of the most difficult media of art expression, and a great and abiding love for the things he sees around him in his beautiful land of Italy. We look in vain for tricks of the needle and acid and artificial dexterities of the printing-rag, and, failing to find them, are most thankful. Simple and unassuming, honest and frank as the man who made them, these plates speak with a quiet dignity that is almost a reserve, with a restraint that approaches austerity. And because they are a product of a soul and mind and hand that feel for the subjects depicted that affection that only a Latin knows for his native land and the things of it, so we others, who also love Italy, are quite at home among those interpretations of something so dear to us, too.

Fabio Mauroner was born near Udine, the capital city of Friuli, and is a member of one of the

Fig. 102. Fabio Mauroner, *Venezia from Vignole*, 1932

Etching, artist's proof, 22.2 × 30.5 cm (8 3/4 × 12 in.), signed in pencil
The Trout Gallery, Dickinson College, Carlisle, PA, 2011.5.4

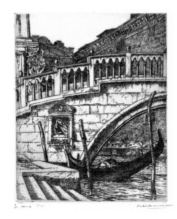

Fig. 103. Fabio Mauroner, *The Madonna of the Gondoliers*, 1935

Etching, 14.9 × 12.4 cm (5 7/8 × 4 7/8 in.), signed in pencil
The Trout Gallery, Dickinson College, Carlisle, PA, 2011.5.5

oldest families of that very ancient country. Now he lives in Venice, the gay, stern, brilliant, somber, altogether unbelievable city which has irresistibly attracted so many artists. And there he works steadily, thoughtfully and patiently over his sketchbook, canvas and copper, producing works entirely in harmony with their creator and with the spirit in which they were conceived.[112]

The most important collection of Mauroner's work was bequeathed by his widow to the Civica Galleria d'Arte Moderna and the Civici Musei e Galleria di Storia e Arte Antica in Udine. Major collections of his works in the United States are in the John Taylor Arms Print Collection in the College of Wooster Art Museum in Wooster, Ohio, and in The Trout Gallery of Dickinson College in Carlisle, Pennsylvania. Mauroner's works are also in the collections of the Art Institute of Chicago, the Uffizi Gallery in Florence, the *Ca' Pesaro* Galleria d'Arte Moderna in Venice, the Baltimore Museum of Art, and the Library of Congress.

Fabio Mauroner and Emanuele Brugnoli

One of Fabio Mauroner's friends in Venice was Emanuele Brugnoli, an instructor at the Accademia di Belle Arti di Venezia and founder of its school of etching. Brugnoli was born in Bologna in 1859 and moved to Venice in 1880. He began teaching at the Academy in 1912. Brugnoli's respect for the younger Mauroner is seen in the dedications on impressions of two of his prints now in the Civica Galleria d'Arte Moderna, Udine. On *Santa Maria Formosa* (1920) the inscription reads, "Al carissimo collega Mauroner (to my dearest colleague Mauroner), Venezia, 1921." On another print Brugnoli wrote, "con sincera stima" (with sincere respect).[113] Brugnoli was similar to Mauroner in his presentation of Venetian life but offered a more panoramic view of the energy of the city and its people. His large-scale 1920 images of *Campo Santa Margarita* (fig. 104; pl. 11) and *Campo Santa Maria Formosa* (fig. 105; pl. 12) teem with the everyday activities of working-class Venetians. Notwithstanding his depiction of everyday life, Brugnoli displayed a keen sense of imagination in representing the

campanile of Santa Margarita not in its contemporary truncated form but as it would have originally appeared prior to 1808. Mauroner and Brugnoli differed from such foreign artists as the American expatriate James McNeill Whistler, John Taylor Arms, and Ernest David Roth, who saw Venice as a series of picturesque views but were largely indifferent in their prints to the daily lives and holiday celebrations of the Venetians. This was, however, precisely what Whistler originally claimed to have discovered, "the Venice of the Venetians." In Mauroner and Brugnoli's work, images of the working-class squares of Campo Santa Margarita, Campo San Giacomo dell'Orio, and Campo San Giovanni in Bragora come to life as centers of everyday Venetian life, whether at the daily fish and flea markets or at the puppet shows during Carnevale. Mauroner and Brugnoli demonstrated an equally high level of dedication to their etchings as did their better known foreign counterparts, but they brought a distinctively local approach to the Venetian scene.

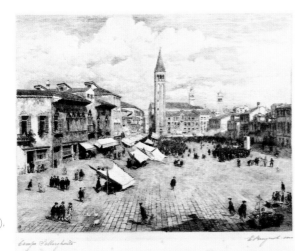

Fig. 104. Emanuele Brugnoli,
Campo Santa Margarita, 1920

Etching, 30.5 x 40.3 cm (12 x 15 7/8 in.),
signed in pencil
Private collection

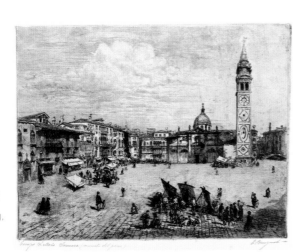

Fig. 105. Emanuele Brugnoli,
Campo Santa Maria Formosa, 1920

Etching, 32.4 x 43.2 cm (12 3/4 x 17 in.),
signed in pencil
Private Collection

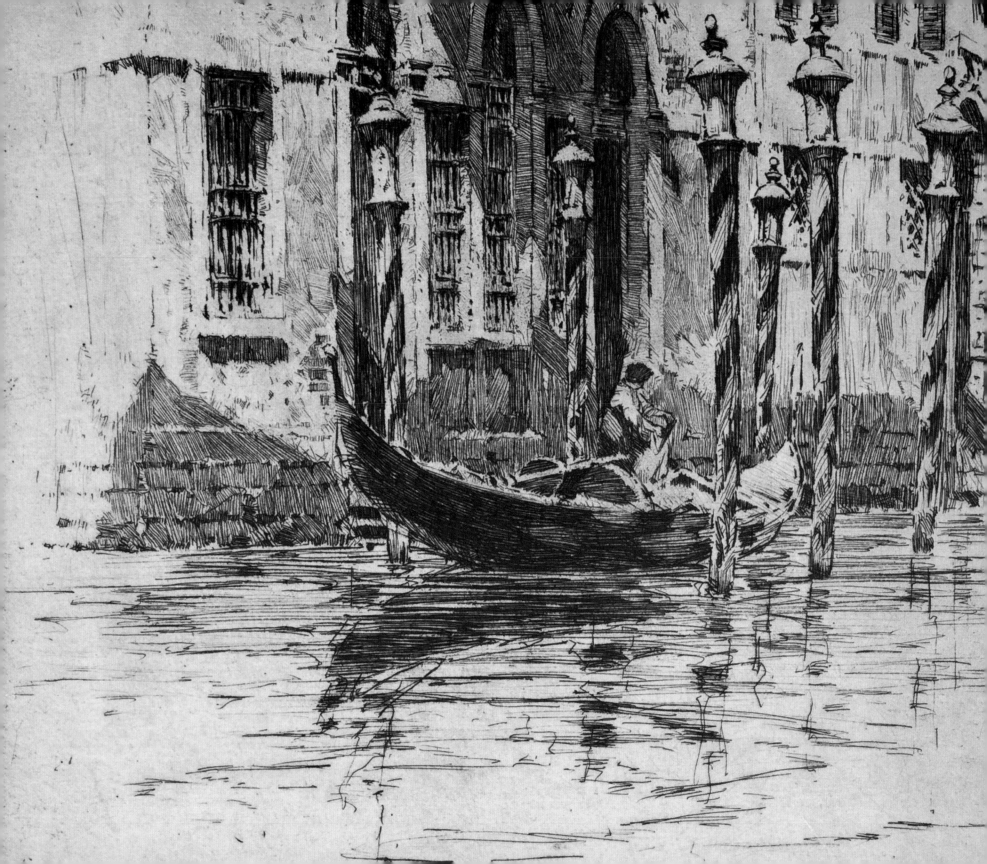

5. Printmakers in Venice, 1905–1935: Other Masters

The previous chapters examine a group of artists of the generation following Whistler that were well known to one another, familiar with each other's works, and in many cases influenced each other. Ernest David Roth was the eldest of the group and the earliest to develop in his career as a printmaker. Roth was friends with John Taylor Arms and Louis Rosenberg, and all three would have known Fabio Mauroner and his work in Venice. They all were members of the Society of American Etchers, the Chicago Society of Etchers, and the National Academy. They belonged to the Salmagundi Club in New York, exhibited in many of the same venues, and their work was handled by many of the same print galleries. Although Roth lived and had his studio in New York City, all had homes in the close-in towns and villages of Connecticut. All of them were attracted to the beauty and light of Venice.

Of course, many other printmakers, both American and foreign, were also attracted to Venice during this period. Since the eighteenth-century Grand Tours, English artists had always been par-ticularly attracted to the city. Even an abbreviated list of the most noteworthy British printmakers that worked in Venice during this time would include Andrew Affleck, Frank Brangwyn, Nelson Dawson, Francis Dodd, Hedley Fitten, Albany Howarth, Sydney Mackenzie Litten, Henry Rushbury, Sydney Tushingham, Francis Sydney Unwin, and William Walcot. In addition, the Scottish artists David Muirhead Bone, D. Y. Cameron, and James McBey created striking prints of Venice, as did the Australian artists Lionel Lindsay and Eric Glidden Scott. Other contemporary European artists that recorded the lagoon city included the Swede Axel Haig, the German Ernst Oppler, the Czechs Tavik Frantisek Šimon and Jan Vondrous, and the quasi-French Edgar Chahine, who was born in Venice of Armenian parents, brought up in Constantinople, studied in Venice, but eventually lived and worked in Paris.

In addition to the previously discussed American artists, Earl Stetson Crawford, Arthur Heintzelman, Bertha Jaques, John Marin, Cadwallader Washburn, the expatriate Herman Armour Webster, and Levon West all created their own

Jan Charles Vondrous, *Venezia* (detail), fig. 116, pl. 81.

Fig. 106. John Marin, *The Window, Venice (La Fenestre)*, 1907

Etching, 18 × 12.9 cm (7 1/16 × 5 1/16 in.), signed in the plate
Private collection

Fig. 107. John Marin, *The Small Clock Tower of Santa Maria Zobenigo, Venice*, 1907

Etching, 20.1 × 14 cm (7 15/16 × 5 1/2 in.), signed in pencil
Private collection

individual visions of Venice, as did the expatriate Canadian artists Frank and Caroline Armington, Donald Shaw MacLaughlan, and Clarence Gagnon. A selection of the most important of those artists represented in the exhibition is discussed in this essay.

John Marin

John Marin (1870–1953) arrived in Venice for a six-week stay in April 1907.[114] He had begun etching less than two years prior to his visit, executing approximately fifty plates of Paris and Amsterdam. In Venice, he stayed with his family in the Pension Gregory on the Grand Canal not far from the Piazza San Marco. Marin's stepbrother Charles Bittinger later wrote that, while in Venice, the artist refused to accompany the family to an exhibition of Whistler's work for fear that he might be overly influenced by Whistler's imagery.[115] No documents exist for an exhibition of Whistler's work in Venice at that time, and the reference may be a calculated bit of misdirection, since all of Marin's prints are clearly dependent on Whistler's style and many suggest an acquaintance with the older American's work in Venice.

Marin produced twenty plates based on his stay in Venice, all small, all mirror images, and all Whistler-like to some degree. *The Window, Venice (La Fenestre)* (fig. 106; pl. 23) is a view across the bridge and the canal in front of the Church of Santa Maria dei Miracoli at the eastern edge of the Cannaregio district. Marin organized his composition around the diagonal of the bridge parapet and the geometry of the windows, the steps of the bridge, and the arched Gothic doorway of the unassuming building seen across the canal. Likewise, Marin's etching *The Small Clock Tower of Santa Maria Zobenigo, Venice* (fig. 107; pl. 24) is set on a bridge directly behind the artist's *pensione*. Looking across the Ponte Zaguri, Marin depicted the adjacent buildings of the little Campiello de la Feltrina and the back wall and bell tower of the church of Santa Maria del Giglio, commonly called Zobenigo in Venetian dialect.

Marin absorbed both Whistler's emphasis on a central vignette and the calligraphic style that evokes the dilapidation of the walls rather than recording each detail of the surface. The Whistlerian formula emerges again and again in Marin's Venetian prints, including his *Ponte di Donna Onesta, Venice* (Zigrosser 56) and *Della Fava, Venice* (Z 64).

Though many of these subjects are of the everyday aspects of the Venetian experience, Marin was not immune to the allure of the more famous tourist attractions of the city, and portrayed the Church of Santa Maria della Salute (Z 53), the Basilica of San Marco (Z 52), and the Piazzetta and Ducal Palace (Z 65) in different plates. These, too, are rendered in Whistler's broken line work and calligraphic style. Interestingly, Marin also rendered two unusual views in 1907 that have parallels in early works by both Roth and Mauroner. Marin did two etchings of the boats out on the canal of San Pietro (Z 51 and 57) and one of the *Ponte del Paradiso* (Z 55) near the Campo Santa Maria Formosa. Might the young American etcher have crossed paths with Mauroner and Roth during his development as a printmaker?

Herman Armour Webster

Herman Armour Webster (1878–1970) was born in New York in 1878.[116] After graduating from Yale in 1900, where he was one of the editors and illustrators of the *Yale Record*, Webster visited Paris to see the Universal Exposition. He studied briefly with the French avante-garde painter and printmaker Alphonse Mucha before returning to the United States. In 1904 Webster again traveled to Paris to continue his art studies under the academician Jean-Paul Laurens at the Académie Julian.[117] During this time Webster saw an exhibition of the dramatic Parisian views of the etcher Charles Meryon (1821–1868) at the Bibliothèque Nationale, inspiring the young artist to learn more about printmaking. After just seven months at the academy, Webster left to study the work of Meryon and the technique of etching. He was largely self-taught, although the Canadian expatriate Donald Shaw MacLaughlan assisted him in his studies.[118] Webster's early work of Rouen, Paris, Toledo, and Cordova reflects the style of Meryon's architectural views but with the greater informality of Meryon's closest follower, Maxime Lalanne (1827–1886).

Webster exhibited his etchings in the 1905 Salon de la Société des Artistes Français, and two years later was elected an associate member of the Royal Society of Painter-Etchers and Engravers in London. In January 1908 he had his first solo exhibition in the United States at the Albert Roullier Gallery in Chicago, and his first one-person show

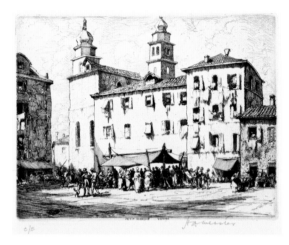

Fig. 108. Herman Armour Webster, *Campo San Sebastiano, Venice (Le Petit Marché, Venise)*, 1927

Etching, 13.3 × 17.5 cm (5 1/4 × 6 7/8 in.), signed in pencil
Private collection

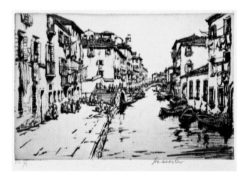

Fig. 109. Herman Armour Webster, *Rio della Sensa, Venice*, 1932

Drypoint, second state, 16 × 25 cm (6 1/4 × 9 7/8 in.),
signed in pencil
Private collection

in New York at Frederick Keppel & Company in 1910. Webster's etching career spanned sixty years, during which he produced countless paintings, watercolors, and drawings, as well as 232 etchings, thirty of which depict Venice. Webster first visited Venice in 1914, although he produced only one etching, *Traghetto, Venice*, as a result of the trip. His career was interrupted by World War I; he served with the French military, earning the Croix de Guerre at Verdun in 1916, and then with the American Expeditionary Forces from 1917 to 1919. His eyes were damaged by German gas attacks during the war, causing him to give up etching in favor of painting and watercolor until he was sufficiently recovered in 1926.

In 1926–27 Webster returned to Venice, executing five small plates at this time. His 1927 *Campo San Sebastiano, Venice (Le Petit Marché, Venise)* (fig. 108;

pl. 83) is typical of these works in both its diminutive size and its emphasis on the everyday activities of Venetians—in this instance the daily market in the Campo San Sebastiano, behind the church of Angelo Raffaello, far from the city's tourist attractions in a poorer neighborhood of the Dorsoduro district. Of the thirty-two prints Webster executed of Venice, only half-a-dozen were of the major sights—the Rialto Bridge, the Salute, or the Piazza San Marco. He was fonder of the working-class districts of Cannaregio and Dorsoduro, and was more interested in the activities of the local Venetians than Roth, Arms, Rosenberg, or any of the other American artists working in the city.

Webster began using the engraving technique of drypoint in 1930, for his Venice prints. During the next five years he produced eighteen prints of the city, utilizing both etching and drypoint. His 1932 canal scene of *Rio della Sensa, Venice* (figs. 109, 110; pls. 84, 85) is included in the exhibition in both its rare second state and in the finished sixth state. In the earlier impression, Webster used the drypoint to create the rich inking of the windows, the boats, for the ripples in the water to the lower right, and for the shadows beneath the bridge. In the later state,

he added shading to the façades along the right side of the canal, and scraped the drypoint burr off the lines on the plate, clarifying the details of the bridge, boats, and water.

The 1933 *Campo Santa Margarita, Venice* (fig. 111; pl. 86) was one of Webster's largest prints. The square, located in Dorsoduro, is among the most spacious in Venice after Piazza San Marco. As mentioned in the discussion of Emanuele Brugnoli, Santa Margarita's relative unimportance as a tourist attraction made it an unusual subject for Venetian view painters and printmakers in the eighteenth century. Only with the advent of a realist aesthetic did the square and its inhabitants receive the attention of local and foreign artists. The broad panoramic view of the working-class campo includes Webster's carefully observed vignettes of everyday life—the fish sellers at the base of the Scuola dei Varotari, the shoppers, and, in the foreground, the tourists lugging their bags across the campo. Webster's figures are larger than those of Brugnoli, and the human element assumes greater importance. At about the same time that Webster created this drypoint, he also rendered the western end of the square in a pen-and-ink sketch (fig. 112; pl. 87).

For the drawing, Webster moved north to the center of the square, looking back toward the Scuola del Varotari, the fish stalls, and the tower of Santa Maria del Carmine. Along the right side of the square, he depicted the same palaces that appear in Roth's 1913 etching (fig. 31; pl. 58) and in Brugnoli's 1920 print (fig. 104; pl. 11).

Donald Shaw MacLaughlan

Herman Webster was good friends with Donald Shaw MacLaughlan (1876–1952), who was widely regarded as one of the finest view etchers of the early twentieth century. He was Canadian, born and raised on a farm in Prince Edward Island but moved with his family to Boston in 1890. To complicate matters of nationality further, most of MacLaughlan's outstanding works of art were created when he lived and worked in France and later Italy. MacLaughlan first studied art in Boston under J. W. O. Hamilton.

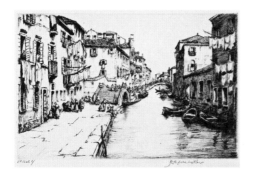

Fig. 110. Herman Armour Webster, *Rio della Sensa, Venice,* 1932
Drypoint, sixth state, 16 × 25 cm (6 1/4 × 9 7/8 in.), signed in pencil
Private collection

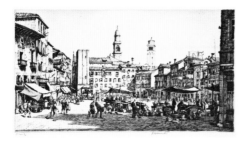

Fig. 111. Herman Armour Webster, *Campo Santa Margarita, Venice,* 1933
Drypoint, third state, 20.8 × 38.3 cm (8 1/4 × 15 1/16 in.), signed in pencil
Private collection

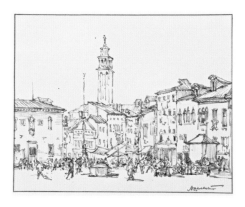

Fig. 112. Herman Armour Webster, *Campo Santa Margarita, Venice,* undated

Pen and ink, 19 x 24.5 cm (7 1/2 x 9 5/8 in.), signed in ink
Private collection

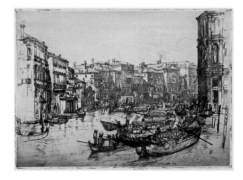

Fig. 113. Donald Shaw MacLaughlan, *The Grand Canal Near the Rialto,* 1908

Etching, 26.9 x 38.1 cm (10 5/8 x 15 in.)
The Trout Gallery, Dickinson College, Carlisle, PA, 2011.1.3

By 1898, however, he had settled in Paris to complete his education at the École des Beaux-Arts.

Within a very short period of time MacLaughlan established himself as a major international etcher. In 1901 two of his etchings were accepted by the prestigious Salon de la Société Nationale des Beaux-Arts, and in 1903 he was elected an associate of the Salon. Etchings created during this period, such as *Ruelle du Pecheur* (Bruette 50), were a major influence to artists of many nationalities. MacLaughlan gave instruction to other expatriate Canadian artists then living in Paris, most notably Clarence Gagnon and Frank and Caroline Armington. From 1905 to 1914 MacLaughlan lived and worked in the small town of Asolo, near Venice, where he etched some of his most important and engaging images.

MacLaughlan's 1908 etching of *The Grand Canal Near the Rialto* (fig. 113; pl. 20) is a result of this early visit to the Veneto. The print, a mirror image, was done from the north side of the Rialto Bridge. The Palazzo dei Camerlenghi is on the right and the Ca' da Mosto, on the opposite bank, is in the center. In the foreground the Grand Canal is dominated by fruit and vegetable barges on their way to and from the market around the bend. The draftsmanship is casual, in some places even a bit undisciplined. The arbitrary scratches in the water, the cursory details of the gondola on the left, and the attempt to convey clouds above contribute little to the success of the etching. An early apologist described this informality as a positive attribute of MacLaughlan in comparison with Whistler:

Where Whistler sought, with the utmost delicacy of line and the subtlest skill in printing, to evoke veritable magic spells by virtually "painting" his pictures on the plate, Mr. MacLaughlan has proceeded to bite his lines with an ever-increasing breadth and boldness—joyousness, even. The result is a range of effects wholly different from Whistler's, yet none the less characteristic of their common subject—effects mainly of dazzling sunlight on gray stone and rippling water, distilling that lyric intoxication which is of the very soul and at-

mosphere of Venice, and which he has captured most completely in such plates as Venetian Noontime *and the* Songs from Venice.[119]

The *Canal of the Little Saint* (fig. 114; pl. 21) is another plate from this early period in MacLaughlan's career. For his depiction of the Palazzo Soranzo (in mirror image) at the intersection of the canals of the Rio del Mondo Novo and the Rio del Palazzo, the artist clearly relied on Whistler's formula in plates such as *The Doorway* (fig. 2). MacLaughlan placed his figures in the doorways and windows of a truncated palace, as seen across an indeterminate expanse of water. In MacLaughlan's plate, however, Whistler's economy of means yields to both an overabundance of surface detail in the palace, and a too-fleeting description of the façades on the right. As his career progressed, MacLaughlan's draftsmanship became more confident, his balance between networks of lines and open space more assured. His 1926 etching *The Salute* (fig. 115; pl. 22) is more accomplished. The buildings are more clearly defined, with a more systematic approach to the shadows. In this asymmetrical composition, MacLaughlan struck a balance between

the well-articulated façades of the votive church and the unworked, blank areas to the left. Although MacLaughlan generally drew directly on the plate without preparatory drawings, here he reversed the image on the plate to produce an accurate image of the site in the printed impressions.

In 1929 James Laver, curator in the department of engraving, illustration, design, and painting at the Victoria and Albert Museum, wrote of MacLaughlan:

> *His debt to Whistler is much less real than the Venice set would lead one at first to suppose. In reality the two artists looked at Venice with very different eyes, and translated their vision into very different results. MacLaughlan's is the less charming, but the more masculine art. He cares less for atmosphere and more for the forms of the buildings. Light for him is something that defines, not something the vibration of which obscured distinct vision. . . . The younger etcher is much more precise. His chosen moment is at high noon with somewhat hard, vertical shadows. His darks are darker, his illuminated surfaces more summary. . . .[120]*

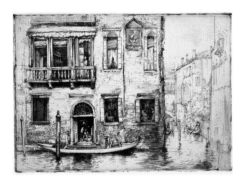

Fig. 114. Donald Shaw MacLaughlan, *The Canal of the Little Saint*, 1909

Etching, 20.3 × 28.6 cm (8 × 11 1/4 in.), signed in pencil
Private collection

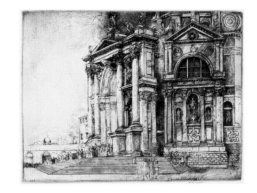

Fig. 115. Donald Shaw MacLaughlan, *The Salute*, 1926

Etching, 25.4 × 34.3 cm (10 × 13 1/2 in.), signed in pencil
Private collection

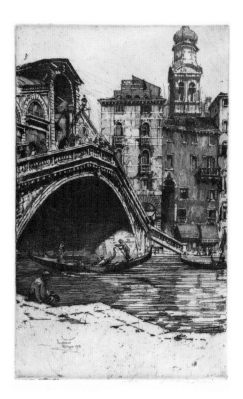

Fig. 66. Jan Charles Vondrous, *Venezia (Rialto Bridge)*, 1914

Etching, 32 × 20 cm (12 5/8 × 7 7/8 in.), signed in pencil
Private collection

Jan Charles Vondrous

Jan Charles Vondrous (1884–1956; also known as John C. Vondrous) was born near Prague in 1884 and immigrated to the United States when he was nine years old.[121] As a young artist, Vondrous enrolled in etching classes under James D. Smillie, who also taught Ernest Roth, at the National Academy of Design in New York. After completing his studies in 1904, Vondrous became interested in translating the modern architecture of New York's buildings and bridges into etchings. Many of these works were published between 1914 and 1917 and were well received in America, although the artist's attention also was drawn to Europe, particularly to the cities of Bruges and Venice. Vondrous traveled to Italy for the first time in 1912 and spent the majority of his time in Venice. He returned to Venice in 1914 and 1924, completing a series of approximately forty etchings of the city that are particularly fine examples of both the artist's topographical work and his interest in everyday life.

In 1915 he was honored with a bronze medal for printmaking at the Panama-Pacific Exposition in San Francisco.[122] Throughout his career he exhibited his prints of Venice extensively in both America and Europe. He was affiliated with the Chicago Society of Etchers, the Brooklyn Society of Etchers, the California Society of Printmakers, and the Association of Czech Graphic Arts Hollar. In 1929 Vondrous returned to his native Czechoslovakia, living and working in Prague.

Vondrous's Venetian work is characterized by a balance of strong draftsmanship and subtle tone. He captured many of the familiar and popular sites of Venice, the Grand Canal, the Ducal Palace, and the Rialto Bridge, but he also depicted anonymous side canals and deserted boats. As a young artist studying in New York with Smillie, Vondrous was certainly aware of Whistler's Venetian prints, but his work also reflects knowledge of contemporary artists and photographers. His 1914 view of *Venezia (Rialto Bridge)* (fig. 66; pl. 80) utilized a sharp angle similar to that in Roth's earlier etching (fig. 18; pl. 49) and Ferdinando Ongania's 1891 photograph (fig. 28). Vondrous moved slightly to his right and a little closer to the canal, as can be detected in a

comparison of the windows on the buildings opposite and the angle of the bridge. His rendering of the famous bridge is more careful than Roth's earlier, sketchier version, and less interested in the brilliant Venetian light than either of the prints by Roth or John Taylor Arms (fig. 65; pl. 2). He recorded Venetians going about their daily affairs on and about the bridge, an element his American contemporaries eschewed. Vondrous's print *Venezia (Canal with a Gondola)* (fig. 116; pl. 81) is of an unidentified palace on an unidentified canal. We see a gondola moored in front of its great water gate, with a figure on the steps beyond the boat. Vondrous captured the reflections and shadows in the water with a few quickly drawn lines, similar to the style of Herman Webster (fig. 110; pl. 85) and Edward Synge (fig. 81; pl. 79). *Ducal Palace* (fig. 117; pl. 82), however, is a far more conventional tourist view. Vondrous presents the monumental core of the city along the Molo, from the old prisons on the right, past the Bridge of Straw and the Ducal Palace, to the Piazzetta, the Campanile, and Sansovino's Renaissance Library of San Marco. In this brilliant early impression, a few lines suggest the calm waters of the *Bacino* around the two gon-

dolas in the center of the image. The artist's detailed architectural rendering is closer to the etching of the same site by Mortimer Menpes (fig. 9) than to the more evocative vignettes of Whistler.

Vondrous's older countryman Tavik František Šimon (T. F. Šimon; 1877–1942) was born in Bohemia under the Austrian Empire. Šimon showed a talent for drawing early in life, and at seventeen he attended the Academy of Art in Prague. After graduating from the academy in 1900, he received two travel scholarships, one of them for his first trip to Italy, where he was captivated by the intensity of urban life. Traveling throughout Europe, Šimon portrayed the markets, streets, alleys, and quiet corners. In Paris in 1903 and in London in 1905 he attended the two major posthumous Whistler retrospectives.

In 1908 Šimon completed a series of prints of Venice that offered a fresh perspective of the city. His *Lagoon in*

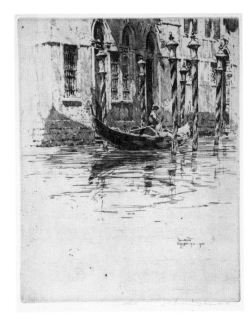

Fig. 116. Jan Charles Vondrous, *Venezia (Canal with a Gondola)*, 1914–15

Etching, 25.4 × 20.3 cm (10 × 8 in.), signed in pencil
Private collection

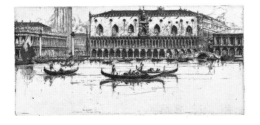

Fig. 117. Jan Charles Vondrous, *Ducal Palace*, 1914–17

Etching, first state, 16.5 × 35.9 cm (6 1/2 × 14 1/8 in.), signed in pencil
Private collection

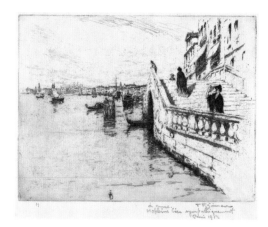

Venice (fig. 118; pl. 76) is of the Ponte della Veneta Marina on the basin of San Marco, in the Castello district close to where Whistler lived during the last months of his Venetian sojourn in 1880. Simon's etching is a variant of Whistler's print of the Riva (fig. 3), a view looking northwest toward Piazza San Marco. Beyond the crest of the bridge is the façade of the Church of the Pietà along the Riva degli Schiavoni and in the distance is the Ducal Palace and the bell tower of San Marco. The details of the distant scene were less important to Simon than the bridge in the foreground and the people around the span. A Venetian woman dressed in black pauses along the balustrade to peer across the lagoon, shading her eyes from the early morning sun. Another woman crossing the bridge passes a man idly looking out over the basin.

Sydney Mackenzie Litten

Sydney Mackenzie Litten (1887–1949) was a student of the influential British printer Frank Short (1857–1945), who served as head of the engraving school at the Royal College of Art from 1891 to 1924.[123] As both artist and teacher, Short advanced the theory of learned omission—the fewer the lines etched on the plate the greater the thought residing in the work—a concept Whistler had championed since the 1850s.[124] Litten represented the later generation of artists in the British etching revival. His interest in tonal effects, the structure of his compositions, and his overall aesthetic sensibility in etching illustrate Short's theories and are typical of Whistler's prints from the late 1870s and 1880s. As his student, Litten had access to Short's personal collection, which contained proofs by Whistler, Francis

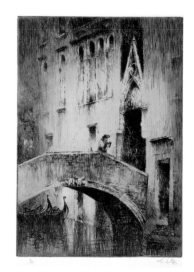

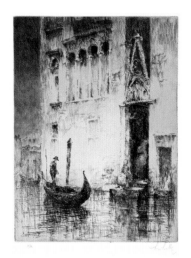

Fig. 120. Sydney Mackenzie Litten, *Ponte del Paradiso Fantasy (Buona Sera)*, undated

Etching, 30 × 22.3 cm (11 3/4 × 8 3/4 in.), signed in pencil
Private collection

Seymour Haden (1818–1910), and Alphonse Legros (1837–1911). By the 1890s Whistler sometimes even proofed some of his later plates in Short's studio.

Sydney Mackenzie Litten rarely dated his plates, but he was in Venice at least as early as 1920 and by 1928 he had published two series of four etchings depicting the city that were clearly influenced by the prints of James McBey. Litten captured many of the city's architectural monuments in the penumbra of dusk or the falling shadows of evening. His subjects range from familiar Grand Canal scenes—Santa Maria della Salute, the Rialto Bridge, the Palazzo Ca' d'Oro—to more obscure bridges and canals in the outlying neighborhoods. His image of the *Ponte del Paradiso* (fig. 119; pl. 13) is a subject that also attracted Roth (fig. 47; pl. 68), Arms (fig. 67; pl. 4), Marin, and MacLaughlan. As

with the Arms version, the print is in reverse of the actual site. Litten employed densely hatched shadows and a thin layer of surface tone to produce the delicate nocturnal image. He sometimes printed on light blue paper, as seen here, to give an added intensity to the mystery of evening light.

Litten was not above an imaginative modification of his subjects, as seen in his image *Ponte del Paradiso Fantasy (Buona Sera)* (fig. 120; pl. 14). The artist repeated the architectural background from *Ponte del Paradiso*, but eliminated the isolated figure and the bridge, replacing them with a gondolier and a woman sitting on steps that descend into the canal. This is pure artistic license, since a bridge has existed on this spot from the end of the seventeenth century, with the last reconstruction in stone dating to 1901.

Litten's *Ponte Tre Archi* (fig. 121; pl. 15) is a view through the arches of a well-known bridge on the upper reaches of the Cannaregio Canal. Under densely shadowed arches, two gondoliers are silhouetted against strong lights from the distance. Litten placed almost all the line work in the upper half of the plate, with only a few informal marks to suggest the water in the foreground.

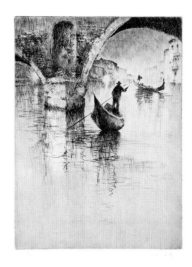

Fig. 121. Sydney Mackenzie Litten, *Ponte Tre Archi*, undated

Etching, 30.2 × 22.3 cm (11 7/8 × 8 3/4 in.), signed in pencil
Private collection

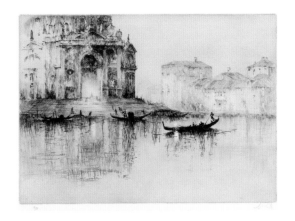

Fig. 122. Sydney Mackenzie Litton, *Steps of the Salute*, undated

Etching, 24.9 × 35 cm (9 3/4 × 13 3/4 in.), signed in pencil
Private collection

The etcher brought the subtle use of selective wiping to its height in *Steps of the Salute* (fig. 122; pl. 16). In this otherwise conventional view of the church, he applied a veil of ink over the entire plate, wiping a bit of ink only from the top of the steps and the light of the gondola and its reflection to produce the nighttime illuminations. Litten's Venetian etchings resonate with the influence of both McBey and Whistler. The line work is economical yet effective, and his selective wiping of the inked plates creates tonal effects that translate into radiant reflections of buildings in the waters of dark canals.

James McBey

The Scottish artist James McBey (1883–1959) was a contemporary of Litten, Roth, and Arms. McBey was a great admirer of Whistler's work, and first came into contact with his etchings in galleries in Scotland. Margaret MacDonald characterizes McBey's style as not unlike that of Whistler,

a "similar combination of loose vertical lines and ink tones to convey mysterious palaces half lost in darkness."[125] McBey first went to Venice in September 1924 and, after an extended stay the following year, produced thirty-two plates of the city. Unlike those in the Whistler circle, Arms, and many other Venetian view etchers, the Scottish artist believed that the printed view should be seen with the correct orientation of the subject, so that the drawing on the plate should always be in reverse. Subsequently, McBey sometimes turned his back on the scene and drew his representation while looking into a rearview automobile mirror that he affixed to his easel.[126]

In his lyrical etching *Barcarolle* (fig. 123), McBey conveyed the sense of an almost deserted

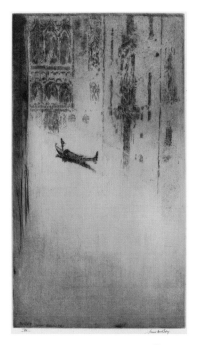

Fig. 123. James McBey, *Barcarolle*, 1925

Etching, 37.8 × 21.3 cm (14 7/8 × 8 3/8 in.)
Rosenwald Collection, National Gallery of Art, Washington, DC

canal at dusk, as the last daylight dissipates. An isolated gondolier, in full song, sings the *barcarole* of the title. McBey contrasted the darker line work of the architecture with the broad swath of water that dominates the lower half of the image. He toned the broad, un-etched areas of the water subtly, to create delicate effects of light and shadow, and employed his etched lines sparingly in the architecture, creating networks of vertical lines to represent deep shadows. The expanse of the empty canal, in stark contrast to the surrounding buildings, is responsible for the elusive visual tension of the work. *Barcarolle* is a calmly mysterious and romantic image, akin to the effects that Whistler realized in his heavily veiled, darker Venetian scenes, such as *Nocturne: Palaces* (K 202) and *Nocturne* (K 184).

Echoes of Whistler's vision of Venice are found in many of McBey's prints. *The Doorway, Venice* (fig. 124; pl. 17) is compositionally related to Whistler's images of isolated palace water gates along anonymous canals, but the heavily worked plate is closer to Whistler's Amsterdam etchings. In many ways, McBey's print is closer to the Venetian images of Otto Bacher (fig. 5) and Ernest Roth (fig. 22; pl. 48). The 1928 *Molo* (fig. 125; pl. 18) is

closer to Whistler in style, a restrained variation of the American's long views along the Riva that culminate in the church of the Salute. McBey was inspired here by two Whistler works, combining the long view of the Riva (fig. 3) with the vertical format and evocative design of *Upright Venice* (fig. 46). His image of the *Palazzo dei Cammerlenghi* (fig. 126; pl. 19), however, is a more original design, resisting any easy comparison with Whistler's formats.

McBey's view, from the Rialto Bridge looking north on the Grand Canal, is an asymmetrical composition that juxtaposes the great mass of the old Republic's financial center on the left with the line of gondolas and the façades of the palaces along the opposite bank. The artist left a Whistler-esque film of ink across the lower part of the plate, darkening the water of the Grand Canal in the shadow of the bridge.

Martin Hardie, keeper of prints and drawings at the Victoria and Albert Museum from 1921 to

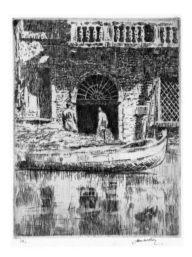

Fig. 124. James McBey, *The Doorway, Venice*, 1930

Etching, 20.9 × 16.3 cm (8 1/4 × 6 7/16 in.), signed in pencil
Private collection

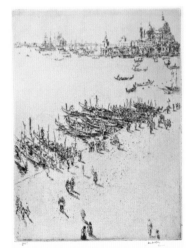

Fig. 125. James McBey, *Molo*, 1928

Etching, 31.6 × 23.9 cm (12 × 9 3/8 in.), signed in pencil
Private collection

1935, spent time with McBey in Venice in 1925 while the artist was preparing his series of Venice etchings. He wrote of McBey's indefatigable Venetian work ethic in 1938:

> [Venice] is at its best on the rare days that are grey, or in the soft opalescent atmosphere of the dawn. That was the atmosphere which McBey sought. Every morning, during a month which I spent in his company in the autumn of 1925, he was out at five o'clock to see whether the sun was rising in mist or cloud, or in a sky of blue. Never have I known anyone with such untiring energy and passion for work. He began at dawn; he spent hours at the end of the Rialto or at a table under the shade of the Chioggia Café in the Piazzetta, making pen-and-ink notes of figures; or in a gondola on the canals or the Giudecca, making studies of shipping, of buildings and their reflections; at night he would be out again in his gondola, working on a copper plate by the light of three tallow candles in an old tin.[127]

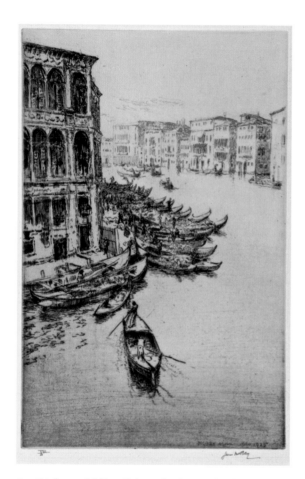

Fig. 126. James McBey, *Palazzo dei Cammerlenghi*, 1930
Etching, 32.7 x 21.2 cm (12 7/8 x 8 3/8 in.), signed in pencil
Private collection

Epilogue

The market for etchings of picturesque European views declined after the 1929 stock market crash. American artists and collectors turned to the familiar urban scenery of America, of New York and Chicago, or the regional views of the rural countryside. The avant-garde imagery of a new generation of artists reflected a different cultural aesthetic in the 1930s, dominated by increasingly nonrepresentational imagery. An era that began with Meryon and Lalanne and the etching revival of the nineteenth century, and that reached its apogee with the works of Whistler, Tissot, Cameron, Arms, Roth, and Bone, came to an end with World War II. Mauroner abandoned printmaking in 1938 and died a decade later. Rosenberg only made a few prints after the 1930s. Arms died in 1953. Ernest Roth continued to make etchings of European sites for a decade after the war, but also spent considerable time printing for other artists, such as John Sloan and Reginald Marsh.

Affection for the matchless beauty of Venice, however, never really ebbed. Richard Estes's photo-realist prints of Venice remain as desirable among collectors today as the earlier vogue for Arms and Roth prints in the 1920s and early 1930s. The ongoing allure of Venice may be summed up in the words of the eminent economist and philosopher John Kenneth Galbraith, at whose memorial service his youngest son, Peter Galbraith, saluted his father for all the things he had learned from him: the power of clear and persuasive writing; the importance of a career in public service; and the appreciation of beauty, from the hills of Vermont to the canals of Venice. "My father was always an optimist," he said. "When someone asked what he hoped for when he died, he said 'I'm hoping for heaven, but I'll settle for Venice.'"[128]

NOTES

1 Helen Fagg, "American Prints," *Fine Prints of the Year: An Annual Review of Contemporary Etching and Engraving*, ed. Malcolm C. Salaman, vol. 4 (London: Halton and Truscott Smith, Ltd., 1926), 16.

2 The etching technique reverses the design on the plate during printing, a process taken into account by an artist if he or she is concerned with accuracy. The term "mirror image" is used throughout the essays to indicate when the printed cityscape is in reverse of the actual location.

3 Whistler's time in Venice has been extensively researched and written about in Alastair Grieve, *Whistler's Venice* (New Haven: Yale University Press, 2000) and Margaret F. MacDonald, *Palaces in the Night: Whistler in Venice* (London: Lund Humphries, 2001). See also Margarita M. Lovell, *Venice: The American View, 1860–1920* (San Francisco: The Fine Arts Museum, 1984), 75–76. Sections of chapters 1 and 5 are adapted from Eric Denker, *Whistler and His Circle in Venice* (London: Merrill Publishers, 2003).

4 John Ruskin, "Letter 79: Life Guards of New Life," *Fors Clavigera 7* (July 1877), as collected in E. T. Cook and Alexander Wedderburn, eds., *The Works of John Ruskin*, vol. 29 (London: George Allen, 1903–12), 160.

5 Letters reproduced in MacDonald, *Palaces in the Night*, 141–45.

6 John Julius Norwich, "Whistler's Etchings of Venice," in *James McNeill Whistler: The Venetian Etchings*, ed. Margaret F. MacDonald (London: Art Partnerships International Ltd., 2001), 16.

7 Beginning in the late 1860s, Whistler began to mark his paintings and prints with a new signature in which his initials, JMW, were combined into what at first resembled a dragonfly but soon evolved into a butterfly. Whistler also adopted this motif for his correspondence, and later often referred to himself as "the butterfly." The design of the butterfly evolved as time passed, and eventually became a versatile symbol, representing the artist as well as serving as the artist's signature.

8 Katherine Lochnan, *The Etchings of James McNeill Whistler* (New Haven and London: Yale University Press, 1984), 212. Lochnan's book is the best examination of Whistler's career as a printmaker, and the starting point for any

scholar commencing a Whistler print project.

9 Otto Bacher, *With Whistler in Venice*, 2nd ed. (New York: The Century Company, 1908), 144.

10 Josephine W. Duveneck, *Frank Duveneck: Painter—Teacher* (San Francisco: John Howell Books, 1970), 74.

11 Bacher, *With Whistler in Venice*, 13.

12 Elizabeth Robins Pennell and Joseph Pennell, *The Life of James McNeill Whistler* (London: William Heinemann, 1908), 273.

13 Mortimer Menpes, *Whistler as I Knew Him* (London: A. and C. Black, 1904), 89.

14 Ibid., chapter 2.

15 Rosemary T. Smith, *Two Views of Venice* (Philadelphia: Arthur Ross Foundation, 1999), catalogue of an exhibition at the Arthur Ross gallery, University of Pennsylvania, Philadelphia, PA. I am indebted to Smith's seminal work on Menpes from both her dissertation research and her essay in the exhibition catalogue.

16 James Abbott McNeill Whistler Letters, University of Glasgow.

17 Pennell and Pennell, *Life of James McNeill Whistler*, 261.

18 Unless otherwise noted, biographical information on Ernest David Roth is from the artist's handwritten notes in the Roth Collection of the Mattatuck Museum Arts and History Center in Waterbury, Connecticut.

19 Annalisa Porzio, *L'Inventorio della Regina Margherita di Savoia: Dipinti tra Ottocento e Novecento a Palazzo Reale di Napoli* (Naples: Arte Tipografica Editrice, 2004), 194.

20 Frank Jewett Mather, Jr., "The Etchings of Ernest D. Roth," *The Print-Collector's Quarterly* 1, no. 4 (October 1911): 443.

21 Eva Madden, "A Rising Young Etcher," *The Fine Arts Journal* (September 1914): 433–35.

22 Elizabeth Whitmore, *Ernest D. Roth, N. A.* (New York: T. Spencer Hudson, 1929), unpaginated. Whitmore's essential 1929 book, the first in the Crafton series on American etchers, was written with Roth's assistance, but the checklist is incomplete. Many early etchings, produced in small editions, are omitted, and the list of works only includes works done by early 1929 when Roth was fifty years old, approximately midway through his career.

23 For *A Quiet Canal*, see Appendix A, no. 3.

24 John Taylor Arms, "Ernest D. Roth, Etcher," *The Print Collector's Quarterly* 25, no. 1 (February 1938): 41, remains the finest and most extensive appreciation of Roth's work to date.

25 Appendix A, nos. 5, 13, and 2, respectively.

26 Whitmore, *Ernest D. Roth,* unpaginated.

27 Mather, "The Etchings of Ernest D. Roth," 448.

28 Ibid., 444.

29 Peter Hastings Falk, ed., *The Annual Exhibition Record of the Art Institute of Chicago, 1888–1950* (Madison, CT: Soundview Press, 1990), 769.

30 Whitmore, *Ernest D. Roth,* unpaginated.

31 Frank Weitenkampf, "Ernest D. Roth, Etcher: A Note on Evolution," *Arts and Decoration* (May 1916): 336.

32 Arms, "Ernest D. Roth, Etcher," 43–44.

33 Archives, Mattatuck Museum, Waterbury, CT.

34 The author is aware of only three occurrences of multiple states in Roth's oeuvre, and only one appears to have multiple-edition states: *The Stones of Venice* of 1926 (pls. 71, 72).

35 Roth employed the same technique in *The Stones of Venice* (pls. 71, 72), resulting in a similar contrast between the two impressions included, but additional changes were made to the plate as well.

36 Carl Zigrosser, "Introduction," *Catalogue of An Exhibition of Etchings by Ernest D. Roth* (New York: Frederick Keppel & Company, 1914).

37 *Velin* in French can mean "vellum," "the skin," or "wove paper." In the context of paper, it commonly refers to wove paper. *Petit velin* may refer to vellum from a very young or unborn animal, which was used to create a very thin, delicate sheet. *Verger* is laid paper; *vergé ancien* is antique laid paper, in which the pulp is denser along the chain lines.

38 Mather, "The Etchings of Ernest D. Roth," 443–56.

39 Weitenkampf, "Ernest D. Roth, Etcher," 336–37.

40 Herbert C. Pell, Jr., *Ernest D. Roth* (New York: Frederick Keppel & Company, 1916), 5, 11.

41 Joby Patterson, *Bertha E. Jaques and the Chicago Society*

of Etchers (Paterson, NJ: Fairleigh Dickinson University Press, 2002), 126.

42 *Official Catalogue of the Department of Fine Arts, Panama-Pacific International Exposition* (San Francisco: The Wahlgreen Company, 1915), 220.

43 Frank Jewett Mather, Jr., *Catalogue of An Exhibition of New Etchings of Spain by Ernest D. Roth* (New York: Frederick Keppel & Company, 1921).

44 Arms, "Ernest D. Roth, Etcher," 45.

45 Appendix A, no. 38.

46 Arms, "Ernest D. Roth, Etcher," 45.

47 Ibid., 46–47.

48 Whitmore, *Ernest D. Roth,* unpaginated.

49 B. K., *Exhibition of Etchings by Ernest D. Roth, A.N.A. of New York* (Washington, DC: National Museum, Smithsonian Institution, Division of Graphic Arts, 1926), unpaginated.

50 Appendix A, no. 33.

51 Author unidentified, "introduction," to *Contemporary American Etchers* (1932), www.oldandsold.com/articles03/etching10.shtml.

52 Thomas W. Leavitt, *André Smith* (Ithaca, NY: Andrew Dickson White Museum of Art, Cornell University, 1968). Introductory essay contains biographical material supplied by Attilio J. Banca, friend and assistant of the artist. Smith's father had an export concern and was in Hong Kong for business. The family moved to Germany in 1887, but returned to the United States in 1890, after Smith's father died.

53 Elton W. Hall, "The Etchings of Ernest Roth and André Smith," in *Aspects of American Printmaking, 1800–1950,* ed. James F. O'Gorman (Syracuse: Syracuse University Press, 1988), 181.

54 Reproduced in J. Nilsen Laurvik, *The Etchings of J. André Smith* (New York: Arthur H. Hahlo & Co., 1914), unpaginated. Text reprinted from *The Print-Collector's Quarterly* 4, no. 2 (April 1914): 167–82. For Christmas 1914, Smith gave Roth a dedicated copy of the slender volume, which is now in the Roth Collection at the Mattatuck Museum, Waterbury, CT. For *Venice from the Redentore,* see also Appendix A, no. 30; for the *Santa Maria della Salute,* see Appendix A, no. 33.

55 *Official Catalogue of the Department of Fine Arts, Panama-Pacific International Exposition* (San Francisco: The Wahlgreen Company, 1915), 222.

56 Jennifer Saville, *John Taylor Arms: Plates of Perfect Beauty* (Honolulu, HI: Honolulu Museum of Arts, 1995), 8–9. I am indebted to the author both for her excellent catalogue and her knowledge of Arms's prints, shared during lengthy cordial exchanges over a period of many years.

57 Ben L. Bassham, *John Taylor Arms: American Etcher* (Madison, WI: Elvehjem Art Center, 1975), 3.

58 Robert Getscher, *Felix Bracquemond and the Etching Process: An Exhibition of Prints and Drawings from the John Taylor Arms Collection in the College of Wooster Art Center Museum* (University Heights, OH: John Carroll University Fine Arts Gallery, 1974), 5. This collection was purchased by Arms's friends and neighbors Ward and Miriam Canaday and given to the College of Wooster in 1968. The collection includes Arms's original inventory, specifying the date and means of acquisition for each print.

59 Judith Goldman, *American Prints: Process and Proofs* (New York: Harper and Row, 1971), 37–8.

60 William Dolan Fletcher, *John Taylor Arms: A Man for All Time* (New Haven, CT: The Sign of the Arrow, 1982), the standard catalogue raisonné of Arms. Each Arms print is hereafter designated by the Fletcher number.

61 Saville, *John Taylor Arms*, 62.

62 The several sketch plates that Arms produced as part of his one-hour and two-hour etching demonstrations are excluded from this count.

63 Fletcher, *John Taylor Arms*, 304.

64 Just a few yards beyond the boatyard lived Ernest Roth's friend and colleague Fabio Mauroner. Arms met Mauroner in 1926, and they later became close friends.

65 Fletcher, *John Taylor Arms*, 304.

66 John Taylor Arms, Diaries, 1932–36, Archives of American Art, Smithsonian Institution, Washington, DC.

67 Keith Shaw Williams, Papers, Archives of American Art, Smithsonian Institution, Washington, DC.

68 John Taylor Arms, handwritten inventory, Archives, College of Wooster, Wooster, OH.

69 Dorothy Noyes Arms and John Taylor Arms, *Hill Towns*

and Cities of Northern Italy (New York: The MacMillan Company, 1932).

70 Throughout his career, Arms produced architectural prints that, with few exceptions, show the mirror image of the site. Of the set of ten Venetian prints, only three represent the actual topography of the subjects.

71 Dorothy Noyes Arms, "John Taylor Arms: Modern Mediaevalist," in The Print Collector's Quarterly 21, no. 2 (April 1934): 137.

72 Ferdinando Ongania, Calli e Canali in Venezia (Venice: Ongania, 1891–92), 81; also published in English in 1893 as Streets and Canals in Venezia, with an introduction by Pompeo Molmenti. Ongania's publication served as a vocabulary of Venetian views for Roth and Arms and their generation. The photographic view of the Rialto Bridge from this angle ultimately derives from an unusually large painting of the scene by Michele Marieschi, currently in the State Hermitage Museum, St. Petersburg, Russia.

73 The Arms etchings related to the photographs in ibid., include San Trovaso (F. 177), The Enchanted Doorway, Venezia (F. 227), Shadows of Venice (F. 229), Porta del Paradiso (F. 230), and Venetian Filigree (F. 235).

74 Arms and Arms, Hill Towns and Cities of Northern Italy, 184, F. 230.

75 Whitmore, Ernest D. Roth, pl. 10.

76 Arms, "John Taylor Arms: Modern Mediaevalist," 139.

77 Saville, John Taylor Arms, 64.

78 Harold J. Baily, "Fine Prints of the Year 1932," book review, Prints 3, no. 2 (1933): 4.

79 Elizabeth Luthor Carey, "The Work of John Taylor Arms," Prints 1, no. 5 (September 1931): 8.

80 Arms, "John Taylor Arms: Modern Mediaevalist," 137–39.

81 John Taylor Arms, Diaries, August 26, 1930, collection of Charles Rosenblatt, Cleveland, OH.

82 Saville, John Taylor Arms, 63.

83 John Taylor Arms, Diaries, January–March 1935, Archives of American Art, Smithsonian Institution, Washington, DC (microfilm).

84 In the 1920s Cole Porter rented the Ca' Rezzonico and hosted extravagant parties, which were well documented

in the American press. The city of Venice acquired the building for the Museum of Eighteenth Century Venetian Life in 1935, the year Arms created the etching.

85 "Uno dei piu illustri colleghi della Societa di Chicago venne poi a trovarmi a Venezia, John Taylor Arms; e la commune passion per la bella stampa ci fece diventare buoni amici. (One of the most illustrious members of the Chicago Society of Etchers came to find me in Venice, John Taylor Arms, and our shared passion for beautiful prints led us to become good friends.)" Fabio Mauroner, "Acquaforte," unpublished, undated manuscript, Civici Musei e Gallerie de Storia e Arte (Archives), Comune di Udine, 24.

86 Arms, Diaries, November 4, 1929, collection of Charles Rosenblatt, Cleveland, OH.

87 Galleria d'Arte Moderna, Udine.

88 Arms and Arms, *Hill Towns and Cities of Northern Italy*, 201.

89 Gail McMillan, *Catalogue of the Louis Rosenberg Collection* (Eugene: University of Oregon, 1978), 7. All of the biographical details are derived from McMillan's introduction to the catalogue, prepared with the assistance of Rosenberg.

90 C. L. Morgen, "The Etchings and Drypoints of Robert Fulton Logan," *The Print Connoisseur* (January 1929): 11–27.

91 Malcolm C. Salaman, *L. C. Rosenberg, A.R.E.*, Modern Masters of Etching 22 (London: The Studio Limited, 1929), 4.

92 McMillan, *Catalogue of the Louis Rosenberg Collection*, 39 and Appendix D, no. 1.

93 McMillan, *Catalogue of the Louis Rosenberg Collection*, 25.

94 Salaman, *L. C. Rosenberg*, 8.

95 Ibid.

96 John Taylor Arms, "The Drypoints of Louis Conrad Rosenberg, A.N.A.," *Prints* 5 (May 1935): 7.

97 McMillan, *Catalogue of the Louis Rosenberg Collection*, 15.

98 Arms, "The Drypoints of Louis Conrad Rosenberg," 2.

99 Appendix D, no. 7.

100 Campbell Dodgson, *Fine Prints of the Year: An Annual Review of Contemporary Etching, Engraving & Lithogra-*

phy (London: Halton & Company, Ltd., 1937), 21–2.

101 Samuel Chamberlain, *Etched in Sunlight: Fifty Years in the Graphic Arts* (Boston: Boston Public Library, 1968), 177–78.

102 Mauroner, "Acquaforte"; and Isabella Reale, *Fabio Mauroner, Incisore* (Udine: Grafiche Editoriali Artistiche Pordenonesi, 1984). My special thanks to Dr. Reale for making this material, some of it still unpublished, available to me.

103 "Sobrio, timido e modesto malgrado i successi che poi rimeritarono la sua opera appassionata . . ."; Reale, *Fabio Mauroner, Incisore*, 7.

104 Ibid., 7–8.

105 Porzio, *L'Inventario della Regina Margherita di Savoia*, 194, 214.

106 Appendix A, nos. 2, 16, 17. An impression of the otherwise unrecorded horizontal image is in the Rosenwald Collection of the National Gallery of Art, titled *A Cloisters, Venice*, 1943.3.7498.

107 *La Sagra (Campo San Giovanni della Bragola)* (Reale 78), *La Processione (The Votive Bridge of Santa Maria della Salute)* (Reale 79, pl. 34), and *The Regatta (San Toma)* (Reale 80).

108 *The Piazzetta* (Reale 87), and *The Grand Canal (Canalazzo)* (Reale 84).

109 *Catalogo: XXIV Biennale di Venezia* (Venice: Edizioni Serenissima, 1948), 40–41.

110 Mauroner, unpaginated manuscript. The show was supported by Harriet Bishop Lanier (1866–1931), who was a major patron of the arts in New York and the president of the Society of Friends of Music, an organization she founded in 1913. Mauroner dedicated a set of six of the Venetian etchings to her on the occasion of the Ehrich exhibition, as recorded in an etched frontispiece (Reale 128).

111 Archivio, Civici Musei e Gallerie de Storia e Arte, Comune di Udine.

112 *Exhibition of Prints by Fabio Mauroner* (Wellesley, MA: Wellesley College Art Museum, 1938), unpaginated brochure.

113 Archivio, Civici Musei e Gallerie de Storia e Arte, Comune di Udine.

114 For a more complete discussion of Marin's Venice prints, see Denker, *Whistler and His Circle*.

115 Carl Zigrosser, *The Complete Etchings of John Marin: A Catalogue Raisonné* (Philadelphia: Philadelphia Museum of Art, 1969), 11.

116 Webster's biographical details are found in his curriculum vitae, preserved in the Archives of American Art in Washington, DC, and from Janet A. Flint, *Herman A. Webster: Drawings, Watercolors, and Prints* (Washington, DC: Smithsonian Institution, 1974), unpaginated exhibition brochure.

117 Martin Hardie, *Herman A. Webster* (New York: Frederick Keppel & Company, 1910), 8.

118 Flint, *Herman A. Webster*, introduction. Flint had the opportunity to speak to Webster's widow while writing the brochure.

119 Cleveland Palmer, "The Recent Etchings of Donald Shaw MacLaughlan," *The Print Collector's Quarterly* 6, no. 1 (February 1916): 114.

120 James Laver, "The Etchings of Donald Shaw MacLaughlan," *The Print Collector's Quarterly* 18, no. 4 (December 1926): 332.

121 Jiřina Podzemska, *J. C. Vondrouš: Soupis Grafického Díla* (Prague: Hollar, 1963). This brief volume is the most important source for Vondrouš biographical information, and contains the checklist of his complete graphic work. My appreciation to Milos Cvach for his translation of the text.

122 *Official Catalogue of the Department of Fine Arts, Panama-Pacific International Exposition*, 224, 198–229. The judges reviewed the work of many of the view etchers of Europe in the exhibition, and awarded gold medals to MacLaughlan, Webster, Cadwallader Washburn, and André Smith; a silver medal to Roth; and bronze medals to Clifford Addams, Bertha Jaques, and Vondrous.

123 Kenneth M. Guichard, *British Etchers: 1850–1940* (London: Robin Garton, 1977), 47.

124 Emma Chambers, *An Indolent and Blundering Art? The Etching Revival and the Redefinition of Etching in England 1838–1892* (Brookfield, VT: Ashgate Publishing Company, 1999), 4.

125 MacDonald, *Palaces in the Night*, 137.

126 Martin Hardie, "The Etched Work of James McBey,"
 The Print Collector's Quarterly 25 (1938): 427.

127 Ibid., 425.

128 See www.c-spanvideo.org/videoLibrary/clip.
 php?appid=465450824, C-Span, May 31, 2006,
 caption 1:33:40.

Plates

Unless otherwise noted, all works are from a private collection promised to Dickinson College, Carlisle, Pennsylvania. Dimensions are given to the plate mark of the print, with the height preceding the width.

"Venezia," from Karl Baedeker, *Italy: From the Alps to Naples* (Leipzig: Karl Baedeker, 1909), with author additions.
The numbers on the map correspond to plate numbers in this catalogue.

John Taylor Arms (American, 1887–1953)

1

John Taylor Arms, *The Boatyard, San Trovaso*, 1926
Etching, 24.2 x 37.4 cm (9 1/2 x 14 3/4 in.), signed in pencil

2

John Taylor Arms, *Il Ponte di Rialto, Venezia (Shadows of Venice)*, 1930
Etching, 26.2 x 30.8 cm (10 1/4 x 12 1/8 in.), signed in pencil

3

John Taylor Arms, *La Porta della Carta, Venezia,*
1930

Etching, 31.5 x 16.7 cm (12 3/8 x 6 9/16 in.), signed in Arms's
estate stamp

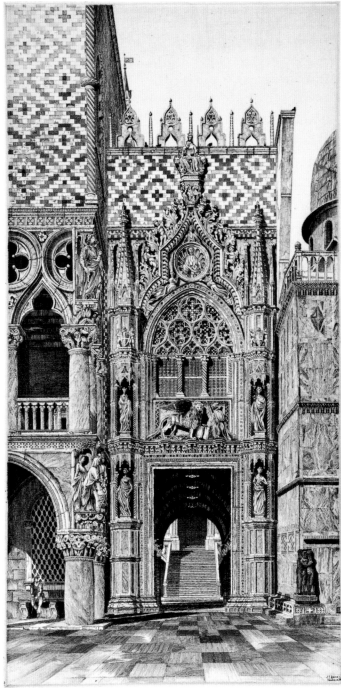

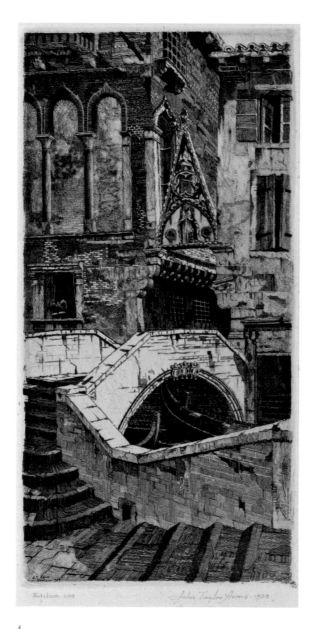

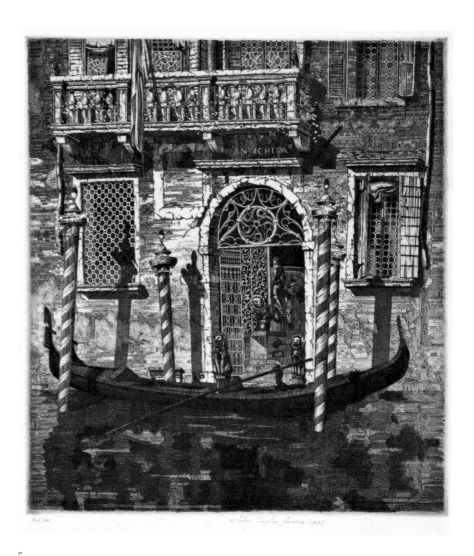

5

John Taylor Arms, *Palazzo dell'Angelo*, 1931
Etching, 18.5 x 17.1 cm (7 1/4 x 6 3/4 in.), signed in pencil

4

John Taylor Arms, *Porta del Paradiso, Venezia*, 1930
Etching, 19.1 x 9.8 cm (7 1/2 x 3 7/8 in.), signed in pencil

6

John Taylor Arms, *Venetian Filigree
(Ca' d'Oro, Venezia)*, 1931

Etching, 27.9 x 26.7 cm (11 x 10 1/2 in.)

Inscribed: To my friend Samuel Chamberlain,
with warmest good wishes, John Taylor Arms

Collection of Charles Rosenblatt

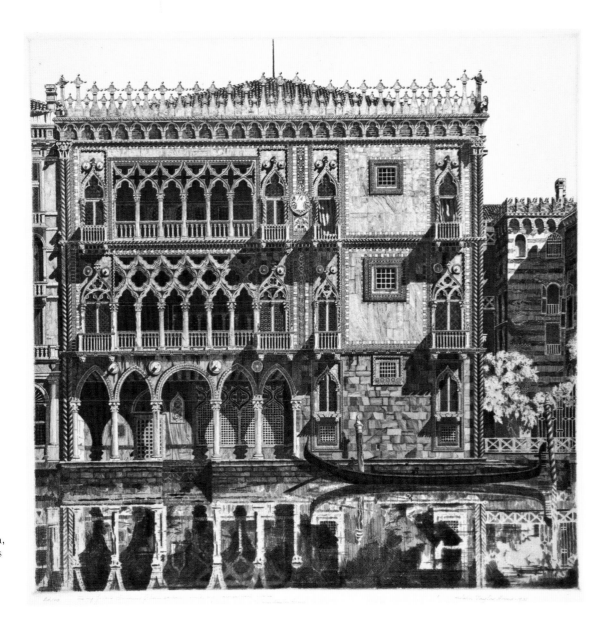

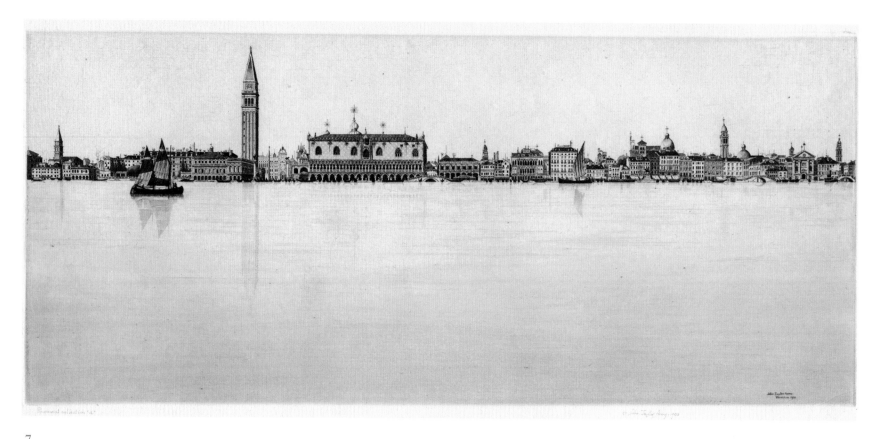

7

John Taylor Arms, *La Bella Venezia*, 1931
Etching, 18.5 x 41.9 cm (7 1/4 x 12 1/2 in.)
Collection of Charles Rosenblatt

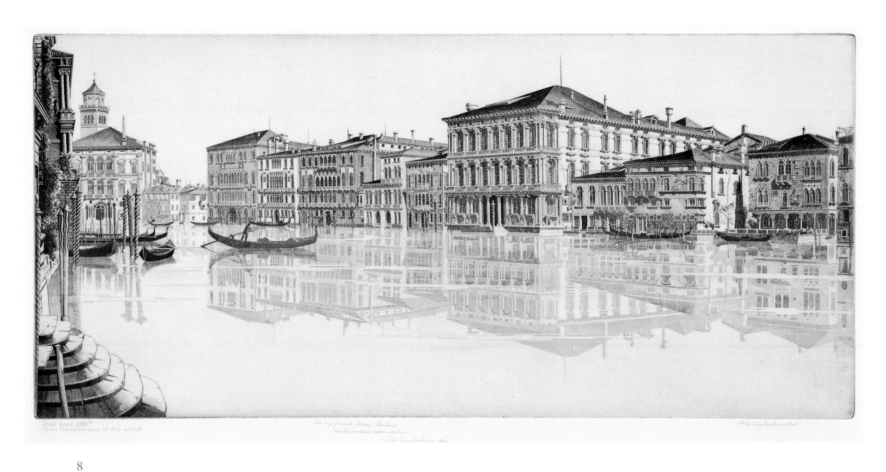

8

John Taylor Arms, *Venetian Mirror*, 1935

Etching, artist's proof, 16.5 x 35.9 cm (6 1/2 x 14 1/8 in.), signed in pencil

Inscribed: To my friend Albert Barker with sincere admiration, John Taylor Arms, 1936

Emanuele Brugnoli (Italian, 1859–1944)

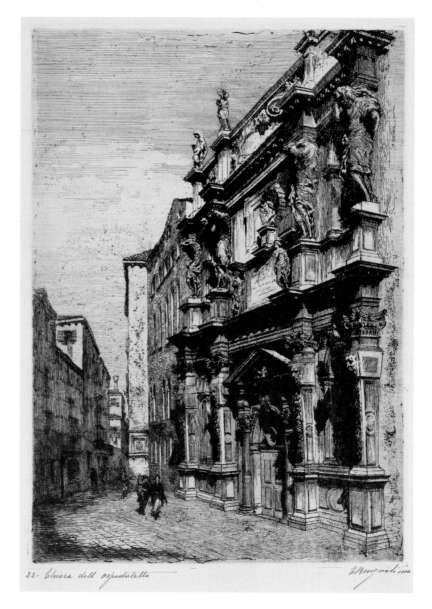

9

Emanuele Brugnoli, *Church of the Ospedaletto*,
undated
Etching, 44.5 x 31.4 cm (17 1/2 x 12 3/8 in.), signed in pencil
The Trout Gallery, Dickinson College, Carlisle, PA, 2011.1.1

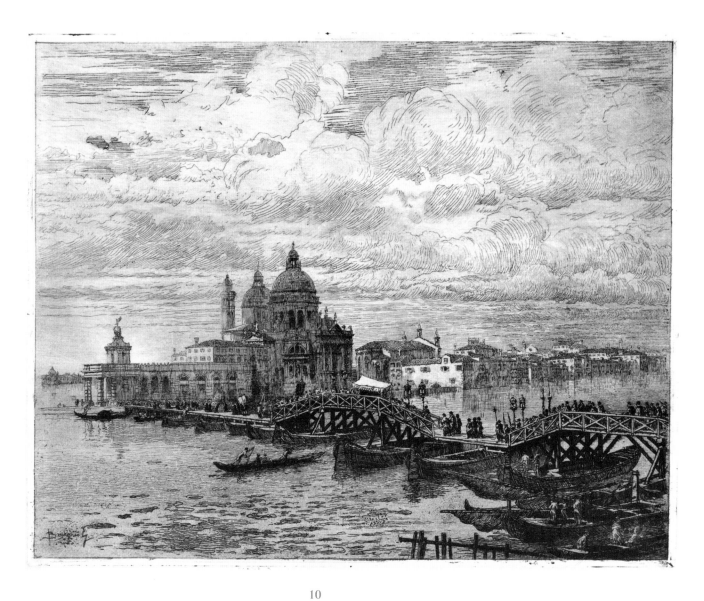

10

Emanuele Brugnoli, *Votive Bridge, the Feast of the Salute*, undated

Etching, 30.5 x 40.3 cm (12 x 15 7/8 in.), signed in the plate

The Trout Gallery, Dickinson College, Carlisle, PA, 2011.1.2

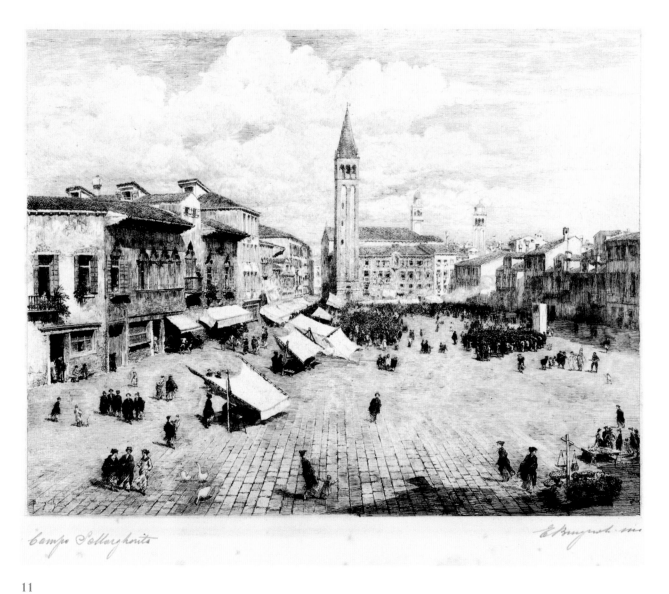

11

Emanuele Brugnoli, *Campo Santa Margarita*, 1920
Etching, 30.5 x 40.3 cm (12 x 15 7/8 in.), signed in the plate

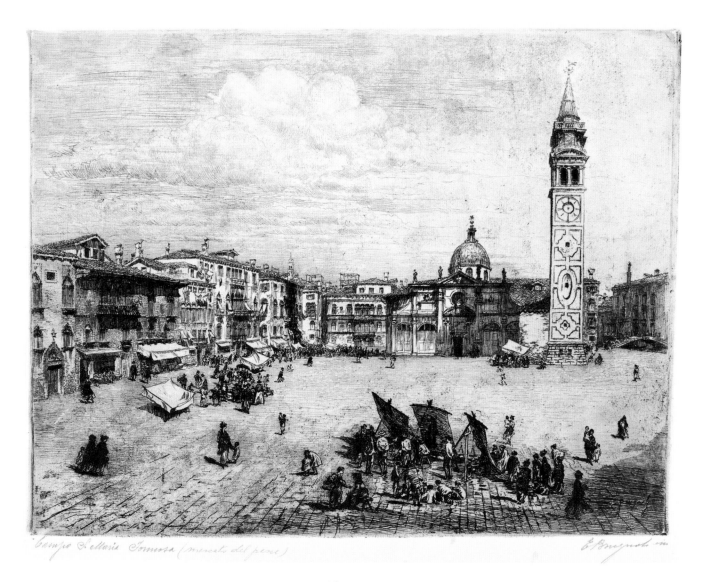

campo S. Maria Formosa (mercato del pesce) E. Brugnoli inc

12

Emanuele Brugnoli, *Campo Santa Maria Formosa*, 1920
Etching, 32.4 x 43.2 cm (12 3/4 x 17 in.), signed in pencil

Sydney Mackenzie Litten (British, 1887–1949)

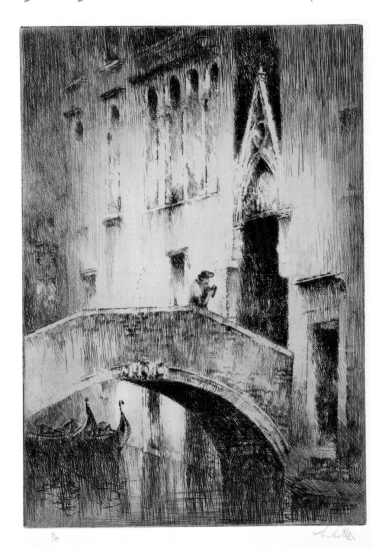

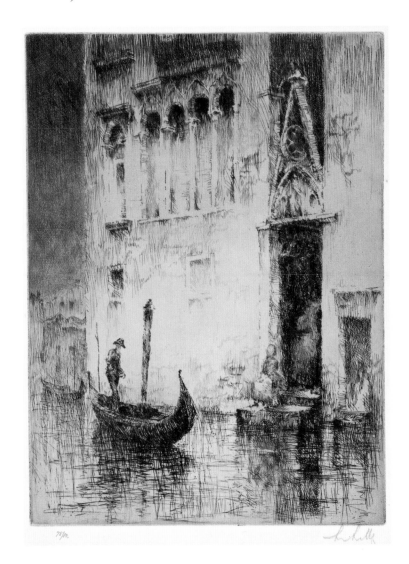

13

Sydney Mackenzie Litten, *Ponte del Paradiso*, undated

Etching, 35.2 x 24.8 cm (13 7/8 x 9 3/4 in.), signed in pencil

14

Sydney Mackenzie Litten, *Ponte del Paradiso Fantasy (Buona Sera)*, undated

Etching, 30 x 22.3 cm (11 3/4 x 8 3/4 in.), signed in pencil

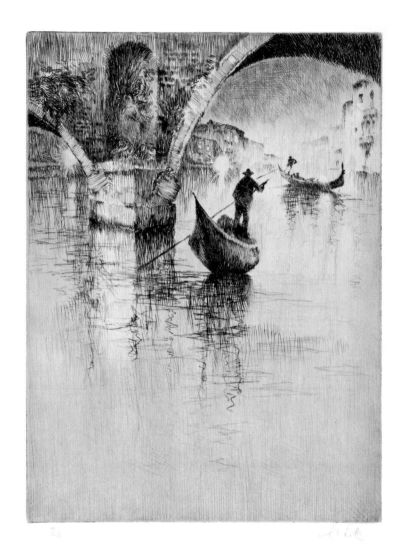

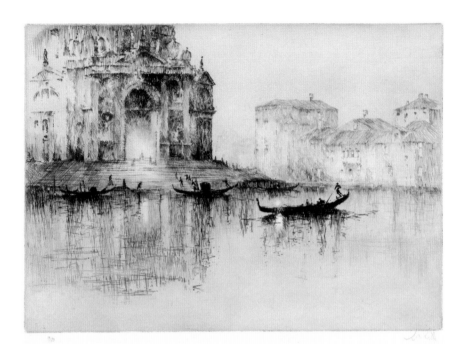

16

Sydney Mackenzie Litten, *Steps of the Salute*, undated

Etching, 24.9 x 35 cm (9 3/4 x 13 3/4 in.), signed in pencil

15

Sydney Mackenzie Litten, *Ponte Tre Archi*, undated

Etching, 30.2 x 22.3 cm (11 7/8 x 8 3/4 in.), signed in pencil

James McBey (Scottish, 1883–1959)

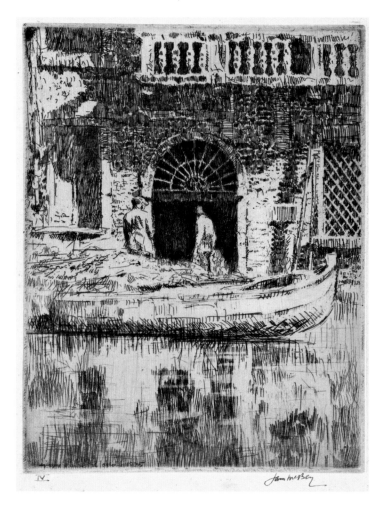

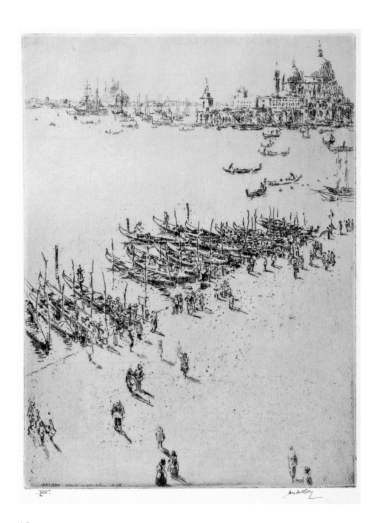

17

James McBey, *The Doorway, Venice*, 1930
Etching, 20.9 x 16.3 cm (8 1/4 x 6 7/16 in.), signed in pencil

18

James McBey, *Molo*, 1928
Etching, 31.6 x 23.9 cm (12 x 9 3/8 in.), signed in pencil

19

James McBey, *Palazzo dei Cammerlenghi*, 1930
Etching, 32.7 x 21.2 cm (12 7/8 x 8 3/8 in.), signed in pencil

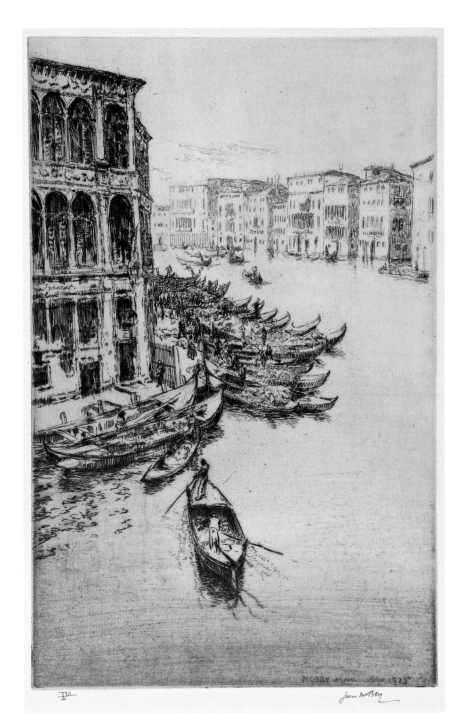

Donald Shaw MacLaughlan (Canadian, 1876–1952)

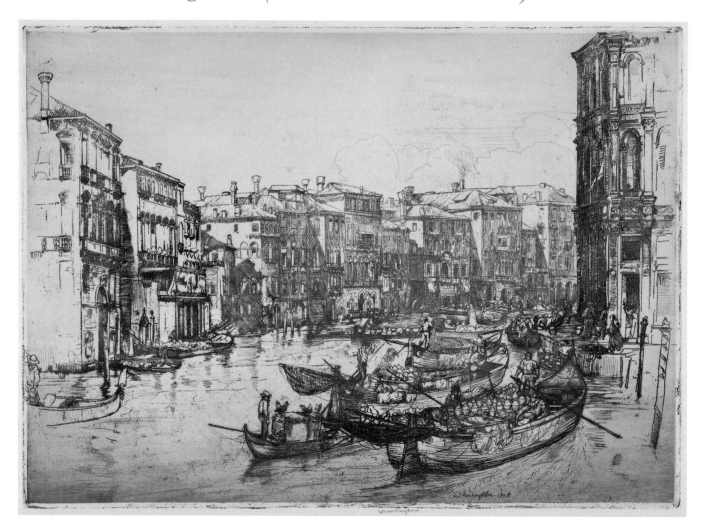

20

Donald Shaw MacLaughlan, *The Grand Canal near the Rialto,* 1907
Etching, 26.9 x 38.1 cm (10 5/8 x 15 in.)
The Trout Gallery, Dickinson College, Carlisle, PA, 2011.1.3

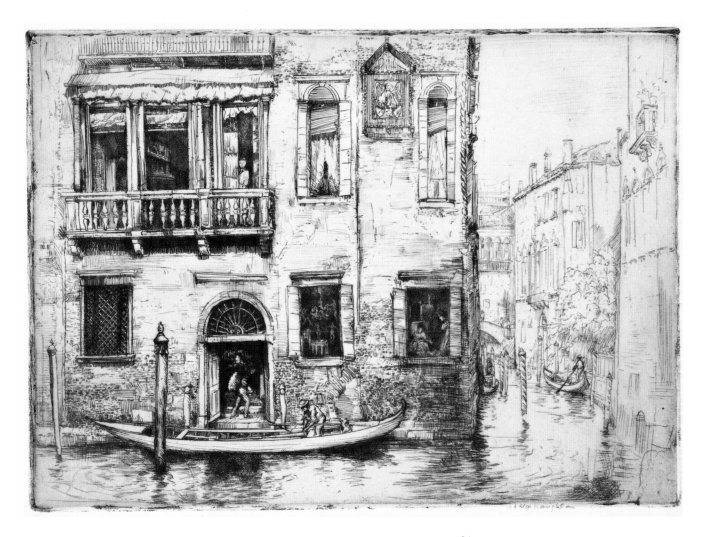

21

Donald Shaw MacLaughlan, *The Canal
of the Little Saint*, 1909

Etching, 20.3 x 28.6 cm (8 x 11 1/4 in.), signed
in pencil

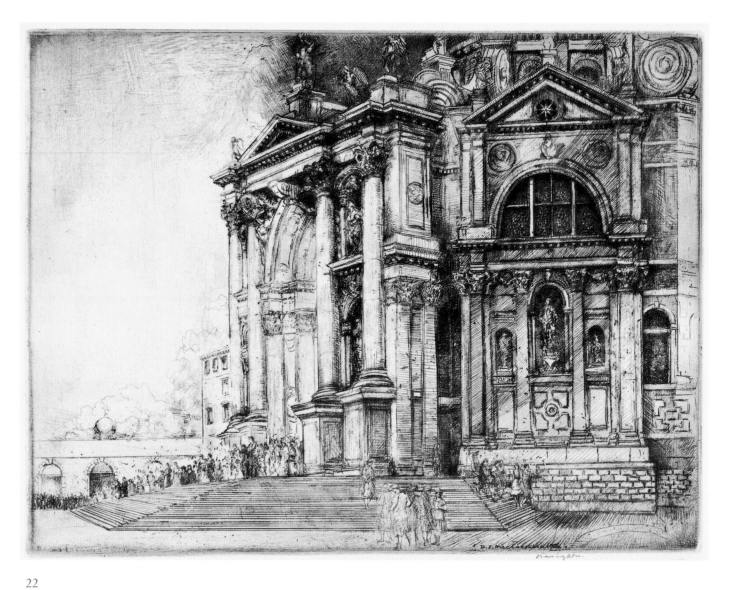

22

Donald Shaw MacLaughlan, *The Salute*, 1926

Etching, 25.4 x 34.3 cm (10 x 13 1/2 in.), signed in pencil

John Marin (American, 1870–1953)

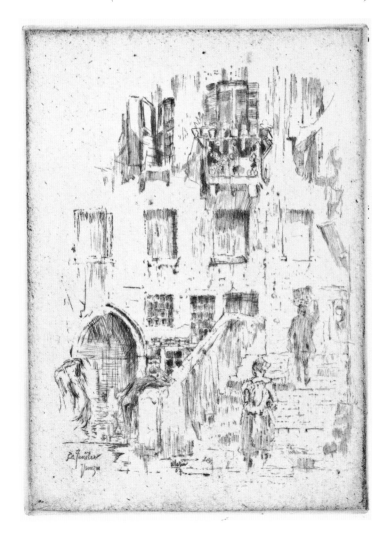

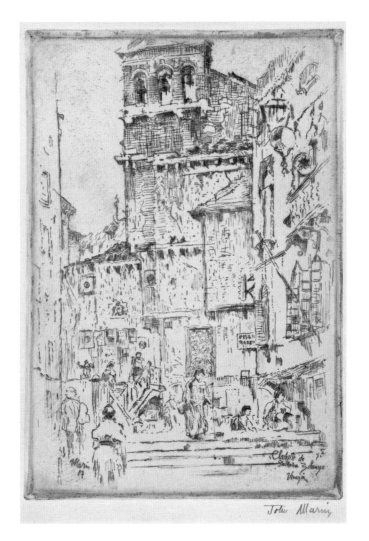

23

John Marin, *The Window, Venice (La Fenestre)*, 1907
Etching, 18 x 12.9 cm (7 1/16 x 5 1/16 in.), signed in the plate

24

John Marin, *The Small Clock Tower of Santa Maria Zobenigo, Venice*, 1907
Etching, 20.1 x 14 cm (7 15/16 x 5 1/2 in.), signed in pencil

Fabio Mauroner (Italian, 1884–1948)

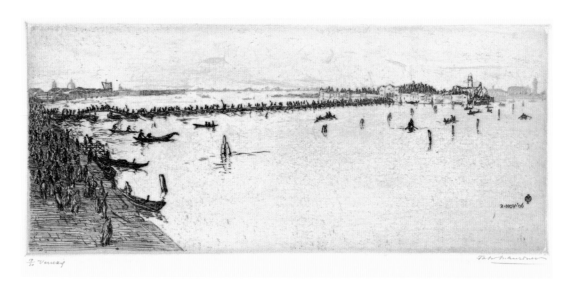

25

Fabio Mauroner, *Bridge of the Dead (Ponte dei Morti)*, 1906

Etching, 12.3 x 27.9 cm (4 7/8 x 11 in.), signed in pencil

The Trout Gallery, Dickinson College, Carlisle, PA, 2011.1.4

26

Fabio Mauroner, *Canal di Quintavalle*, 1907

Etching, 12 x 23.8 cm (4 3/4 x 9 3/8 in.), signed in pencil

The Trout Gallery, Dickinson College, Carlisle, PA, 2011.1.5

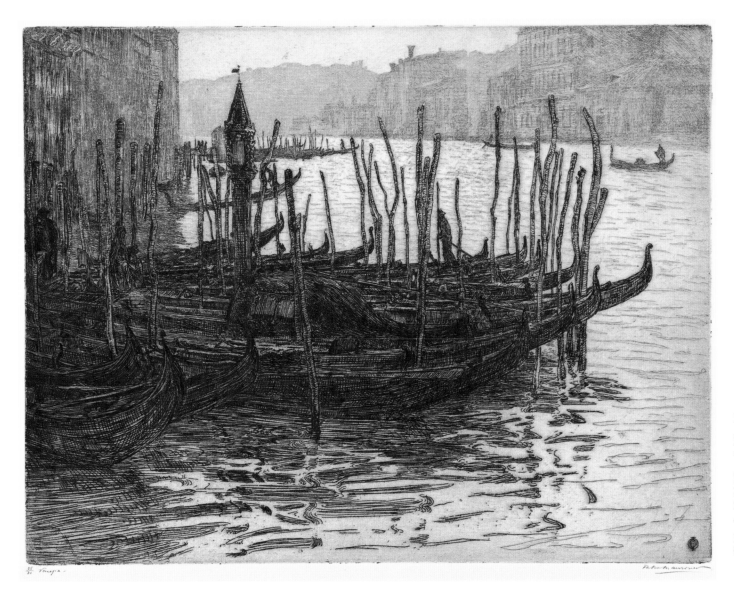

27

Fabio Mauroner, *Il Traghetto*, 1907

Etching and drypoint, 23 x 30.2 cm (9 x 11 7/8 in.), signed in pencil

The Trout Gallery, Dickinson College, Carlisle, PA, 2011.3.1

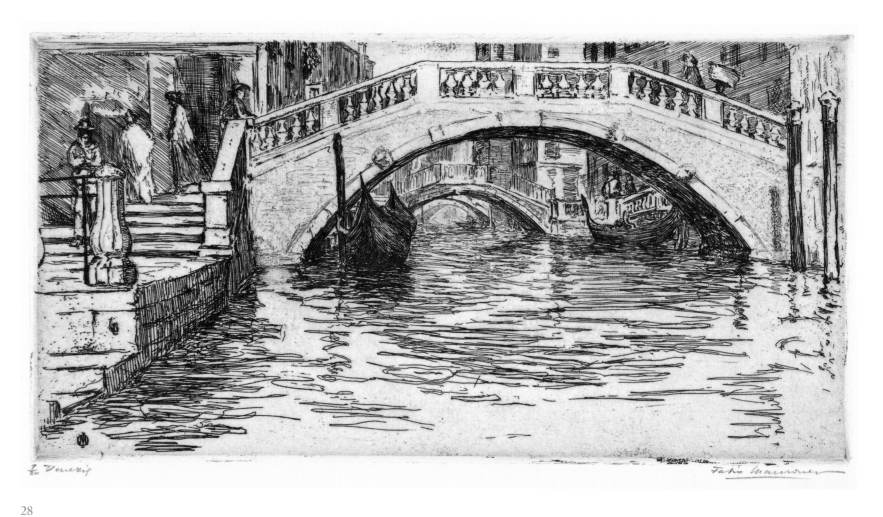

28

Fabio Mauroner, *The Four Bridges*, 1907

Etching and drypoint, 11.8 x 22.8 cm (4 5/8 x 9 1/4 in.), signed in pencil

The Trout Gallery, Dickinson College, Carlisle, PA, 2011.3.2

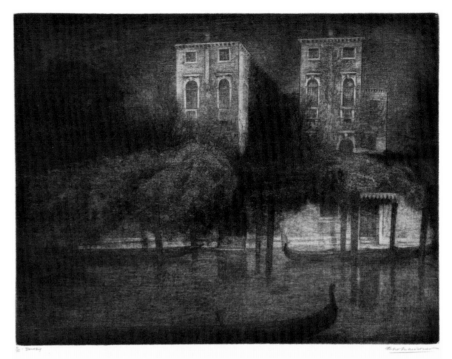

30

Fabio Mauroner, *Palazzo Clary–Rio Ognisanti*, 1920
Mezzotint, 22.8 x 30.3 cm (9 x 11 7/8 in.), signed in pencil
The Trout Gallery, Dickinson College, Carlisle, PA, 2011.3. 4

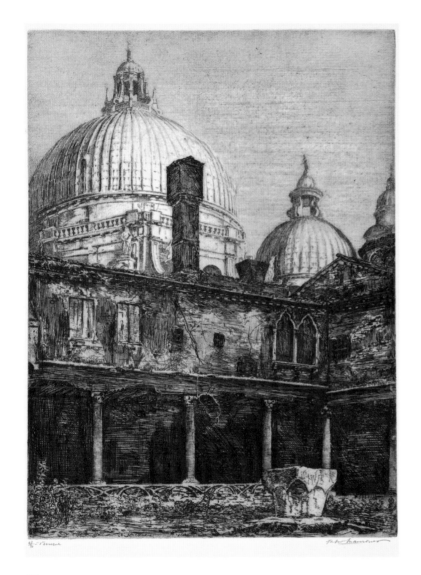

29

Fabio Mauroner, *The Cloisters of San Gregorio*, 1907
Etching, 30.7 x 23 cm (12 1/8 x 9 in.), signed in pencil
The Trout Gallery, Dickinson College, Carlisle, PA, 2011.3.3

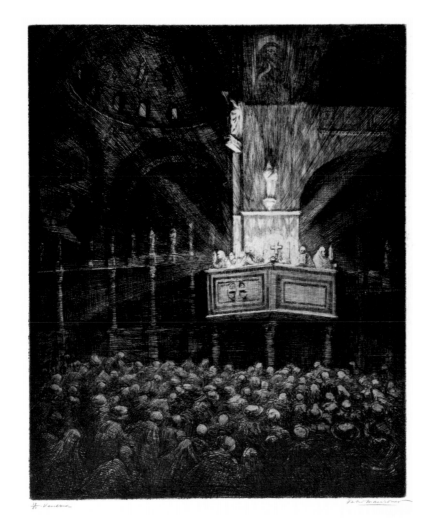

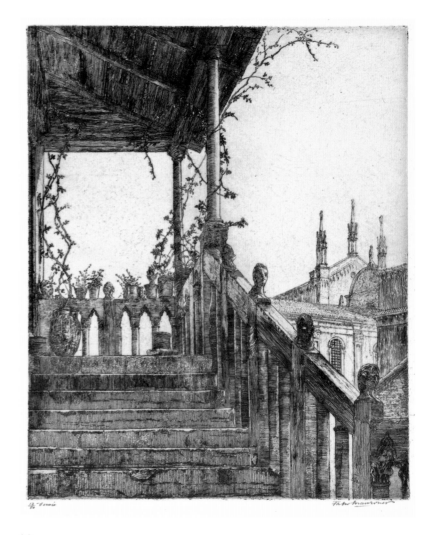

31

Fabio Mauroner, *Benediction of the Holy Relics*, 1920

Etching and drypoint, 26.4 x 22.6 cm (10 3/8 x 8 7/8 in.), signed in pencil

The Trout Gallery, Dickinson College, Carlisle, PA, 2011.3.5

32

Fabio Mauroner, *A Venetian Loggia (Ca' Loredan ai SS. Giovanni e Paolo)*, 1923

Etching, 24 x 20 cm (9 1/2 x 7 7/8 in.), signed in pencil

The Trout Gallery, Dickinson College, Carlisle, PA, 2011.4.1

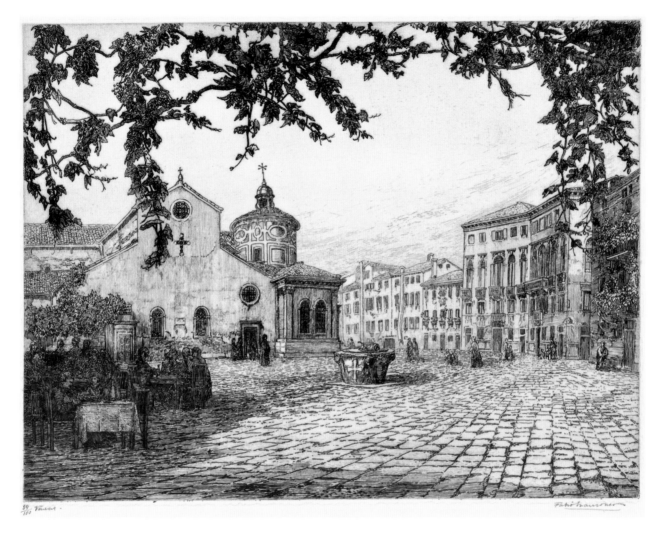

33

Fabio Mauroner, *Trattoria "La Vida" (Campo San Giacomo dell'Orio)*, 1924

Etching, 22.7 x 30.2 cm (8 7/8 x 11 7/8 in.), signed in pencil

The Trout Gallery, Dickinson College, Carlisle, PA, 2011.4.2

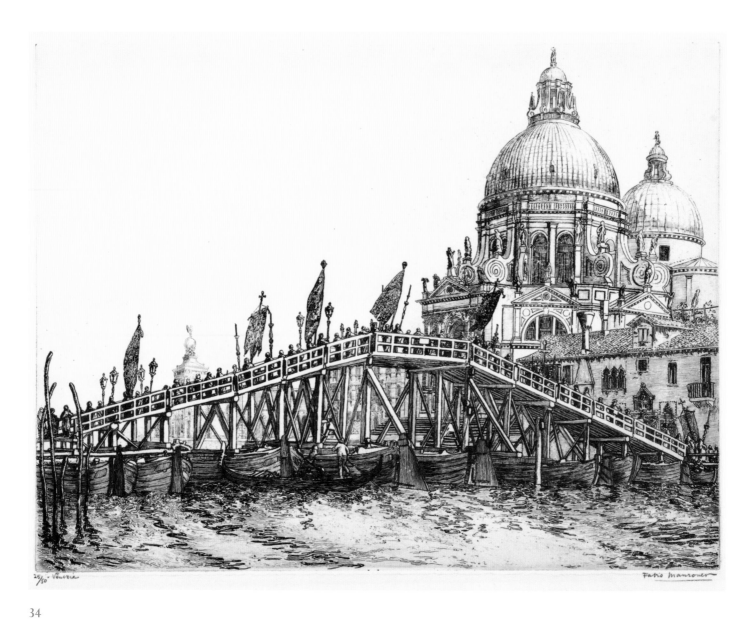

34

Fabio Mauroner, *The Procession (Santa Maria della Salute)*, 1924

Etching, 22.5 x 30 cm (8 7/8 x 11 3/4 in.), signed in pencil

The Trout Gallery, Dickinson, Carlisle, PA, 2011.4.3

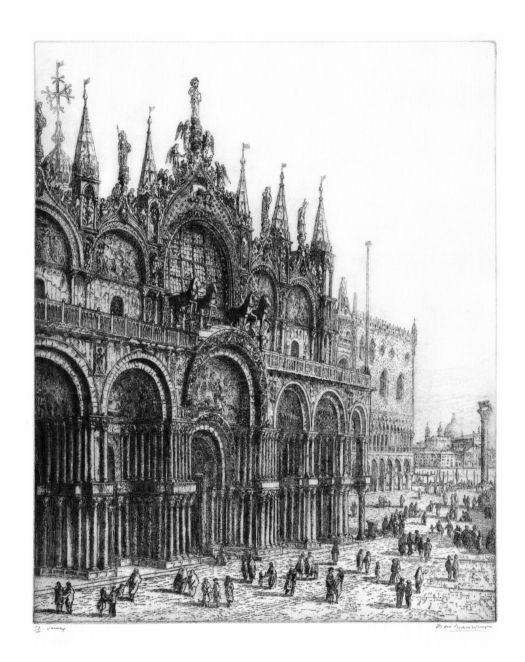

35

Fabio Mauroner, *Basilica of San Marco*, 1926
Etching, 30.2 x 25.2 cm (11 7/8 x 9 15/16 in.), signed in pencil
The Trout Gallery, Dickinson College, Carlisle, PA, 2011.4.4

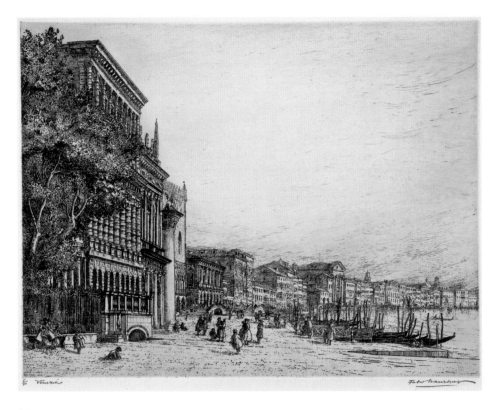

36

Fabio Mauroner, *La Riva degli Schiavoni*, 1926

Etching, 22.7 x 30.2 cm (8 7/8 x 11 7/8 in.), signed in pencil

The Trout Gallery, Dickinson College, Carlisle, PA, 2011.4.5

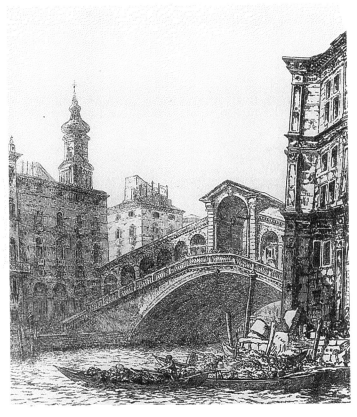

37

Fabio Mauroner, *Morning at the Rialto*, 1929

Etching, 25 x 22.2 cm (9 3/4 x 8 3/4 in.), signed in pencil

The Trout Gallery, Dickinson College, Carlisle, PA, 2011.5.1

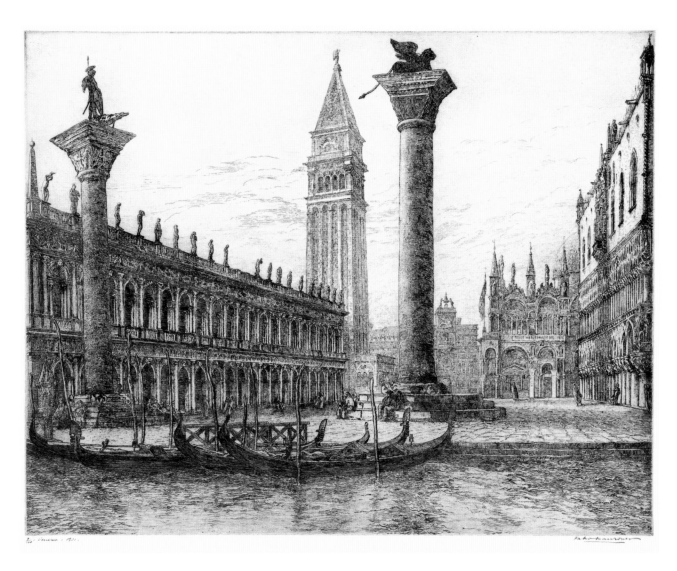

38

Fabio Mauroner, *Il Molo*, 1930
Etching, 30.2 x 39 cm (11 7/8 x 15 3/8 in.), signed in pencil
The Trout Gallery, Dickinson College, Carlisle, PA, 2011.5.2

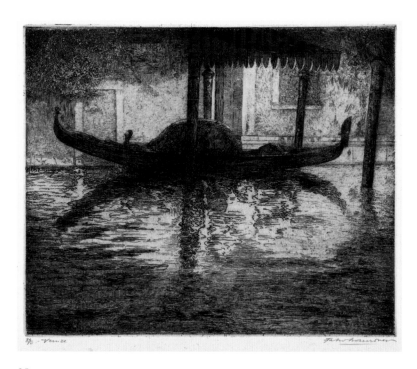

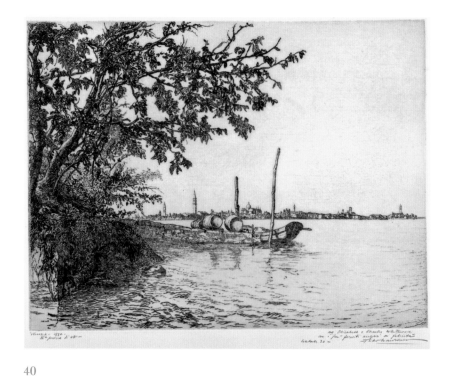

39

Fabio Mauroner, *A Gondola*, 1931

Etching, 16.5 x 20.2 cm (6 1/2 x 8 in.), signed in pencil

The Trout Gallery, Dickinson College, Carlisle, PA, 2011.5.3

40

Fabio Mauroner, *Venezia from Vignole*, 1932

Etching, artist's proof, 22.2 x 30.5 cm (8 3/4 x 12 in.), signed in pencil

Dedicated by the artist to Elizabeth and Charles Whitmore

The Trout Gallery, Dickinson College, Carlisle, PA, 2011.5.4

41

Fabio Mauroner, *The Madonna of the Gondoliers*, 1935

Etching, 14.9 x 12.4 cm (5 7/8 x 4 7/8 in.), signed in pencil

The Trout Gallery, Dickinson College, Carlisle, PA, 2011.5.5

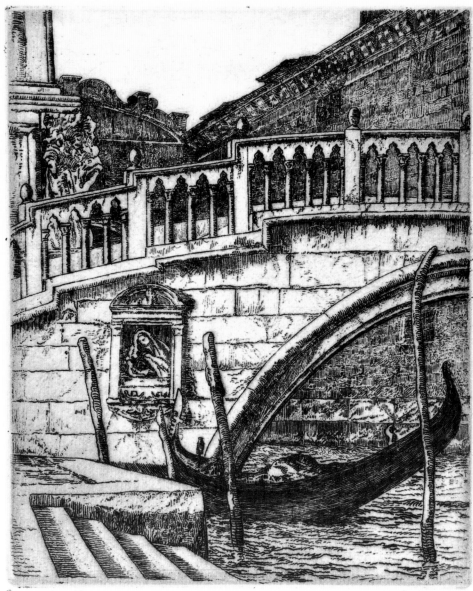

Louis Conrad Rosenberg (American, 1890–1983)

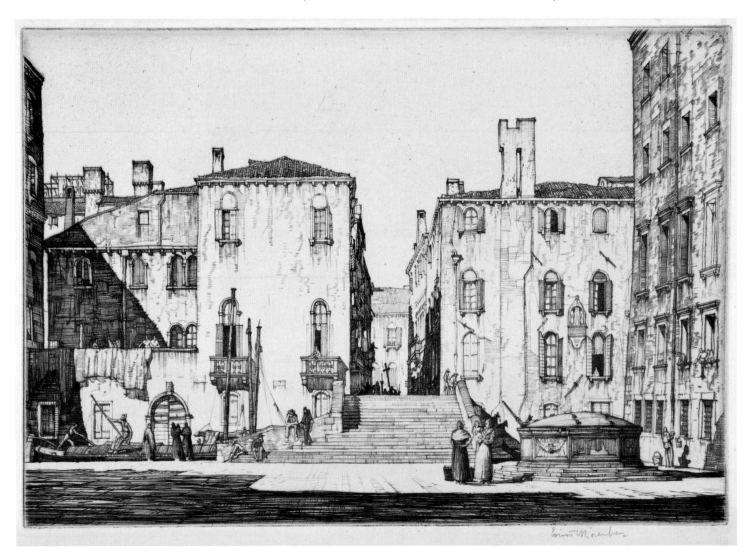

42

Louis Conrad Rosenberg, *Campo dei Gesuiti, Venice*, 1927

Drypoint, 17.8 x 26.3 cm (7 x 10 3/8 in.), signed in pencil

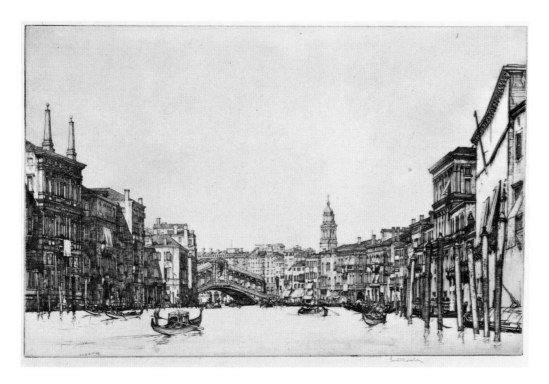

43

Louis Conrad Rosenberg, *Grand Canal, Venice*, 1927

Drypoint, 22.3 x 35.2 cm (8 13/16 x 13 7/8 in.), signed in pencil

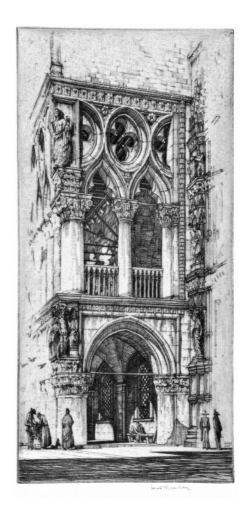

44

Louis Conrad Rosenberg, *Loggia of the Doge's Palace, Venice*, 1927

Drypoint, 27.9 x 13.6 cm (11 x 5 3/8 in.), signed in pencil

Ernest David Roth (American, 1879–1964)

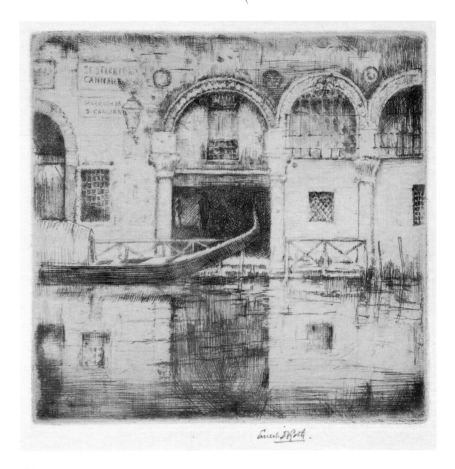

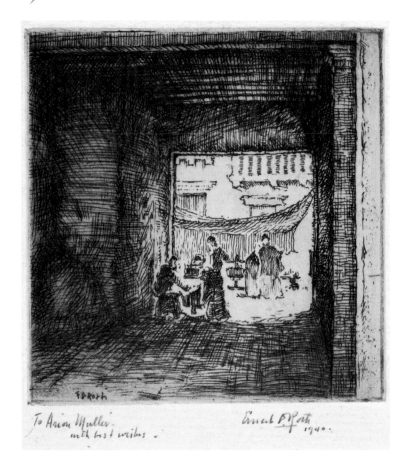

45

Ernest David Roth, *Traghetto, Venice (Ca' da Mosto)*, 1905
Etching, 10.5 x 12.1 cm (4 1/8 x 4 3/4 in.), signed in pencil

46

Ernest David Roth, *Sottoportico*, c. 1906
Etching, 7.5 x 7.6 cm (3 x 3 in.), signed in pencil

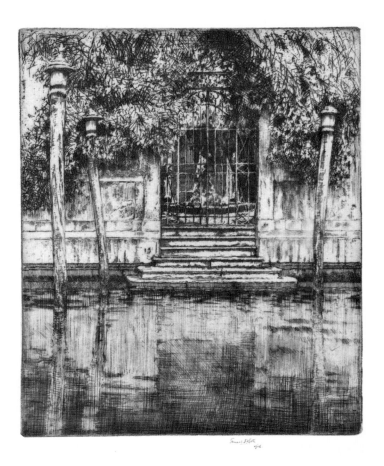

47

Ernest David Roth, *Sottoportico, c.* 1906
Copper plate, 7.5 x 7.6 cm (3 x 3 in.)

48

Ernest David Roth, *The Gate, Venice,* 1906
Etching, 19 x 16.5 cm (7 1/2 x 6 1/2 in.), signed in pencil

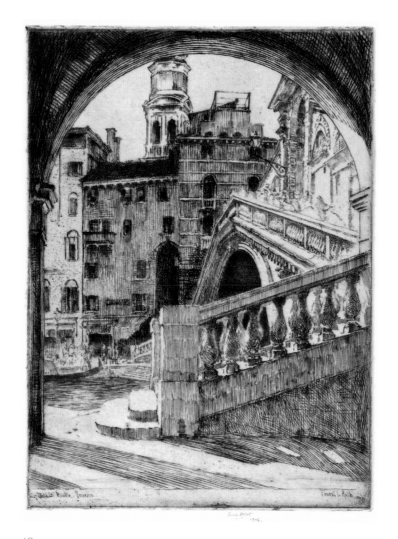

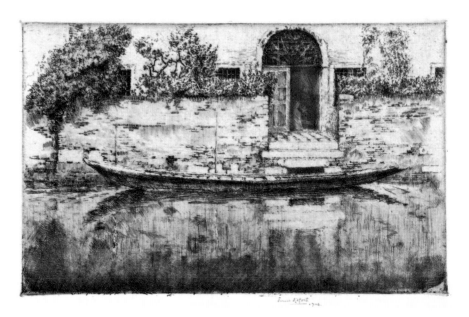

50

Ernest David Roth, *Reflections, Venice*, 1906
Etching, 14.6 x 24.1 cm (5 3/4 x 9 1/2 in.), signed in pencil

49

Ernest David Roth, *Near the Rialto, Venice*, 1906
Etching, 24.1 x 17.8 cm (9 1/2 x 7 in.), signed in pencil

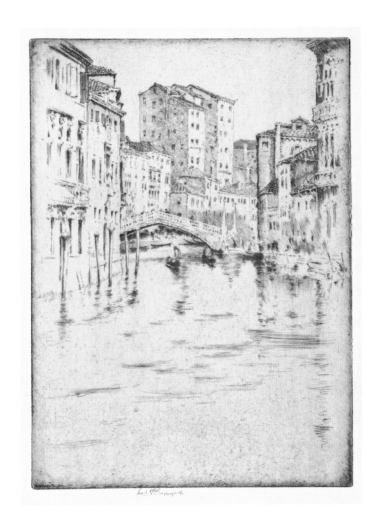

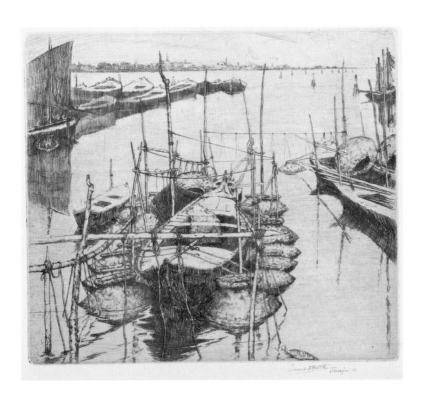

52

Ernest David Roth, *Drying Nets (Canal di Quintavalle)*, 1905-7
Etching, 17.8 x 21 cm (7 x 8 1/4 in.), signed in pencil

51

Ernest David Roth, *The Ghetto*, 1907
Etching, 24.1 x 17.4 cm (9 1/2 x 6 7/8 in.), signed in pencil

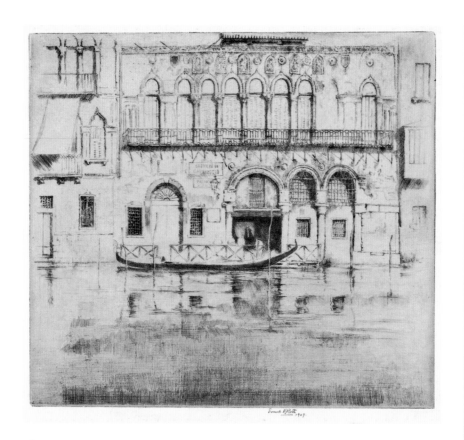

53

Ernest David Roth, *An Old Palace, Venice (Ca' da Mosto)*, 1907
Etching, 20.3 x 22.9 cm (8 x 9 in.), signed in pencil

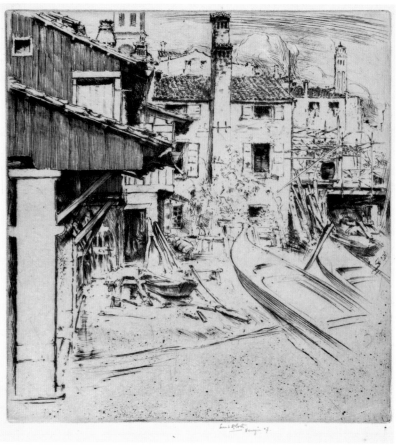

54

Ernest David Roth, *Boatyard at San Trovaso (Squero)*, 1907
Etching, 21.6 x 19 cm (8 1/2 x 7 1/2 in.), signed in pencil

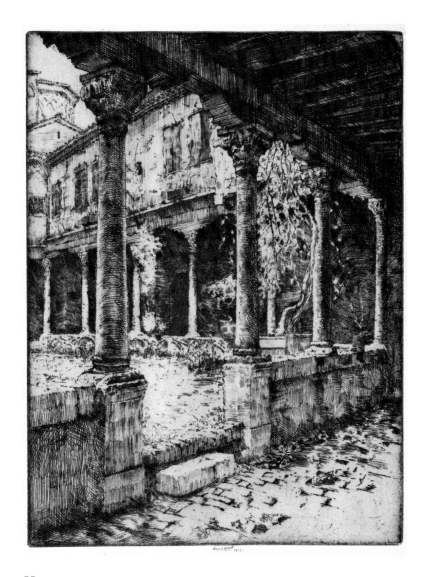

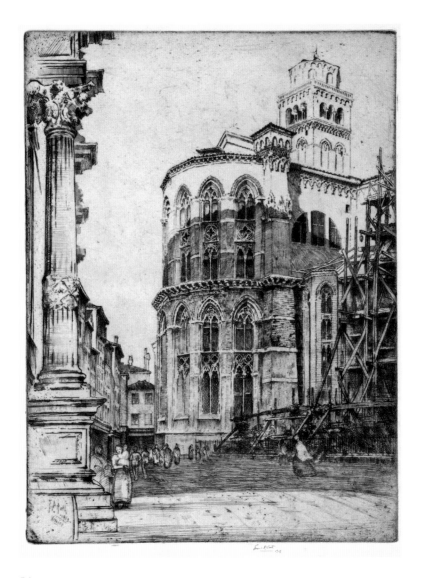

55

Ernest David Roth, *Cloisters of San Gregorio*, 1907
Etching, 30.5 x 22.9 cm (12 x 9 in.), signed in pencil

56

Ernest David Roth, *Church of the Frari, Venice*, 1911–13
Etching, 30.5 x 22.9 cm (12 x 9 in.), signed in pencil

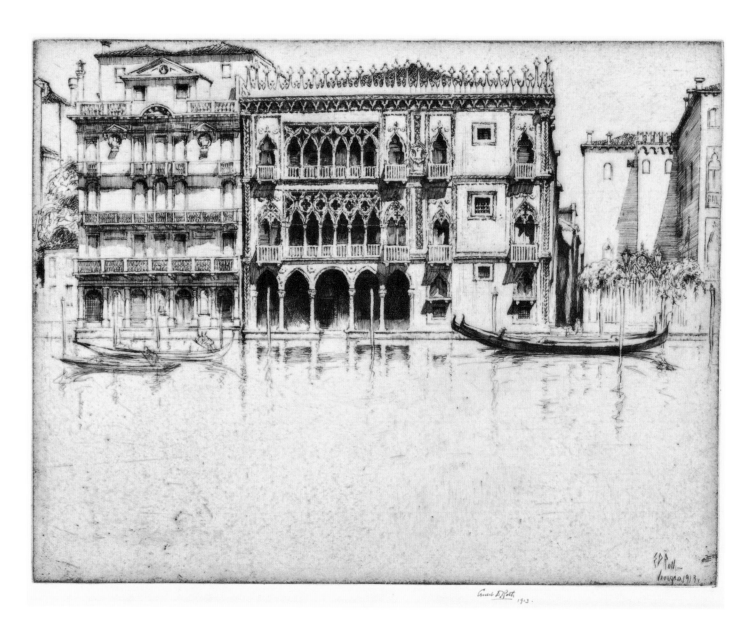

57

Ernest David Roth, *Ca' d'Oro*, 1913

Etching, 22.9 x 30.5 cm (9 x 12 in.), signed in pencil

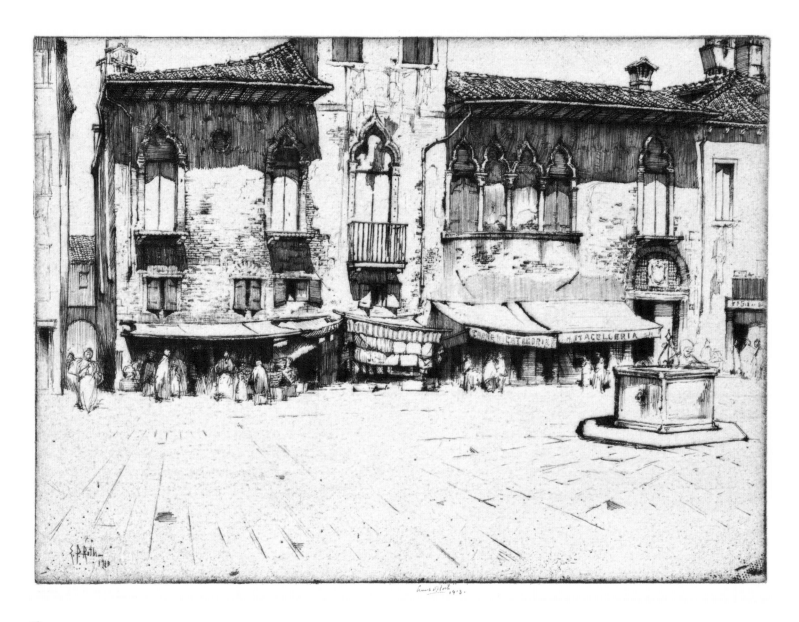

58

Ernest David Roth, *Campo Margarita*, 1913

Etching, 20.3 x 27.3 cm (8 x 10 3/4 in.), signed in pencil

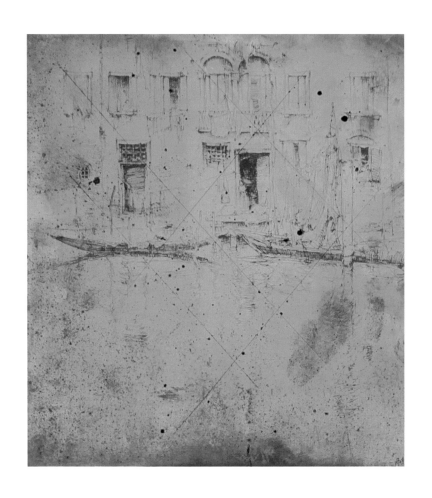

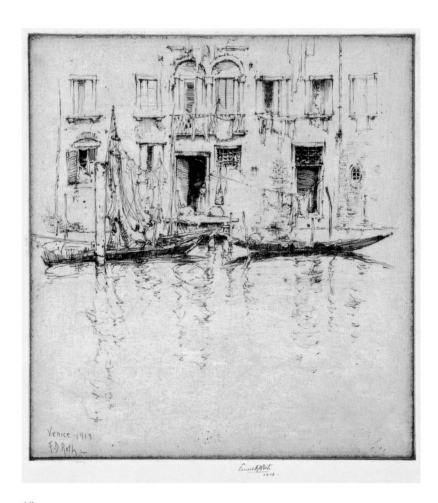

59

Ernest David Roth, *Fish Boats, Venice*, 1913
Copper plate, 18.9 x 17.6 cm (7 1/2 x 7 in.), signed in plate
Collection of Mattatuck Museum, Waterbury, CT

60

Ernest David Roth, *Fish Boats, Venice*, 1913
Etching, 18.9 x 17.6 cm (7 1/2 x 7 in.), signed in pencil

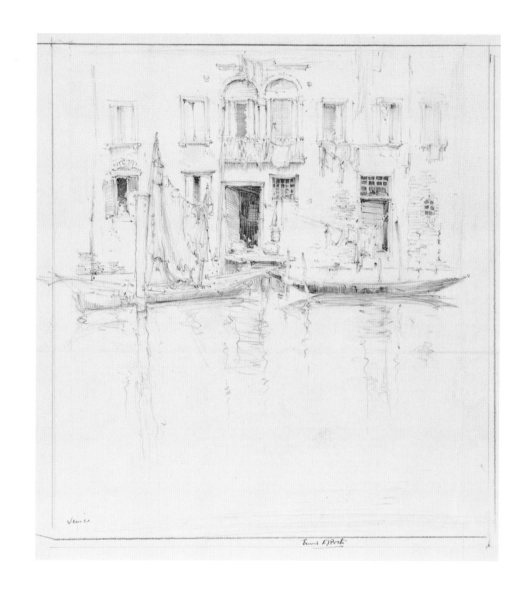

61

Ernest David Roth, *Fish Boats, Venice*, 1913
Preparatory drawing, 18.9 x 17.6 cm (7 1/2 x 7 in.), signed in pencil

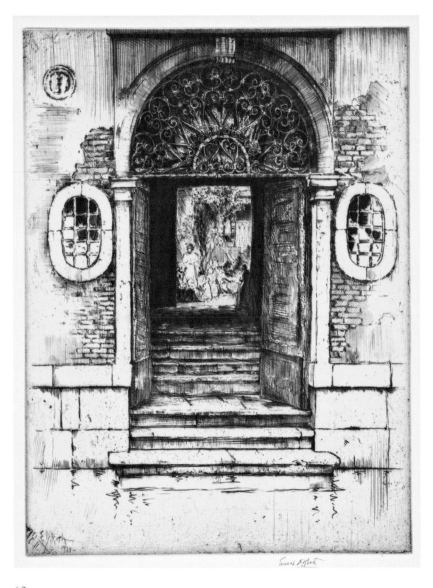

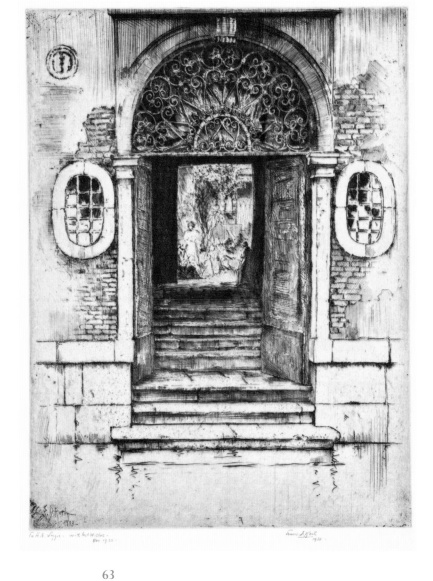

62

Ernest David Roth, *The Iron Grill, Venice,* 1913
Etching, printed in dark brown ink, 26.7 x 19.7 cm (10 1/2 x 7 3/4 in.),
signed in pencil

63

Ernest David Roth, *The Iron Grill, Venice,* 1913
Etching, printed in black ink, 26.7 x 19.7 cm (10 1/2 x 7 3/4 in.),
signed in pencil

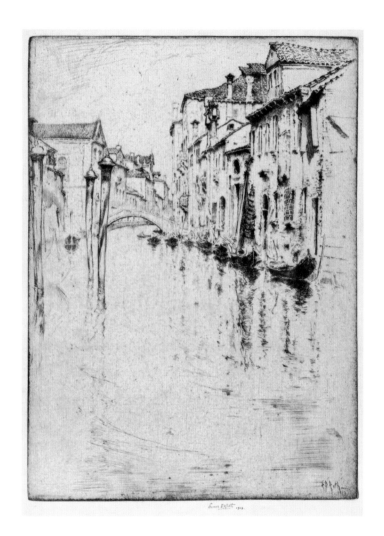

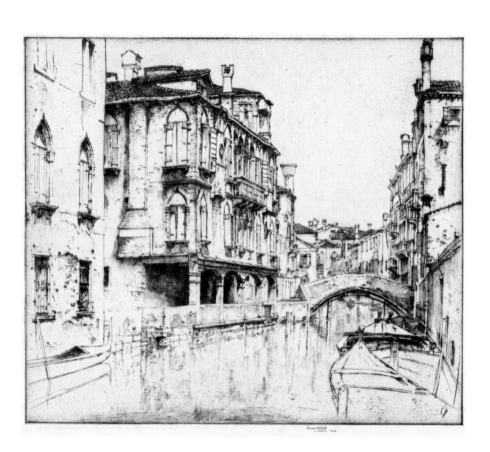

64

Ernest David Roth, *Rio Madonna dell'Orto*, 1913
Etching, 29.5 x 21.6 cm (11 5/8 x 8 1/2 in.), signed in pencil

65

Ernest David Roth, *Rio de Santa Sofia*, 1914
Etching, 28.9 x 34 cm (11 3/8 x 13 3/8 in.), signed in pencil

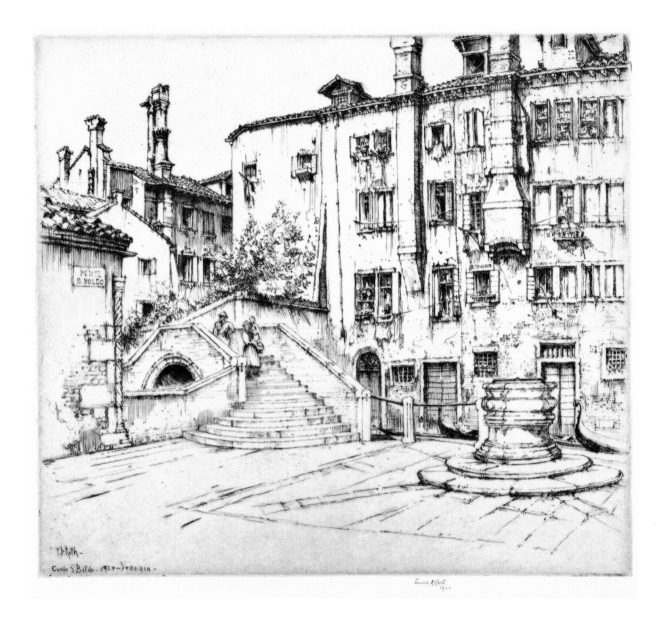

66

Ernest David Roth,
Campo San Boldo, 1924
Etching, 23.5 x 26.4 cm (9 1/4
x 10 3/8 in.), signed in pencil

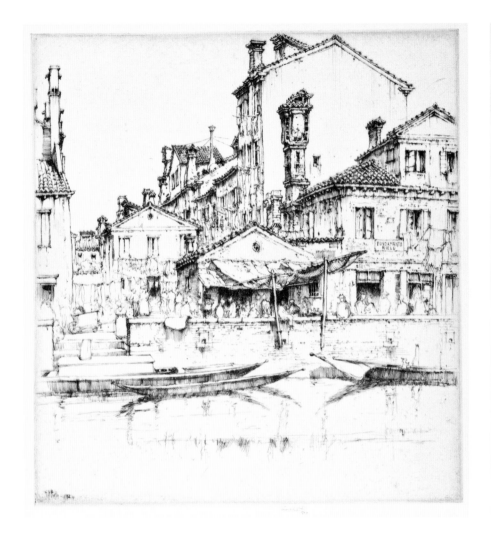

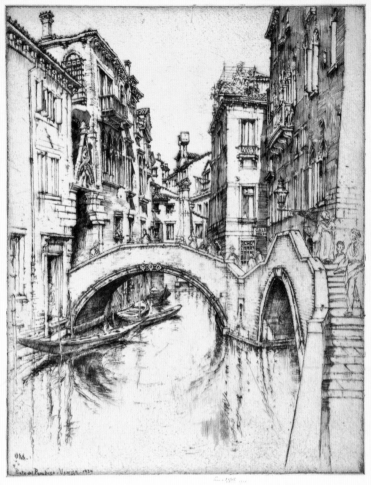

67

Ernest David Roth, *Fondamenta Rielo, Venice*, 1924
Etching, 24.8 x 26.7 cm (9 3/4 x 10 1/2 in.), signed in pencil

68

Ernest David Roth, *Ponte del Paradiso*, 1925
Etching, 30.5 x 23.5 cm (12 x 9 1/4 in.), signed in pencil

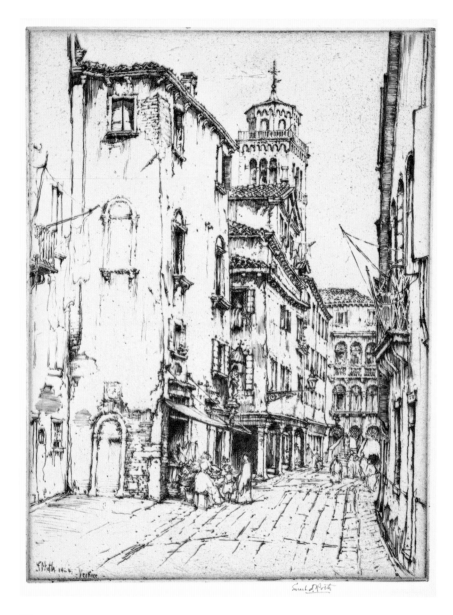

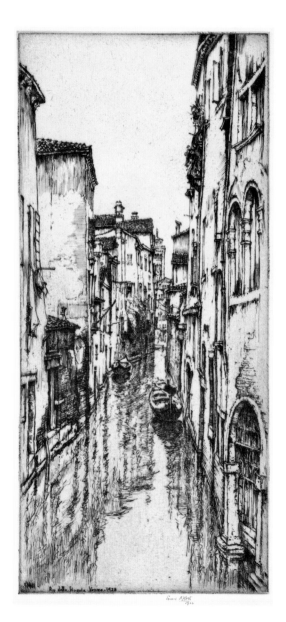

69

Ernest David Roth, *Street in Venice*, 1925
Etching, 24.1 x 17. 8 cm (9 1/2 x 7 in.), signed in pencil

70

Ernest David Roth, *Rio della Pergola*, 1925
Etching, 33.7 x 15.2 cm (13 1/4 x 6 in.), signed in
pencil

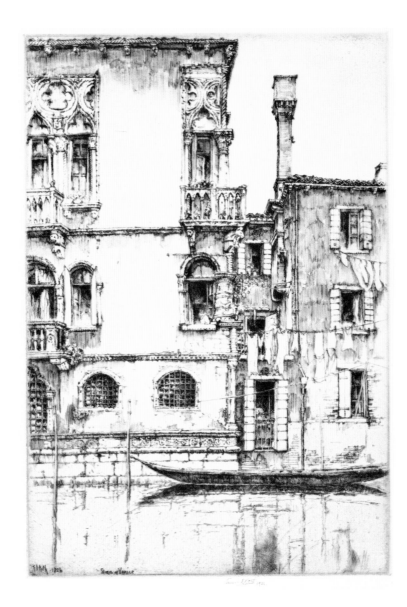

71

Ernest David Roth, *The Stones of Venice*, 1926
Etching, printed on buff paper, 33.7 x 23.5 cm (13 1/2 x 9 1/4 in.), signed in pencil

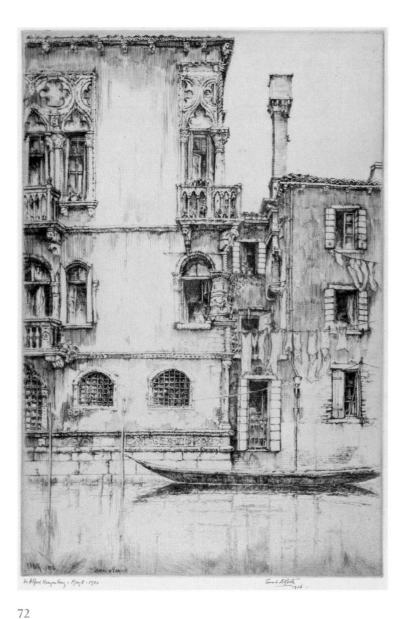

72

Ernest David Roth, *The Stones of Venice*, 1926
Etching, second state, printed on gray paper, 33.7 x 23.5 cm (13 1/2 x 9 1/4 in.),
signed in pencil

Collection of Mr. and Mrs. Robert Martin

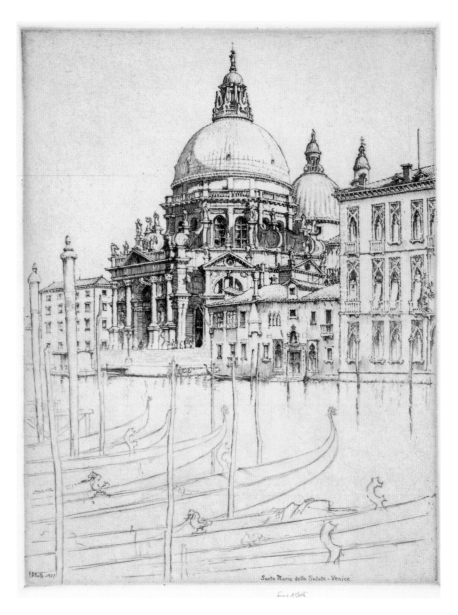

73

Ernest David Roth, *Santa Maria della Salute*, 1937
Etching, 24.1 x 22.9 cm (9 1/2 x 9 in.), signed in pencil

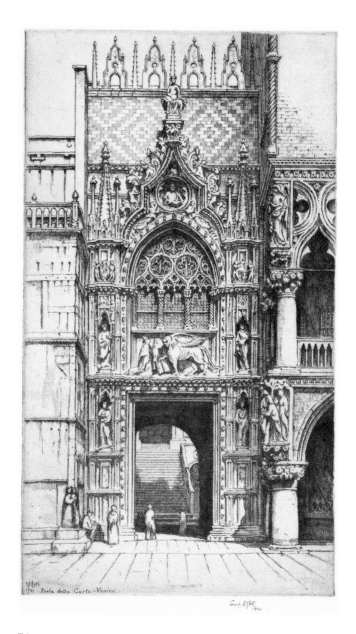

74

Ernest David Roth, *Porta della Carta*, 1941
Etching, 35.6 x 20.3 cm (14 x 8 in.), signed in pencil

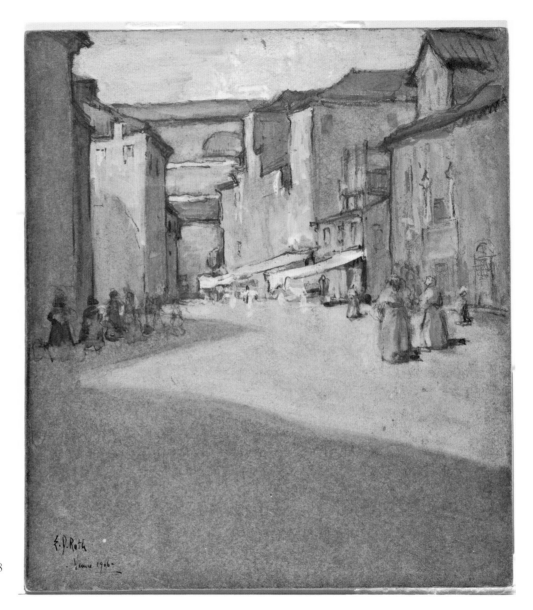

75

Ernest David Roth, *Campo Santa Margarita*, 1906

Oil on paper board, 25.7 x 23.2 cm (10 1/8 x 9 1/8 in.), signed

Tavik František Šimon (Czech, 1877–1942)

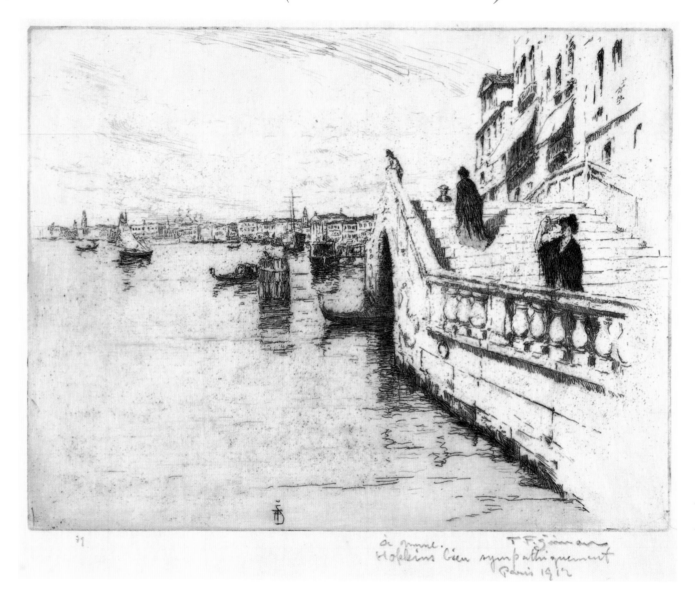

76

Tavik František Šimon,
Lagoon in Venice, 1908
Etching, 18 x 24 cm (7 1/8 x
9 1/2 in.), signed in pencil

Jules André Smith (American, 1880–1959)

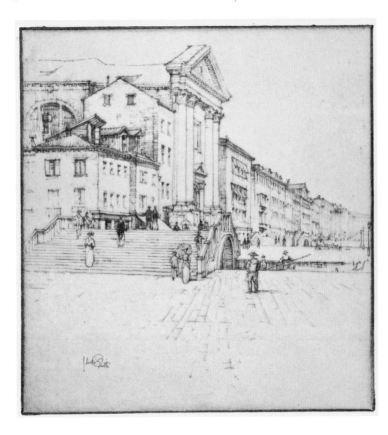

77

Jules André Smith, *The Riva with La Pietà*, 1912
Etching, 21.6 x 20.3 cm (8 1/2 x 8 in.), signed in pencil

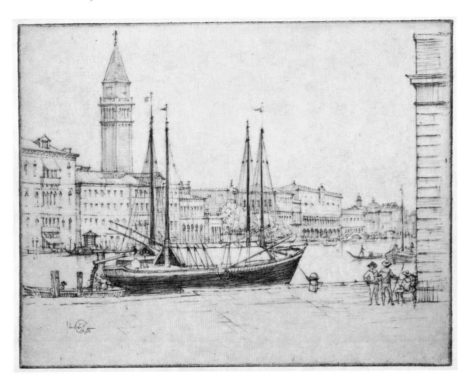

78

Jules André Smith, *Palaces and Barges*, 1913
Etching, 16.5 x 21.6 cm (6 1/2 x 8 1/2 in.), signed in pencil

Edward Millington Synge (British, 1860–1913)

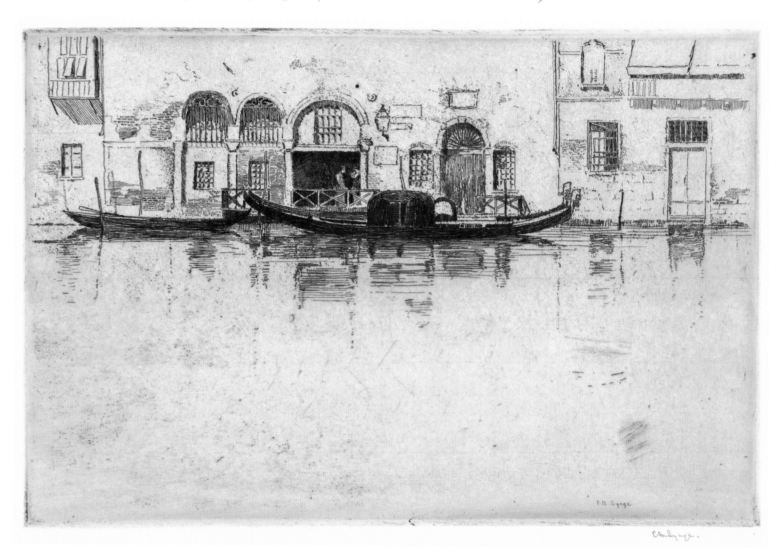

79

Edward Millington Synge, *Ca' da Mosto*, 1906
Etching, 15.7 x 23.8 cm (6 1/8 x 9 3/8 in.), signed in pencil

Jan Charles Vondrous (Czech-American, 1884–1956)

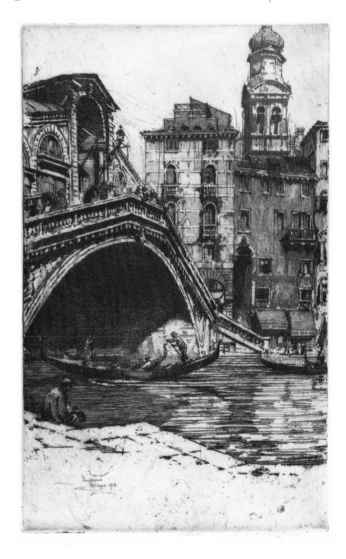

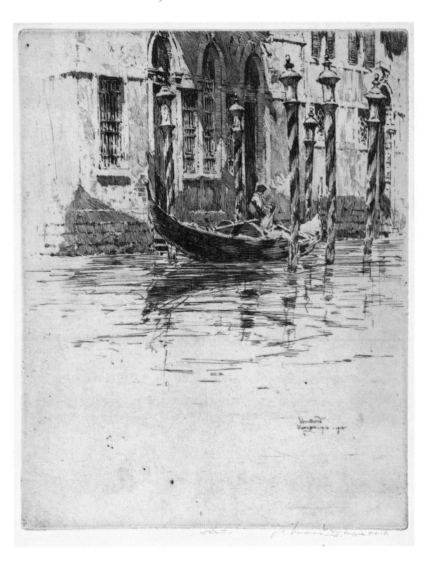

80

Jan Charles Vondrous, *Venezia (Rialto Bridge)*, 1914
Etching, 32 x 20 cm (12 5/8 x 7 7/8 in.), signed in pencil

81

Jan Charles Vondrous, *Venezia (Canal with a Gondola)*, 1914–15
Etching, 25.4 x 20.3 cm (10 x 8 in.), signed in pencil

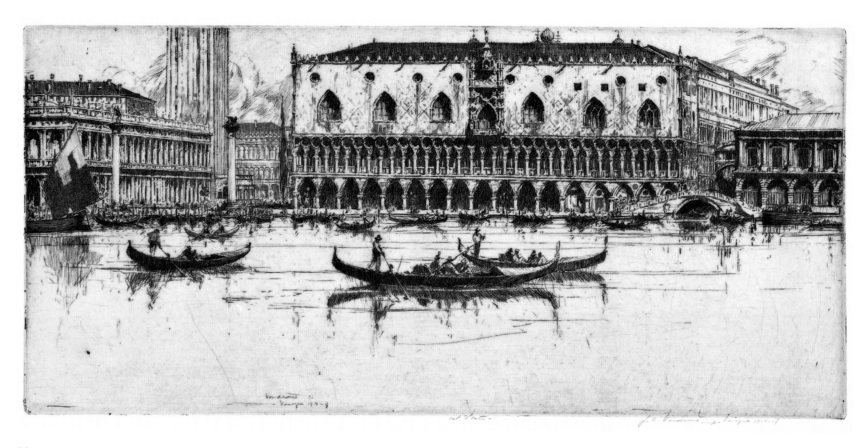

82

Jan Charles Vondrous, *Ducal Palace*, 1914–17

Etching, first state, 16.5 x 35.9 cm (6 1/2 x 14 1/8 in.), signed in pencil

Herman Armour Webster (American, 1878–1970)

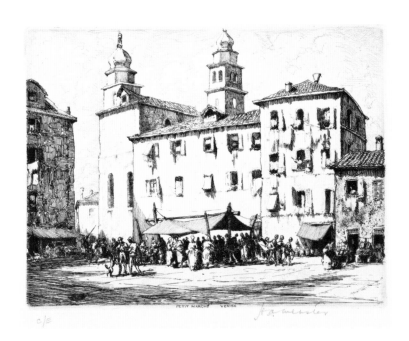

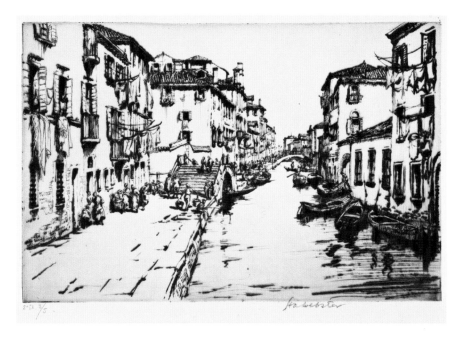

83

Herman Armour Webster, *Campo San Sebastiano (Le Petit Marché, Venise)*, 1927
Etching, 13.3 x 17.5 cm (5 1/4 x 6 7/8 in.), signed in pencil

84

Herman Armour Webster, *Rio della Sensa, Venice*, 1932
Drypoint, second state, 16 x 25 cm (6 1/4 x 9 7/8 in.), signed in pencil

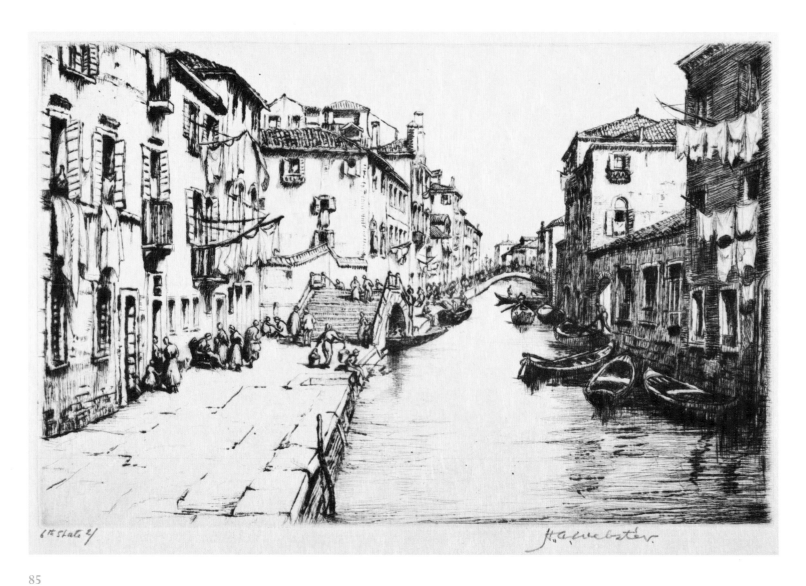

6th State 2/

85

Herman Armour Webster, *Rio della Sensa, Venice*, 1932
Drypoint, sixth state, 16 x 25 cm (6 1/4 x 9 7/8 in.), signed in pencil

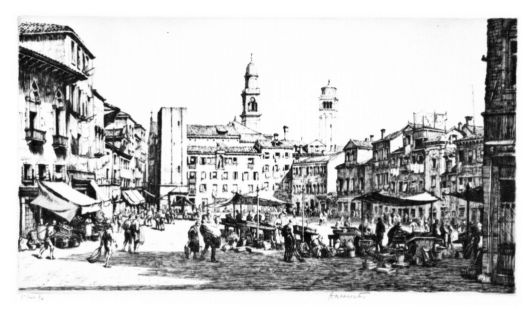

86

Herman Armour Webster, *Campo Santa Margarita, Venice*, 1933

Drypoint, third state, 20.8 x 38.3 cm (8 1/4 x 15 1/16 in.), signed in pencil

87

Herman Armour Webster, *Campo Santa Margarita, Venice*, undated

Pen and ink, 19 x 24.5 cm (7 1/2 x 9 5/8 in.), signed in ink

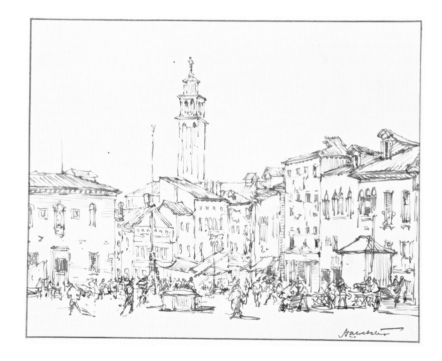

APPENDIX A

Ernest David Roth
ETCHINGS OF VENICE

Whitmore, Elizabeth. *Ernest D. Roth, N.A.* New York: T. Spencer Hudson, 1929. Whitmore is the standard reference on Ernest Roth, including a checklist of his published prints through 1929.

1. *The Bridge*, 1905
Etching, 23.5 x 15.2 cm (9 1/4 x 6 in.)
Whitmore 2

2. *Cloisters of San Gregorio I*, 1905
Etching, 24.1 x 12.1 cm (9 1/2 x 4 3/4 in.)
Whitmore 1

3. *The Quiet Canal*, 1905
Etching, 11.2 x 23 cm (4 3/8 x 9 in.)
Whitmore 6

4. *Traghetto, Venice (Ca' da Mosto)*, 1905
Etching, 10.5 x 12.1 cm (4 1/8 x 4 3/4 in.)
Not in Whitmore
Plate 45

5. *An Arcaded Street I*, 1906
Etching, 21.6 x 19 cm (8 1/2 x 7 1/2 in.)
Whitmore 3

6. *Drying Nets I (small)*, c. 1906
Etching, 7.4 x 7.7 cm (2 7/8 x 3 in.)
Not in Whitmore

7. *The Gate, Venice*, 1906
Etching, 19 x 16.5 cm (7 1/2 x 6 1/2 in.)
Whitmore 4
Plate 48

8. *Near the Rialto, Venice*, 1906
Etching, 24.1 x 17.8 cm (9 1/2 x 7 in.)
Whitmore 5
Plate 49

9. *Reflections, Venice*, 1906
Etching, 14.6 x 24.1 cm (5 3/4 x 9 1/2 in.)
Whitmore 7
Plate 50

10. *Sottoportico*, c. 1906
Etching, 7.5 x 7.6 cm (3 x 3 in.)
Not in Whitmore
Plate 46

11. *Venetian Street with Sottoportico*, c. 1906
Etching, 28.7 x 12.5 cm (11 3/8 x 4 7/8 in.)
Not in Whitmore

12. *The Wooden Bridge*, 1906
Etching, 19 x 21.6 cm (7 1/2 x 8 1/2 in.)
Whitmore 8

13. *The Arcaded Street II*, 1907
Etching, 22.2 x 19 cm (8 3/4 x 7 1/2 in.)
Whitmore 14 (as *A Venetian Doorway*)

14. *Boatyard at San Trovaso (Squero)*, 1907
Etching, 21.6 x 19 cm (8 1/2 x 7 1/2 in.)
Not in Whitmore
Plate 54

Jules André Smith, *The Riva with La Pietà* (detail), fig. 54, pl. 77.

15. *Drying Nets (Canal di Quintavalle)*, 1905-7
Etching, 19.7 x 22.5 cm (7 3/4 x 8 7/8 in.)
Whitmore 12
Plate 52

16. *Cloisters of San Gregorio II (large)*, 1907
Etching, 30.5 x 22.9 cm (12 x 9 in.)
Not in Whitmore
Plate 55

17. *Cloisters of San Gregorio III (horizontal)*, 1907
Etching, 19 x 25.7 cm (7 1/2 x 10 1/8 in.)
Not in Whitmore

18. *The Doorway, Venice*, 1907
Etching, 32.1 x 25.4 cm (12 5/8 x 10 in.)
Not in Whitmore

19. *From the Punta, Venice*, 1907
Etching, 19 x 25.4 cm (7 1/2 x 10 in.)
Whitmore 13

20. *The Ghetto*, 1907
Etching, 24.1 x 17.4 cm (9 1/2 x 6 7/8 in.)
Not in Whitmore
Plate 51

21. *An Old Palace, Venice (Ca' da Mosto)*, 1907
Etching, 20.3 x 22.9 cm (8 x 9 in.)
Not in Whitmore
Plate 53

22. *Two Palaces, Venice*, 1907
Etching, 26.7 x 19.7 cm (10 1/2 x 7 3/4 in.)
Whitmore 25

23. *Church of the Frari, Venice*, 1911–13
Etching, 30.5 x 22.9 cm (12 x 9 in.)
Not in Whitmore
Plate 56

24. *Ca' d'Oro*, 1913
Etching, 22.9 x 30.5 cm (9 x 12 in.)
Whitmore 41
Plate 57

25. *Campo Margarita*, 1913
Etching, 20.3 x 27.3 cm (8 x 10 3/4 in.)
Whitmore 42
Plate 58

26. *Fish Boats, Venice*, 1913
Etching, 18.9 x 17.6 cm (7 1/2 x 7 in.)
Not in Whitmore
Plate 60

27. *The Iron Grill, Venice*, 1913
Etching, 26.7 x 19.7 cm (10 1/2 x 7 3/4 in.)
Whitmore 43
Plate 62

28. *On the Grand Canal, Venice*, 1913
Etching, 24.1 x 22.9 cm (9 1/2 x 9 in.)
Whitmore 44

29. *Rio Madonna dell'Orto*, 1913
Etching, 29.5 x 21.6 cm (11 5/8 x 8 1/2 in.)
Not in Whitmore
Plate 64

30. *Venice from the Redentore*, 1913
Etching, 20.2 x 27.8 cm (8 x 11 in.)
Whitmore 45

31. *The Zattere*, 1913
Etching, 17.2 x 31.8 cm (6 3/4 x 12 1/2 in.)
Whitmore 46

32. *Rio de Santa Sofia*, 1914
Etching, 28.9 x 34 cm (11 3/8 x 13 3/8 in.)
Not in Whitmore
Plate 65

33. *Santa Maria della Salute I*, 1914 (marred plate)
Etching, 30.2 x 23 cm (11 7/8 x 9 1/16 in.)
Not in Whitmore

34. *Campo San Boldo*, 1924
Etching, 23.5 x 26.4 cm (9 1/4 x 10 3/8 in.)
Whitmore 79
Plate 66

35. *Fondamenta Rielo, Venice*, 1924
Etching, 24.8 x 26.7 cm (9 3/4 x 10 1/2 in.)
Whitmore 80
Plate 67

36. *Ponte del Paradiso*, 1925
Etching, 30.5 x 23.5 cm (12 x 9 1/4 in.)
Whitmore 90
Plate 68

37. *Rio della Pergola*, 1925
Etching, 33.7 x 15.2 cm (13 1/4 x 6 in.)
Whitmore 88
Plate 70

38. *The Salute from the Giudecca*, 1925
Etching, 26.7 x 17.3 cm (10 1/2 x 6 3/4 in.)
Whitmore 96

39. *Santa Maria della Salute (Christmas card)*, 1925
Etching, 12.4 x 10.5 cm (4 7/8 x 4 1/16 in.)
Not in Whitmore

40. *Street in Venice*, 1925
Etching, 24.1 x 17. 8 cm (9 1/2 x 7 in.)
Whitmore 92
Plate 69

41. *The Stones of Venice*, 1926
Etching, 33.7 x 23.5 cm (13 1/2 x 9 1/4 in.)
Whitmore 98
Plate 71

42. *Santa Maria della Salute*, 1937
Etching, 24.1 x 22.9 cm (9 1/2 x 9 in.)
Not in Whitmore
Plate 73

43. *Porta della Carta*, 1941
Etching, 35.6 x 20.3 cm (14 x 8 in.)
Not in Whitmore
Plate 74

44. *Shipping, Venice*, 1941 (begun 1926)
Etching, 27.6 x 37 cm (10 7/8 x 14 5/8 in.)
Not in Whitmore

APPENDIX B

Jules André Smith
PRINTS OF VENICE

1. *Parked Gondolas, Venice,* 1912
Etching, 37.6 x 27.3 cm (14 3/4 x 10 3/4 in.)

2. *The Riva with La Pietà,* 1912
Etching, 21.6 x 20.3 cm (8 1/2 x 8 in.)

3. *A Bit of the Grand Canal (San Marcuola),* 1913
Drypoint, 13.9 x 20.4 cm (5 1/2 x 8 in.)

4. *An Angle of Venice,* 1913–14
Etching, 25.2 x 16.3 cm (9 7/8 x 6 3/8 in.)

5. *Boatyard, Venice,* 1913–14
Etching, 25.2 x 18 cm (9 7/8 x 7 1/8 in.)

6. *Bridge of Santi Apostoli,* 1913–14
Etching, 17.8 x 24.1 cm (7 x 9 1/2 in.)

7. *Campo Fosca,* 1913–14
Etching, 23.2 x 18.3 cm (9 1/8 x 7 3/16 in.)

8. *Campo Maria Nova,* 1913–14
Etching, 27.3 x 17.2 cm (10 3/4 x 6 3/4 in.)

9. *Campo Santa Margarita,* 1913
Etching, 10.2 x 16.5 cm (4 x 6 1/2 in.)

10. *Campo Santa Maria Formosa,* 1913–14
Etching, 19 x 20.3 cm (7 1/2 x 8 in.)

11. *The Jewel of Venice (Santa Maria della Salute),* 1913
Etching, 29.6 x 21.3 (11 5/8 x 8 3/8 in.)

12. *The Lion of St. Mark's,* 1913–14
Etching, 23.5 x 16.5 cm (9 1/4 x 6 1/2 in.)

13. *The Little Foundry,* 1913–14
Etching, 18 x 27.6 cm (7 1/8 x 10 7/8 in.)

14. *The Molo,* 1913–14
Etching, 17.8 x 21.6 cm (7 x 8 1/2 in.)

15. *Palaces and Barges,* 1913–14
Etching, 16.5 x 21.6 cm (6 1/2 x 8 1/2 in.)

16. *Ponte della Verona,* 1913–14
Etching, 28 x 18.4 cm (11 x 7 1/4 in.)

17. *Porta della Carta,* 1913–14
Etching, 35.2 x 14.3 cm (13 7/8 x 5 5/8 in.)

18. *San Geremia,* 1913–14
Etching, 25.4 x 21 cm (10 x 8 1/4 in.)

19. *San Giorgio Maggiore,* 1913–14
Etching, 29.4 x 19.8 cm (11 1/2 x 7 3/4 in.)

20. *Sunshine and Flowers, Venice,* 1913–14
Etching, size unavailable

21. *Towers and Domes (The Salute from the Giudecca),* 1913–14
Etching, 17.8 x 22.2 cm (7 x 8 3/4 in.)

22. *Venice,* 1921
Drypoint, 11.8 x 16.8 cm (4 5/8 x 6 5/8 in.)

23. *Santa Maria della Salute, Venice*, c. 1921
Etching, 30.5 x 19 cm (12 x 7 1/2 in.)

APPENDIX C

John Taylor Arms
ETCHINGS OF VENICE

Fletcher, William Dolan. *John Taylor Arms: A Man for All Time*. Eastern Press: New Haven, 1982. Fletcher is the standard catalogue raisonné for Arms's prints.

1. *The Boatyard, San Trovaso*, 1926
Etching, 24.2 x 37.4 cm (9 1/2 x 14 3/4 in.)
Fletcher 177

2. *Rio dei Santi Apostoli*, 1930
Etching, 20.4 x 15.3 cm (8 x 6 in.)
Fletcher 226

3. *Porta della Carta (The Enchanted Doorway, Venezia)*, 1930
Etching, 31.5 x 16.7 cm (12 3/8 x 6 9/16 in.)
Fletcher 227

4. *Il Ponte di Rialto, Venezia (The Shadows of Venice)*, 1930
Etching, 26.2 x 30.8 cm (10 1/4 x 12 1/8 in.)
Fletcher 229

5. *Porta del Paradiso*, 1930
Etching, 19.1 x 9.8 cm (7 1/2 x 3 7/8 in.)
Fletcher 230

6. *La Bella Venezia*, 1931
Etching, 18.5 x 41.9 cm (7 1/4 x 12 1/2 in.)
Fletcher 232

7. *Palazzo dell'Angelo*, 1931
Etching, 18.5 x 17.1 cm (7 1/4 x 6 3/4 in.)
Fletcher 233

8. *Venetian Filigree (Ca' d'Oro, Venezia)*, 1931
Etching, 27.9 x 26.7 cm (11 x 10 1/2 in.)
Fletcher 235

9. *The Balcony (Venetian Gateway)*, 1931
Etching, 20.7 x 13.2 cm (8 1/8 x 5 3/16 in.)
Fletcher 237

10. *Venetian Mirror (The Grand Canal, Venice)*, 1935
Etching, 16.5 x 35.9 cm (6 1/2 x 14 1/8 in.)
Fletcher 289

APPENDIX D

Louis Conrad Rosenberg
DRYPOINTS OF VENICE

McMillan, Gail. *Catalogue of the Louis Conrad Rosenberg Collection*. Eugene: University of Oregon Library, 1978. McMillan is the standard catalogue raisonné for Rosenberg's prints.

1. *Bridge in Venice (Ponte Cavallo)*, 1925
19.1 x 24.8 cm (7 1/2 x 9 3/4 in.)
McMillan 39

2. *Campo dei Gesuiti, Venice, 1927*
17.8 x 26.4 cm (7 x 10 3/8 in.)
McMillan 55

3. *St. Mark's Doorway, Venice, 1927*
24.4 x 17.8 cm (10 x 7 in.)
McMillan 56

4. *Loggia of the Doge's Palace, Venice, 1927*
27.9 x 13.6 cm (11 x 5 3/8 in.)
McMillan 57

5. *Grand Canal, Venice, 1927*
22.9 x 35.6 cm (9 x 14 in.)
McMillan 60

6. *Tintoretto's House on the Rio della Sensa, 1929*
18.7 x 12.1 cm (7 3/8 x 4 3/4 in.)
McMillan 76

7. *Piazza Santa Maria Formosa, Venice, 1935*
18.6 x 29.2 cm (7 5/16 x 11 1/2 in.)
McMillan 120

APPENDIX E

Herman Armour Webster
PRINTS OF VENICE

"Herman Armour Webster." Archives of American Art, Smithsonian Institution, Washington, DC. The reference numbers are from a typed list of Webster's prints donated to the Archives of American Art by the artist's widow, Moune G. H. Webster.

1. *Traghetto, Venice, 1914*
Etching, 12.5 x 16 cm (4 7/8 x 6 1/4 in.)
Webster 79

2. *La Madonna, Venice, 1926*
Etching, 9.5 x 12.1 cm (3 3/4 x 4 3/4 in.)
Webster 85

3. *Bâteaux de Pêche (Fish Boat), Venice, 1926*
Etching, 17.7 x 22.8 cm (7 x 9 in.)
Webster 86

4. *San Barnaba, Venice, 1926*
Etching, 10.5 x 7.1 cm (4 1/8 x 2 3/4 in.)
Webster 87

5. *Il Redentore, Venice, 1927*
Etching, 12.6 x 15.5 cm (5 x 6 1/8 in.)
Webster 90

6. *Le Petit Marché (The Little Market), Venice, 1927*
Etching, 13.3 x 17.5 cm (5 1/4 x 6 7/8 in.)
Webster 92

7. *A Street in Venice*, 1928
Etching, 18 x 24.7 cm (7 1/8 x 9 3/4 in.)
Webster 100

8. *La Casa di Mario* or *The Ghetto, Venice*, 1930
Drypoint, 19.9 x 28 cm (7 3/4 x 11 in.)
Webster 105

9. *Ospedale Civile, Venice*, 1930
Drypoint, 25 x 33.3 cm (9 7/8 x 13 1/8 in.)
Webster 106

10. *Little Israel, Venice*, 1930
Drypoint, 24 x 35.3 cm (9 1/2 x 13 7/8 in.)
Webster 107

11. *Venetian Moonlight*, 1930
Drypoint, 24 x 18 cm (9 1/2 x 7 1/8 in.)
Webster 109

12. *San Simeone Piccolo, Venice*, 1931
Drypoint, 25 x 35 cm (9 7/8 x 13 3/4 in.)
Webster 110

13. *Ponte Megio, Venice*, 1931
Drypoint, 32.4 x 23.5 cm (12 3/4 x 9 1/4 in.)
Webster 111

14. *Rialto at Night, Venice*, 1931
Etching, 21.1 x 15.2 cm (8 1/4 x 6 in.)
Webster 112

15. *Giudecca Canal, Venice*, 1932
Etching, 25.2 x 35.3 cm (10 x 13 7/8 in.); trimmed to 23 x
35.3 (9 x 13 7/8 in.)
Webster 116

16. *Rio della Sensa, Venice*, 1932
Drypoint, 16 x 25 cm (6 1/4 x 9 7/8 in.)
Webster 118

17. *Fondamenta de l'Arzere, Venice*, 1932
Drypoint, 18 x 25.7 cm (7 1/8 x 10 1/8 in.)
Webster 119

18. *Rio dell'Agnello, Venice*, 1932
Drypoint, 30.4 x 21.4 cm (12 x 8 1/2 in.)
Webster 120

19. *La Dogana, Venice*, 1932
Drypoint, 21 x 33 cm (8 1/4 x 13 in.)
Webster 121

20. *Interior of Santa Maria della Salute, Venice*, 1933
Etching, 22.3 x 30.5 cm (8 3/4 x 12 in.)
Webster 124

21. *San Pietro di Castello, Venice*, 1933
Drypoint, 21.8 x 36.7 cm (8 1/2 x 14 1/2 in.)
Webster 126

22. *Campo Santa Margarita, Venice*, 1933
Drypoint, 20.8 x 38.3 cm (8 1/4 x 15 in.)
Webster 126

23. *Cannaregio, Venice*, 1933
Drypoint, 16.7 x 20 cm (6 1/2 x 7 7/8 in.)
Webster 127

24. *The Nave of Santa Maria della Salute, Venice*, 1934
Drypoint, 25.8 x 18.8 cm (10 1/8 x 7 3/8 in.)
Webster 129

25. *La Piazzetta, Venice*, 1935
Etching, 9.5 x 7.5 cm (3 3/4 x 3 in.)
Webster 136

26. *Interior of San Marco, Venice*, 1935
Etching, 12 x 9 cm (4 3/4 x 3 1/2 in.)
Webster 137

27. *Mulino Stucky, Venice*, 1948
Etching, 16.3 x 25.4 cm (6 1/2 x 10 in.)
Webster 170

28. *Rain in the Piazzetta, Venice*, 1948
Etching, 10.7 x 19.2 cm (4 1/4 x 7 1/2 in.)
Webster 171

29. *Sailboats in Venice*, 1951
Etching, 17.5 x 24 cm (6 7/8 x 9 1/2 in.)
Webster 175

30. *Mercato, Venice*, 1954
Drypoint, 10 x 13.8 cm (4 x 5 1/2 in.)
Webster 193

31. *The Little Giudecca, Venice*, 1958
Etching, 10.7 x 19.2 cm (4 1/4 x 7 1/2 in.)
Webster 210

32. *Rio dei Carmine, Venice*, 1959
Etching, 18 x 25 cm (7 1/8 x 9 7/8 in.); plate later reduced
to 17 x 23 cm (6 3/4 x 9 in.)
Webster 217

BIBLIOGRAPHY

PRIMARY SOURCES

JOHN TAYLOR ARMS

John Taylor Arms. Diaries, 1929–1930. Collection of Charles Rosenblatt, Cleveland, OH.

John Taylor Arms. Diaries, 1932–1936. Archives of American Art, Smithsonian Institution, Washington, DC.

John Taylor Arms. Handwritten inventory. Archives, College of Wooster, Wooster, OH.

FABIO MAURONER

Fabio Mauroner Collection, Archivio, Civici Musei e Gallerie de Storia e Arte, Comune di Udine, Italy.

ERNEST DAVID ROTH

Ernest D. Roth Collection. Mattatuck Museum Arts and History Center, Waterbury, CT.

HERMAN A. WEBSTER

Herman A. Webster. "Curriculum Vitae." Archives of American Art in Washington, DC.

KEITH SHAW WILLIAMS

Keith Shaw Williams papers. Archives of American Art, Smithsonian Institution, Washington, DC.

PUBLISHED SOURCES

Arms, Dorothy Noyes. "John Taylor Arms: Modern Mediaevalist." *The Print Collector's Quarterly* 21, no. 2 (April 1934): 126–41.

———, and John Taylor Arms. *Hill Towns and Cities of Northern Italy*. New York: The MacMillan Company, 1932.

Arms, John Taylor. "The Drypoints of Louis Conrad Rosenberg, A.N.A." *Prints* 5 (May 1935): 1–9.

———. "Ernest D. Roth, Etcher." *The Print Collector's Quarterly* 25, no. 1 (February 1938): 32–57.

Bacher, Otto. *With Whistler in Venice*. 2nd edition. New York: The Century Company, 1908.

Baily, Harold J. "Fine Prints of the Year 1932." *Prints* 3, no. 2 (1933): 1–14.

Bassham, Ben L. *John Taylor Arms: American Etcher*. Madison, WI: Elvehjem Art Center, 1975.

Cary, Elizabeth Luthor. "The Work of John Taylor Arms." *Prints* 1, no. 5 (September 1931): 1–13.

Catalogo: XXIV Biennale di Venezia. Venice: Edizioni Serenissima, 1948.

Chamberlain, Samuel. *Etched in Sunlight: Fifty Years in the Graphic Arts*. Boston: Boston Public Library, 1966.

Chambers, Emma. *An Indolent and Blundering Art? The Etching Revival and the Redefinition of Etching in England 1838–1892*. Brookfield, VT: Ashgate Publishing Company, 1999.

Dan, Maria Masau. *Incisori del Novecento nelle Venezie: Tra Avanguardia e Tradizione*. Venice: Albrizzi Editore, 1983.

Denker, Eric. *Whistler and His Circle in Venice* (London: Merrill Publishers, 2003).

Dodgson, Campbell. *Fine Prints of the Year: An Annual Review of Contemporary Etching, Engraving & Lithography*. London: Halton & Company, Ltd., 1937.

Fagg, Helen. "American Prints." *Fine Prints of the Year: An Annual Review of Contemporary Etching and Engraving*, edited by Malcolm C. Salaman, vol. 4. London: Halton and Truscott Smith, Ltd., 1926.

Falk, Peter Hastings, ed. *The Annual Exhibition Record of the Art Institute of Chicago, 1888–1950*. Madison, CT: Soundview Press, 1990.

Fletcher, William Dolan. *John Taylor Arms: A Man for All Time*. New Haven: The Sign of the Arrow, 1982.

Flint, Janet A. *Herman A. Webster: Drawings, Watercolors, and Prints* (exhibition brochure). Washington, DC: Smithsonian Institution, 1974.

Getscher, Robert. *Felix Bracquemond and the Etching Process: An Exhibition of Prints and Drawings from the John Taylor Arms Collection in the College of Wooster Art Center Museum*. University Heights, OH: John Carroll University Fine Arts Gallery, 1974.

———. *The Stamp of Whistler*. Oberlin, OH: Allen Memorial Art Gallery, 1977.

Goldman, Judith. *American Prints: Process and Proofs*. New York: Harper and Row, 1971.

Grieve, Alastair. *Whistler's Venice*. New Haven: Yale University Press, 2000.

Guichard, Kenneth M. *British Etchers: 1850–1940*. London: Robin Garton, 1977.

Hall, Elton W. "The Etchings of Ernest Roth and André Smith." In *Aspects of American Printmaking, 1800–1950*, edited by James F. O'Gorman. Syracuse: Syracuse University Press, 1988.

Hardie, Martin. *Herman A. Webster*. New York: Frederick Keppel & Co., 1910.

———. "The Etched Work of James McBey." *The Print Collector's Quarterly* 25 (October 1938): 420–45.

K., B. [author unknown]. *Exhibition of Etchings by Ernest D. Roth, A.N.A. of New York* (exhibition brochure). National Museum, Smithsonian Institution, Division of Graphic Arts, January 2–29, 1926.

Laurvik, J. Nilsen. *The Etchings of J. André Smith*. New York: Arthur H. Hahlo & Co., 1914.

Laver, James. "The Etchings of Donald Shaw MacLaughlan." *The Print Collector's Quarterly* 18,

no. 4 (December 1926): 322–44.

Leavitt, Thomas W. *André Smith*. Ithaca, NY: Andrew Dickson White Art Museum, Cornell University, 1968.

Lochnan, Katherine. *The Etchings of James McNeill Whistler*. New Haven and London: Yale University Press, 1984.

Lovell, Margarita M. *Venice: The American View, 1860–1920*. San Francisco: The Fine Arts Museum, 1984.

MacDonald, Margaret F. *Palaces in the Night: Whistler in Venice*. London: Lund Humphries, 2001.

Madden, Eva. "A Rising Young Etcher." *The Fine Arts Journal* (September 1914): 433–44.

Mather, Frank Jewett Jr., "The Etchings of Ernest D. Roth." *The Print-Collector's Quarterly* 1, no. 4 (October 1911): 443–56.

———. "Introduction." *Catalogue of An Exhibition of New Etchings of Spain by Ernest D. Roth*. New York: Frederick Keppel & Company, December 1–31, 1921.

Mauroner, Fabio. "Acquaforte." Unpublished, undated manuscript. Civici Musei e Gallerie de Storia e Arte (Archives), Comune di Udine, Italy.

Menpes, Mortimer. *Whistler as I Knew Him*. London: A. and C. Black, 1904.

McMillan, Gail. *Catalogue of the Louis Rosenberg Collection*. Eugene: University of Oregon, 1978.

Morgen, C. L. "The Etchings and Drypoints of Robert Fulton Logan." *The Print Connoisseur* (January 1929): 11–27.

Norwich, John Julius. "Whistler's Etchings of Venice." In *James McNeill Whistler: The Venetian Etchings*, edited by Margaret F. MacDonald, 15–21. London: Art Partnerships International Ltd., 2001.

Official Catalogue of the Department of Fine Arts, Panama-Pacific International Exposition. San Francisco: The Wahlgreen Company, 1915.

Ongania, Ferdinando. *Calli e Canali in Venezia*. Venice: Ongania, 1891–92 (other later editions in English and German).

Palmer, Cleveland. "The Recent Etchings of Donald Shaw MacLaughlan." *The Print-Collector's Quarterly* 6, no. 1 (February 1916): 111–27.

Patterson, Joby. *Bertha E. Jaques and the Chicago Society of Etchers*. Paterson, NJ: Fairleigh Dickinson University Press, 2002.

Pell, Herbert C. Jr., *Ernest D. Roth*. New York: Frederick Keppel & Company, 1916.

Pennell, Elizabeth Robins, and Joseph Pennell. *The Life of James McNeill Whistler*. London: William Heinemann, 1908.

Porzio, Annalisa. *L'Inventario della Regina Margherita di Savoia: Dipinti Tra Ottocento e Novecento a Palazzo Reale di Napoli*. Naples: Arte Tipografica Editrice, 2004.

Reale, Isabella. *Fabio Mauroner, Incisore*. Udine: Grafiche Editoriali Artistiche Pordenonesi, 1984.

Ruskin, John. "Letter 79: Life Guards of New Life." *Fors Clavigera* 7 (July 1877). In *The Works of John Ruskin*, vol. 29, edited by E. T. Cook and Alexander Wedderburn. London: George Allen, 1903–1912.

Salaman, Malcolm. C. L. C. Rosenberg, A.R.E. In *Modern Masters of Etching,* no. 22. London: The Studio Limited, 1929.

Saville, Jennifer. *John Taylor Arms: Plates of Perfect Beauty*. Honolulu, HI: Honolulu Museum of Arts, 1995.

Smith, Rosemary T. *Two Views of Venice*. Philadelphia: Arthur Ross Foundation, 1999.

Wellesley College Art Museum. *Exhibition of Prints by Fabio Mauroner*. Wellesley, MA: Wellesley College Art Museum, March 1–10, 1938.

Whitmore, Elizabeth. *Ernest D. Roth, N. A.* New York: T. Spencer Hudson, 1929.

Weitenkampf, Frank. "Ernest D. Roth, Etcher: A Note on Evolution." *Arts and Decoration* (May 1916): 336–37.

Wuerth, Louis. *Catalogue of the Etchings of Joseph Pennell*. Boston: Little, Brown, and Company, 1928.

www.c-spanvideo.org/videoLibrary/clip. php?appid=465450824. C-Span, May 31, 2006, caption 1:33:40.

Zigrosser, Carl. *The Complete Etchings of John Marin: A Catalogue Raisonné*. Philadelphia: Philadelphia Museum of Art, 1969.

———. *Catalogue of An Exhibition of Etchings by Ernest D. Roth* (exhibition brochure). New York: Frederick Keppel & Company, March 26–April 18, 1914.

INDEX

Page numbers in bold indicate illustrations.

X–Y–Z